CHINESE LANDSCAPES MADE EASY

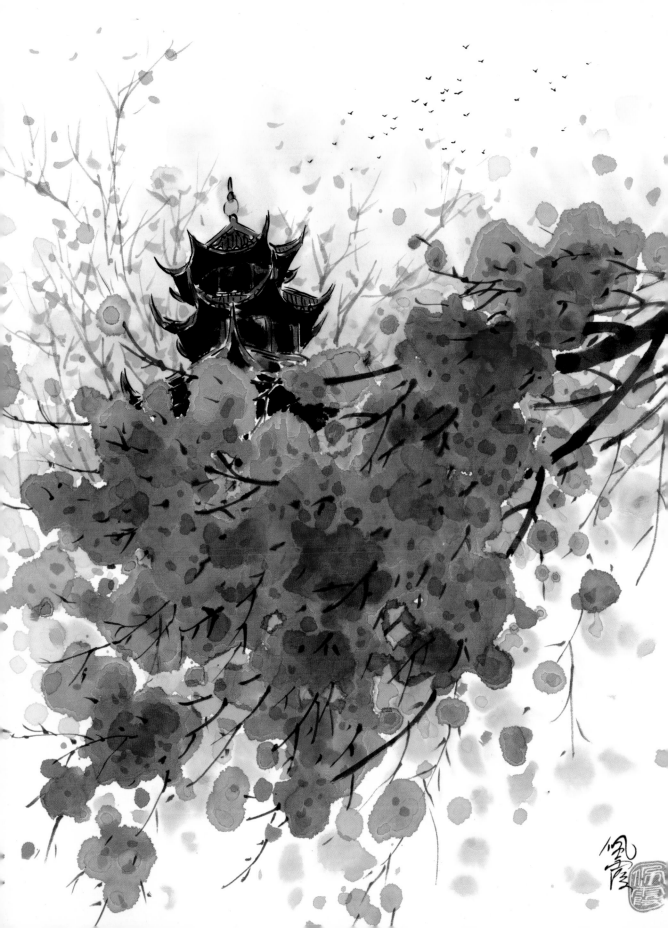

CHINESE LANDSCAPES MADE EASY

Rebecca Yue

BATSFORD

First published in the United Kingdom in 2007 by
Batsford
151 Freston Road
London W10 6TH

An imprint of Anova Books Company Ltd

ISBN-13 9780713490473

A CIP catalogue record for this book is available from the British Library.

10 9 8 7 6 5 4 3 2 1

Reproduction by Anorax Imaging Ltd, Leeds
Printed by Craft Print International Ltd, Singapore

This book can be ordered direct from the publisher at the website: www.anovabooks.com, or try your local bookshop

ACKNOWLEDGMENTS

Traditionally Chinese landscape painting is a very male-dominated subject because in the past women were supposed to stay at home, and only men could travel and admire the great landscapes. So women lacked the direct inspiration to produce landscape paintings, and were confined to creating flower and bird paintings. Even in modern times there are still very few established women Chinese landscape painters. My first master, who taught me landscape painting, took me in against all advice, and with criticism from his fellow masters. I was an apprentice under his instruction for more than four years. After that I went on to study flower and bird painting with two further masters, but from time to time I still went back to him to refresh my landscape techniques. He was obviously very disappointed when I finally decided to go abroad to university, but I hope he will be at peace now, knowing that all his teaching was not in vain.

During the time I wrote this book, my beloved sister lost her fight with cancer. She was terribly proud of me writing my first two books, and I wrote this book with fond memories of her. Somewhere in her resting place, I hope that she will be equally delighted by this third book.

I must thank all who showed their support and encouragement after my first two books were published: my family, friends, pupils, acquaintances and many others I had never met before, as well as many I still have not met yet. Your appreciation and enthusiasm make me feel all my hard work has been worthwhile.

Rebecca Yue

CONTENTS

INTRODUCTION

Landscape painting is probably the most popular subject in Chinese brush painting.
The Chinese words for landscape painting literally mean 'Mountain, Water' and, as the
name suggests, mountains and water are two essential features in a traditional landscape
painting. A modern Chinese landscape painting can vary from being very traditional to
completely abstract in style and, as with all other subjects in Chinese painting, either the
expressive non-outline style or the more elaborate outline style can be used. In both styles
compositions are usually ink-dominated, with ink used to construct most of the structure,
after which colours are added to create depth and mood. Although there have been periods
when landscape painting favoured the outline style, the expressive style, which emphasizes
moods and movement over a concern for photographic likeness, has generally proved more
popular – and it remains so today.

Traditional Chinese landscape painting can be classified into types according to the
predominant colours. In 'light colour' paintings, ink is used to construct the basic structures,
and then other colours are applied lightly, with burnt sienna as the predominant colour. In
'blue and green' paintings there is much use of a distinctive Chinese blue (similar to cobalt)
and a rich Chinese green, while Chinese gold, a colour between burnt sienna and bright
gold, predominates in 'gold' paintings. Finally, there is a 'boneless' style, so called because the
inked 'structure' is omitted and only patches of colour are used. Even today, art students in
China are required to learn these different styles, although contemporary Chinese painting
focuses on expression rather than colours.

The traditional manner of learning landscape painting with a master is by a process that
involves three stages and can take three years. First an apprentice learns about the basic
techniques, then they learn to emulate the master's style, and in the final stage the master
guides the apprentice through learning other styles. The style of a traditional master can be
traced back to a particular group, or 'school', of artists who worked in a particular style,
using particular techniques. Generally it was important for an artist to maintain loyalty
to one school during his lifetime, and to not only uphold the techniques and philosophy
of the school, but extend them further. In the past there were rigid distinctions between
schools (each of which were given names); if an artist used a technique that was
characteristic of a particular school he had to openly acknowledge that school and give it
credit. Since the end of the Qing Dynasty (1644–1911) the distinction between schools has
become more flexible. Artists began to work more openly and were free to exchange ideas.
As a result there was a new flowering in this particular genre of Chinese art, which already
had a long and colourful history. But even today many of the names of the old schools are
well-known, and their styles are loyally maintained by artists.

In flower painting, the natural shapes of leaves and flowers can be conveyed effectively
using certain brushstrokes, which makes flower painting quite defined and systematic,
and relatively easy to learn. But in landscape painting, expressing the nature of a single
landscape feature may call on several different techniques, with no hard-and-fast rule as
to how many should be used. In fact, the more techniques you know, the more varied the

feature will be, and the more expressive your painting as a result. For example, waves can be painted using lines with colours dabbed on them. But if you use the 'press and lift' technique and side brushstrokes, the waves will have a more dramatic shape. Using elbow movements will create brushstrokes that give a sense of movement in the painting and will improve the waves even further. Then again, dry and wet brushwork would add volume to the waves and depth to the whole composition. So you can see that the more techniques you have to hand, the more effects you can create.

It is important and necessary for anyone beginning Chinese landscape painting to know some basic techniques before they start to tackle painting landscape features. So in chapter 2 (see page 28) I have carefully selected a collection of basic techniques that are essential to the initial learning process. These techniques will see you through all the instructions that follow, so it is worth going through this chapter first, rather than continually having to refer back to it as you go through the rest of the book. Don't be put off, because even in this chapter there are many simple and attractive examples for you to try your hand at – in the process of learning the basics, you will already have created many masterpieces of your own! Some readers may be familiar with many of the basic techniques explained here, but it is worth going through them again because now they are presented in the context of landscape painting. Instructions are clear and easy to follow, so that even complete beginners can pick up the techniques quite quickly.

Over the course of Chinese landscape painting history, masters have invented countless brushstrokes specifically for this area. For example, there are more than 50 brushstrokes in existence for painting the texture of mountains and rocks. The vast array of brushstrokes is what makes landscape painting, in its present form, the most developed genre in Chinese painting, but it is also what makes it the most difficult genre to learn. Some people feel that certain brushstrokes are intended for painting specific features but, personally, I am sure that the old masters did not intend their invented brushstrokes to be used in this way. Rather, the key to learning to paint landscape is to work hard on the basic brush techniques and to use them when it comes to interpreting the landscape in your artworks. The Chinese masters used this principle themselves in their work, and the way they used the basic strokes led to new types of brushstrokes. So, in a living way, they demonstrated what could be done with the basics. Because I also believe this is the right approach to painting landscape, I am not going to list all the many brushstrokes invented for landscape painting. Instead, I shall concentrate on guiding you through all the essential basic techniques. And in doing this I am actually following the principles of the traditional master painters.

Once we are equipped with all the basic techniques, we can apply them to painting the many different landscape features. We shall start with trees, then mountains, water, types of weather and seasons. Each topic subdivides further into different aspects. For example, under the topic 'Water' we shall deal with streams, rivers, sea, waves, waterfalls and reflections, while under the topic 'Sky' we shall learn how to paint clouds and mist as well as the sky's different moods. There are many examples included in each topic; you can use them for practice or for ideas of principles to apply in your own composition. I shall also demonstrate painting on alum-sized Xuan paper, so that you can compare the differing

effects obtained from absorbent and alum-sized papers (see page 104). Alum-sized paper is often used in landscape painting; many Chinese instruction books, especially books on landscape painting, contain reproductions of paintings done on this kind of paper, although most readers would not realize this unless they were already familiar with the genre.

In chapter 4 each mood or season is illustrated by means of a painting, with complete step-by-step instructions. These give you the chance to put together the techniques you have learned so far and also provide tips on how to achieve special effects. Using new skills you will be given hints on how to make the colour of autumn trees more intense, and shown an effective way of painting lights, to name just a couple.

It is just impossible to pass on to you all the techniques I know. However, I have included sufficient materials for you to be able to get to the point where you can start developing your own landscape paintings and, throughout the book, I also provide a few insights and tips drawn from my own experience as a landscape painter.

I end with a short gallery of my landscape paintings. These are fully developed paintings that are more expressive and complex than the examples studied in the book. They are there to show you what you can look forward to when you get beyond the initial learning stage and continue to develop your skills in Chinese landscape painting.

In the appendix you will find some unique Chinese features, typically found in traditional landscape paintings, such as cottages, pagodas, bridges and boats. I hope these will be useful for readers who would like to create a landscape painting with a Chinese atmosphere.

Learning Chinese landscape painting is a never-ending journey. The further you go, the more you gather in your hands – and the more you go on to create. It is a very rewarding activity because there is personal satisfaction in every effect you create successfully. I hope to help you through the initial stage of this journey with this systematic learning process so that you will be well equipped to go on without hesitation and with great success. Let your enthusiasm and your love of painting be your driving force, and you are sure to go on enjoying Chinese landscape painting for many years to come.

1 MATERIALS AND EQUIPMENT

In Asian art, paper, brush, ink stick and ink stone are called the scholar's 'four treasures'. All are specialist items, and are normally only available in shops that sell Chinese stationery and writing equipment. However, as Chinese art has become more and more popular many more art shops are stocking these materials, and there are also a few mail-order firms that sell them – it is definitely worth looking out for other places that might sell them. When it comes to paints, I have long been using conventional watercolours for teaching as well as for many of my own artworks, and shall explain why when I come to discuss colours. The other accessories I describe in this section are all helpful when learning, and are all simple objects, such as a jar and newspaper, that you can easily find around the house. Although there are many beautiful objects specially manufactured for use in Chinese painting I have not included them here. My aim is to assemble the simplest requirements; it certainly isn't necessary to spend a lot to paint in the Chinese manner.

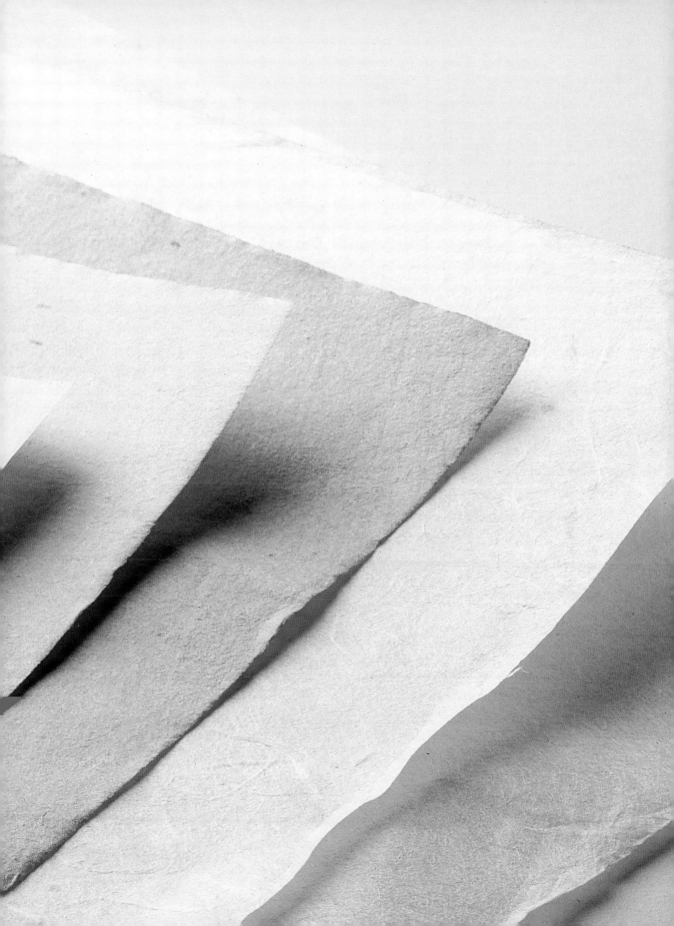

CHINESE BRUSHES

A Chinese brush is made up of a handle and a brush tip. Traditionally the handle is made of bamboo and the brush tip is made of animal hair. Wood and animal horns are also commonly used to make the handles of good quality brushes because they last longer. I have often been asked whether animals are killed to obtain the hair, so I want to make one fact clear: the Chinese don't kill animals simply in order to use their hair. It would hardly be economical, since the animals are more useful alive, providing a constantly renewable supply of hair. But when animals are killed for food, the hair is probably used for making brushes.

Animal hair for making a brush is usually classified by the colour it is dyed. There are white-hair brushes, brown-hair brushes and black-hair brushes. Generally, landscape painting uses a mixture of white-hair, brown-hair and black-hair brushes. The soft white-hair brushes are for broad brushstrokes, the firm brown-hair ones are for general painting and the even firmer black-hair ones are for dry and rough brushwork. There are many brushes made for landscape painting, but I have narrowed the choices down to those you will need for a simple collection, which is all that is necessary for a good start. Some of you may have watched Chinese masters painting landscapes before, using very big brushes. This is because their paintings are usually also very big in size. In fact most of their artworks use the large-size Xuan paper, which measures 66 x 132 cm (26 x 52 in). Many artists even paste several sheets together to create a giant-size paper. But as we are going to be attempting smaller paintings, the brushes we shall be using are going to be smaller.

White-hair comes from the hair of various animals. The brushes made from goat's hair are the most popular, and the best quality. Brushes made of this hair are very soft and are usually referred to as 'soft-hair' (軟毫) brushes. Compared to brown- and black-hair brushes, these soft-hair brushes are not well-suited to the expressive Chinese landscape painting style, where strokes are rougher and made at speed. But a large goat's hair brush will be useful to have, as they can carry a lot of moisture, making them the best brushes for doing washes and splattering effects. Goat's hair brushes are usually not very expensive, so get the largest you can afford. Ti brushes and Hake brushes made of goat's hair are a popular choice, but some of the larger calligraphy brushes are also quite good.

White-hair brush.

Brown-hair brush.

Black-hair brush.

A **Ti brush** (提筆) is a big brush that can be made of any hair. Ti brushes are good for doing washes and broad brushstrokes. There are many white Ti brushes made from goat's hair available and they are generally of acceptable quality. However, I personally prefer a Ti brush made of brown hair or black hair because they are more flexible when it comes to general painting purposes. For doing washes I tend to use the Hake brushes instead.

A **Hake brush** (底紋筆) is a wide, flat brush. The hair can be black or white. The white ones are made of goat's hair and are much cheaper in comparison to the black ones. There are five widths available in the white hair type: 2.5 cm (1 in), 3.8 cm (1½ in), 5 cm (2 in), 6.4 cm (2½ in) and 7.6 cm (3 in). Hake brushes wider than 7.6 cm (3 in) are usually made for mounting in the traditional way. It is useful to have a few Hake brushes of different widths but you can actually create strokes of different widths with a wide Hake brush by holding the brush tip at various angles. However it is more convenient to have at least two different width brushes for painting. It is especially useful when you are doing a multi-colour wash, where one brush holds one colour while the second brush holds the other. Buy one brush that is at least 5 cm (2 in) wide, and avoid buying brushes with metal necks because they eventually rust after getting wet a few times.

Brown-hair comes from foxes, wolves, rabbits, camels and many other animals. These brushes are firmer and, with those made from black hair, are usually referred to as 'tough-hair' brushes (硬毫). They carry less moisture and are more flexible than the soft brushes, and there are more choices available. When the tip of a good brown-hair brush is pressed, it fans out easily and always returns to the upright position when the brush is lifted up again. This makes them very suitable for general painting purposes.

I usually keep a set of four good-quality brown-hair brushes for general painting. They can be used for flower painting as well as landscape painting. A small size **Orchid and Bamboo brush** (小蘭竹) is the largest of the four. A size 3 **Leopard and Wolf hair brush** (三号豹狼毫) is a medium-sized brush. The large and medium brushes can be

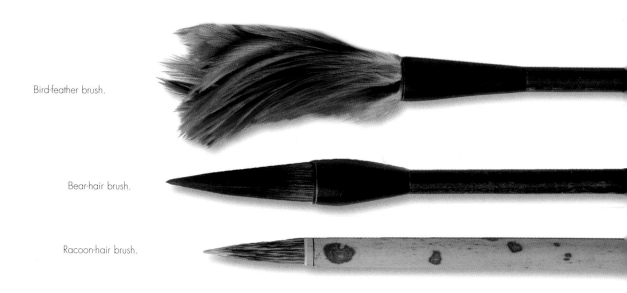

Bird-feather brush.

Bear-hair brush.

Racoon-hair brush.

used for painting trees, mountains, rivers or for large-scale brushwork. A **Red Bean brush** (紅 豆) is a small brush, which is red in colour, and can be used for painting lines and small-scale features. A size 1 small **Wolf-hair brush** (一 号 狼 毫 國 畫 筆) is a very tiny brush for final touches.

There are brown-hair brushes specially made for landscape painting. These brushes have tougher hair and are good for doing dry and rough brushwork. The most popular ones are the **Landscape brushes** (山 水 筆). They come in three sizes, big, medium and small, and are reasonably inexpensive. Personally I prefer the quality of my choice of the above four, and use black-hair brushes for dry and rough brushwork.

In fact, worn-out brushes are very good for painting dry and rough brushwork. When I was an apprentice to my first master, he had a large collection of old brushes that he let me borrow, and always told me never to throw away a brush. He used to say 'you can buy a new brush any time, but you can only make an old brush by constantly using it'. So take his wise words to heart, as I did, and hang on to your old brushes.

Black-hair brushes are made of even firmer hair, from horses, hogs, squirrels, racoons and other animals with tougher hairs. These brushes carry even less moisture than the brown-hair ones. Experienced artists make use of this to create expressive rough and dry brushwork in landscape painting and animal painting. Brushes in this category are more expensive because the hair has to be of very high quality. The hairs cannot be too old or too hard or the brush will not hold moisture. They cannot be too soft either, or they will not create the special dry and rough effects. Many black brushes sold to tourists in Asia are dyed black just for appearance and are not the type of brushes I am talking about here. So if you buy black-hair brushes while touring Asia, do ask what kind of hair they are made of.

A very popular black-hair brush is the **Mountain and Horse brush** (山 馬 筆). The best are made entirely of horse's hair, dyed black. I prefer these over the cheaper versions that are made from brown hair, or a mixture of brown and black. This brush comes in six sizes: big size, medium size, small size, extra small size 1, extra small size 2 and extra small size 3. It is a good idea to have the whole set available, but they are expensive brushes – start your collection with the small size and, when you can afford another, get the extra small size 2 and build up from there.

There are other, rather more expensive, black-hair brushes that are popular with landscape artists. One is the **Racoon-hair brush** (石 獾 筆), another is the **Bear-hair Ti-brush** (熊 毫 提 筆) which is a very responsive and pleasant brush to use for rough work and washes. The **Bird-feather brush** (羽 毛 筆) is specially made for landscape painting, and is perfect for creating broken dry brushwork. Neither a soft-hair brush nor a tough-hair brush, its tip is made from the tail or wing feather of a cockerel.

The brushes on the facing page make a good basic set of brushes to start with when learning landscape painting.

Small size Orchid and Bamboo brush (小 蘭 竹).

Size 3 Leopard and Wolf brush (三 号 豹 狼 毫) or a big size Landscape brush (大 山 水).

Red bean brush (紅 豆) or a small size Landscape brush (小 山 水).

No.1 small Wolf-hair brush (一 号 狼 毫 國 畫 筆).

Goat-hair Hake brush (羊 毫 底 紋 筆), at least 5 cm (2 in) wide, or a Goat-hair Ti brush (羊 毫 提 筆).

Small Mountain and Horse brush (小 山 馬).

A BASIC SET OF BRUSHES FOR LEARNING IN THIS BOOK:

For anyone keen on landscape painting, I strongly recommend buying a Mountain and Horse brush extra small size 2 (小 二 山 馬). And if you are getting an additional Ti-brush, get one made with brown hair or black hair.

'OPENING' A CHINESE BRUSH

The tip of a new Chinese brush is nicely held together by gum, but it is only there for presentation purposes. The tip itself is usually protected with a bamboo or plastic cover when new. Before using a Chinese brush for painting, the brush needs to be 'opened' to remove the gum and loosen the hair. To do this, soak the brush tip in cold water. Don't use hot or warm water to hasten the process; hot and warm water shrink the hair, and will melt the glue that holds the brush tip to the handle (as will prolonged soaking when not in use).

Treat your brushes gently and with respect, and give them enough time to open properly. Soak a new brush in a jar with sufficient cold, clean water to cover the brush tip. In most cases twenty minutes will be long enough to loosen the gum and the brush tip, although a Ti-brush needs about half an hour. After soaking the new brush in water, press the brush tip gently with your fingers. If the hairs are soft and separate, the brush is properly opened. If the tip is still hard and will not separate, do not force it by bending. Instead, return it to the water and soak it for a bit longer. When the brush is fully opened, rinse it thoroughly in clean water to remove all the gum. Dry it between tissues or with a soft towel. The brush is now ready to serve you.

A fully 'opened' brush and a new brush before being 'opened'.

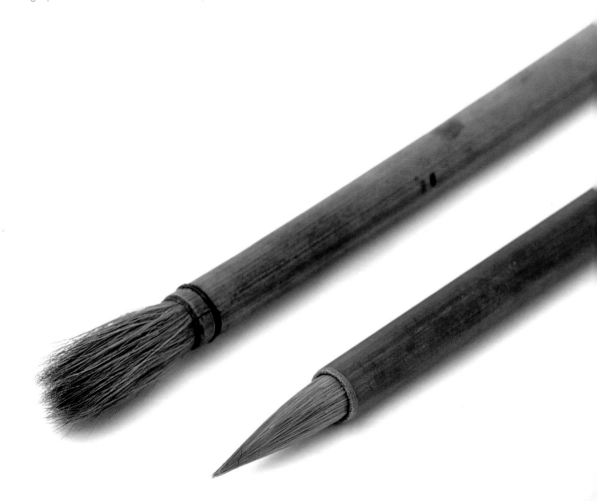

CARING FOR CHINESE BRUSHES

There are a few things you can do to keep your brushes in good condition so that they will last longer.

• Do not put your opened brush back into the bamboo or plastic cover. Once a brush is opened, the tip will be too big for the cover and will be damaged if you try to squeeze it in.

• Do not store wet or damp brushes in airtight containers like plastic bags. Chinese brushes are made of natural materials and they can rot in damp conditions. Always dry them completely before storing them. When the brushes are not in use, you can store them in opened jars with the tips pointing up. Some brushes come with loops of cord at the top and can be hung on a specially made brush hanger. These are available in shops where you can buy Chinese brushes, but you can also make one easily. If you need to carry the brushes with you on painting trips, or to and from classes, the best way is to wrap them in specially made brush mats. A brush mat is made from thin bamboo sticks bound together, with gaps that allow brushes to breathe and dry – you have to be careful, because brushes can easily fall out from the open ends and get lost. I have a foolproof way of keeping my brushes in place. Cut a length of dressmaking elastic to the width of the mat, thread it in and out through the gaps in the mat and sew the ends in place. The loops formed by the elastic are perfect for holding brushes.

• Do not use a good-quality brush for mixing colours. Get a cheap watercolour brush for this, or alternatively use an old brush.

• After each painting session, always clean ink and colours off your brushes. Wipe off excess moisture before putting them away. Do not clean any of your brushes with soap or washing liquid. These are difficult to get rid of and can form a barrier that causes problems when using the brush.

• The brush tip of a good-quality brown-hair or black-hair brush always reshapes to a point when wet. If this fails to happen the brush has passed its best and you should consider getting a new one. Do not discard the old one, because it can be used for mixing colours, and old big brushes are perfect for rough and dry brushwork.

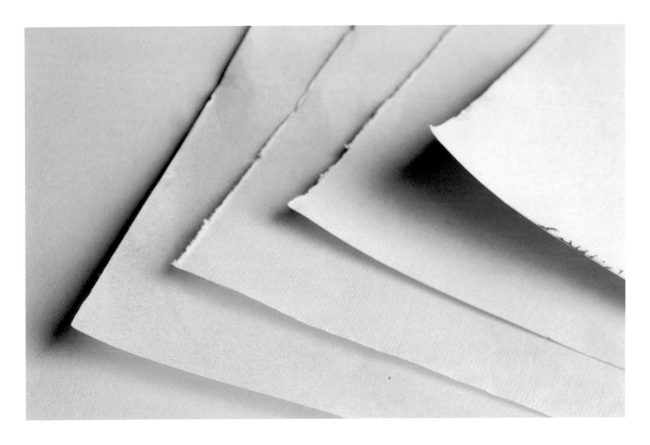

PAPER

Absorbent Xuan paper. This paper is available in various thicknesses, making it suitable for a range of painting methods.

Chinese landscape painting uses **Xuan paper** (宣 紙), made from a mixture of tree bark, bamboo, cotton and other materials. There are many varieties of Xuan paper depending on where it is manufactured. Each variety is produced following a specific formula; some have been passed on for generations, and are closely guarded secrets. Each formula has a name, which is usually printed at one corner of a sheet or across the side of a pack of sheets. Xuan paper is usually available in loose sheets that measure approximately 66 x 132 cm (26 x 52 in), although some varieties may be bigger.

There are two main types of Xuan paper, the absorbent Xuan and the alum-sized Xuan. **Absorbent Xuan paper** is available in different thicknesses. Starting from the thinnest they are one sheet (單 宣), two sheet (雙 夾 宣), three sheet (三 夾 宣) and four sheet (四 夾 宣). One-sheet paper is relatively cheaper so it is good value for learning and practice purposes. The two-sheet thickness is more suitable for serious painting, and the three-sheet and four-sheet thicknesses are seldom available outside Asia, and even there only in specialist shops. Absorbent Xuan paper is usually sold as loose sheets that are sometimes cut in half lengthwise and sold as rolls of 12 or 15 half sheets. Most absorbent Xuan paper that you find outside Asia is one-sheet thickness, but art shops that stock Chinese painting materials can order the two-sheet paper for you if buy a large quantity.

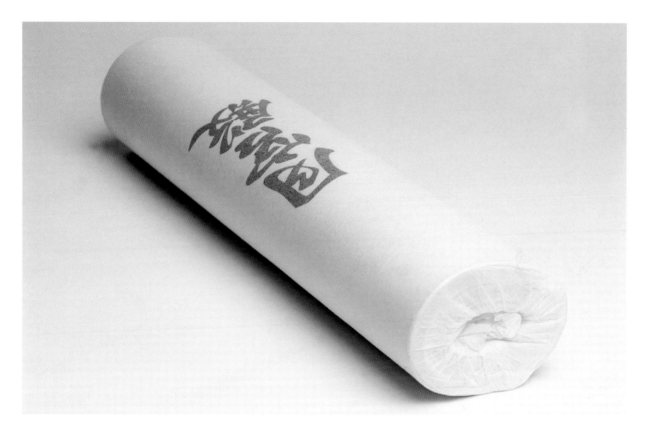

Besides the Chinese, Japanese and Koreans also make Xuan paper. A two-sheet thickness paper made to a Japanese formula, called 'Moon Palace' (月宮殿) comes in continuous rolls, usually about 15 m (50 ft) long each, and has the advantage of being readily available in art shops. It comes in three widths: 38 cm (15 in), 45.5 cm (18 in) and 61 cm (24 in). The paper has a smooth side and a rough side, and I usually advise pupils to use the smooth side for painting, though some artists prefer the rough side for painting rough and dry brushwork. Moon Palace is a good quality Xuan paper and if you are happy and comfortable with it, you should feel free to use it. However, it is not everyone's favourite because some people find it difficult to control the way it absorbs moisture. There are also specialized types of absorbent Xuan paper, such as speckled gold papers that have had bits of gold paper mixed into the pulp when the paper was made, or pre-printed papers with good luck messages. To cut a piece of absorbent Xuan paper, whether a loose sheet or a continuous roll, simply draw a line across the paper with a wet brush and then pull the two sides apart.

Mulberry paper (麻紙) is another good-quality absorbent paper for painting. This paper absorbs moisture more slowly than the more frequently used Xuan paper, which gives more control over brushwork. The mulberry paper made for craft work is different from that made especially for Chinese painting, which has a tighter texture. There are two types of mulberry paper for painting. One is coarse with beautiful mulberry fibre patterns. Washes applied to this paper have a very dramatic effect. The other type is smoother, and comes in white, light beige or dark beige.

A roll of 'Moon Palace'. This type of Xuan paper is readily available in most art shops.

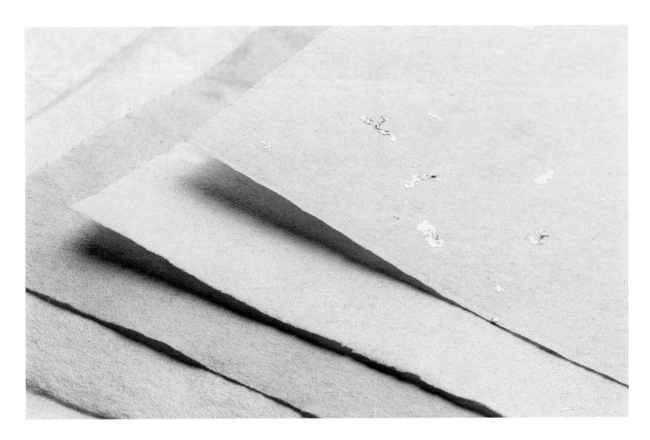

From top: Speckled gold paper, coloured paper, dark beige smooth mulberry paper and coarse mulberry paper.

Alum-sized Xuan paper (矾宣) is absorbent Xuan paper treated with alum, salt and gum. This paper is always associated with outline painting, a technique where an initial outline is filled with layers of colours, but many artists use it for landscape painting in an expressive style. There are three distinctive ways of using this paper:

1 Alum-sized Xuan paper is not exactly non-absorbent, but it does absorb moisture at a very slow rate. This provides artists with time to spread and move the colours before they are finally absorbed, making it an excellent choice for painting mist, fog and clouds, for example.
2 Ink and colours do not run on this kind of paper, so images are sharper. This makes it good for painting features with defined edges, such as mountains.
3 When using a splattering effect, in which large amounts of colours are applied, the paper gives artists a chance to spread the colours in a more controlled manner.

Alum-sized Xuan paper is classified by the formula used in making it rather than by thickness. The type normally available in shops is simply called 'alum-sized Xuan paper' and is sold as loose sheets or in rolls of 12 or 15 half-size sheets (cut lengthwise). The paper can vary in thickness and quality according to where it was made in China. **Cicada's Wings** (蝉翼笺 or 蝉衣笺) is probably the most popular of the good quality varieties. Though it is a very delicate and thin paper, it is very resilient and seldom breaks even when wet. Another good paper, **Mother of Cloud** (云母笺), is thicker and has a slightly quicker rate of absorbing moisture.

It is not advisable to cut a sheet of alum-sized Xuan paper with a wet line. Instead the paper should be cut with a knife or a pair of scissors.

Silk used for Chinese painting is also treated with alum and gum and can be used in the same way as alum-sized Xuan paper. However, because silk is transparent, you need to apply more colour pigment to create good depth.

I shall be using loose sheet absorbent Xuan paper of two-sheet thickness for most of the demonstrations in this book. From time to time, I will also examine examples of artworks on other paper, especially the alum-sized Xuan paper, which is a favourite of many landscape artists. In flower painting, alum-sized paper is used for outline style painting but in landscape painting it is used for both outline style and the expressive non-outline style. I shall demonstrate how to paint in the non-outline style using this paper.

If absorbent Xuan paper of one-sheet thickness is the only paper available to you, it is perfectly fine to use it, but try not to overload your brush with too much moisture during painting. And just maybe it is time for you to persuade your local art shop to stock some two-sheet absorbent Xuan paper and alum-sized Xuan paper.

From top: Cicada's wings, Mother of Cloud and alum-sized silk.

INK

Chinese landscape paintings are ink-dominated, so ink will feature quite a bit in this book. The traditional way of making ink is by grinding an ink stick on an ink stone. Nowadays we also have ready-made liquid ink, but opinion is somewhat divided on whether it is preferable, and I get a lot of feedback from readers asking which kind of ink is best. I am completely convinced that either kind will serve the purpose, and you should just choose whichever you are happiest with. So I shall provide information about both and leave it up to you to choose the kind you like best.

To make ink with an ink stick, you will also need an ink stone. This is made from a stone similar to slate, but much harder, and prices vary between £2 ($4) and £20,000 ($40,000) or more. Although a good quality stone is always better, a cheaper one will suffice as well. There are many sizes available, and it is important to choose one that allows the ink stick to move in a circular motion comfortably. Alternatively, you can use an unglazed ceramic bowl instead of an ink stone. When I was a pupil to my first master, he gave me a ceramic bowl to start with because I was not considered worthy to use an ink stone yet. And I am still using this bowl for grinding my ink: it has served me for more than fifty years.

Prices for ink sticks also vary, from less that £1 ($2) to about £50 ($100) – although antique ink sticks can cost well over £1,000 ($2,000). Ink sticks are classified by name, which is usually engraved on the stick. The most readily available makes are Qian Qiu Guang (千秋光) and Zi Yu Guang (紫玉光). These are usable and are perfectly fine for a beginner. A Tie Zhäi Weng (鐵齋翁書畫寶墨) ink stick for painting and calligraphy is much better quality, but is also much more expensive, although unfortunately there are many inferior imitations of this particular ink stick at lower prices around. You also find ink sticks with beautiful pictures carved on them, but these are more for presentation and the quality is fairly ordinary.

To make ink with an ink stick, first place your ink stone or ceramic bowl on a level surface. Use your brush or an eyedropper to place a few drops of clean water on the surface of the ink stone. Hold the ink stone with one hand so that it will not move around when you are grinding the ink stick on it. Hold the ink stick with the other hand vertically against the water drops and grind against the surface of the stone in a circular motion. You will see dark ink starting to appear. Add a few more drops of water and grind again. Repeat the process of adding a few drops of water followed by grinding until you have made sufficient dark ink. It is not advisable to grind the ink stick on a large pool of water as it will take a long time to turn the large pool of water into thick ink. Besides, thick ink dries up quickly. Test the darkness of the ink from time to time to see whether it is sufficiently dark and thick for your use, and when you finish grinding do not rest the wet part of the ink stick on the ink stone or it will get stuck to the stone as it dries. When the ink you prepared has almost run out, repeat the grinding process again. Clean the stone with soft tissues and cold water. Dry it properly before putting it away. Do not use any abrasive material to clean the stone because you may damage its delicate surface. Always clean the ink stone every time after use because any dry leftover ink on the stone will be very difficult to remove.

There are many manufacturers of quality liquid ink in China. One reliable one is Yi De Gë (一得閣), and is probably the oldest ink maker in China. They make many different types and qualities of ink, liquid as well as sticks. The liquid ink they make for general use is shown on the following page. This is the most basic one, and they also make better quality inks. In fact, some of their very good quality liquid inks are stored and sealed in porcelain jars, which are fast becoming collectors' items. Writing ink is unsuitable for Chinese painting because it runs madly on absorbent paper and you cannot use it for dry brushwork. Chinese ink has gum in it, which means that once it is dry, it is permanent. So it is a good idea to wear old clothes or overalls when using Chinese ink, as any inadvertent splash will be there for good.

It is better to pour liquid ink into a different dish or container from the ones you use for mixing colours. You can use the traditional ink stone, or a small ceramic dish or even a small plastic container. Whatever you use, do clean the ink dish every time you finish painting because any leftover ink will harden and become difficult to remove. New liquid ink freshly poured out of the bottle may be a bit thin but will thicken up very quickly. I usually allow fresh ink to stand for five to ten minutes before using it. However, ink thickens up very quickly if it is left in the open air, so pour out only small amounts at a time and add more when it starts running out. If the ink becomes too thick, add a bit of fresh ink to thin it. Only use water if you also want to make it paler.

An ink stone and ink stick. Always choose an ink stone that allows the ink stick to move in a circular motion easily.

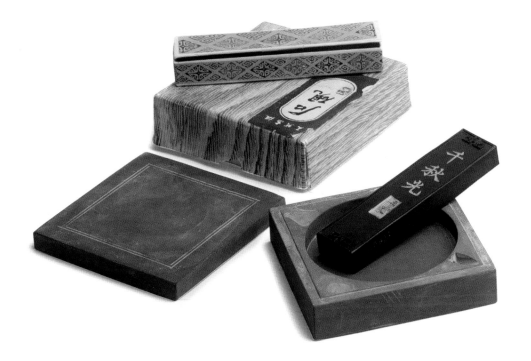

I have used ready-made liquid ink for all the demonstrations and artworks in this book. Here are some terms I shall refer to:

Dark ink Ink that has been freshly poured from the bottle and not left in the open for too long.
Diluted ink Ink to which water has been added, creating a lighter colour.
Medium ink Diluted ink that has a tiny bit of dark ink added to darken it.
Dry ink Dark ink that has been left in the open for a while to thicken up.

COLOURS

There are many types of colours suitable for Chinese brush painting. The specialist kinds are usually manufactured in China, Japan and Korea. In the oldest and most traditional form colours come as powders, which are prepared by adding gum, and crystals that have gum already added. But colours also come in trays and tubes.

Some people insist on using colours manufactured in China or Japan for Chinese painting. Personally I do not see any reason not to use watercolours, and most of my pupils use them with excellent results. Watercolours are more easily available and offer more choice, although Chinese and Japanese colours do have gum in them, which makes life easier when

A bottle of liquid ink. Ink may be a little thin when it is first poured from the bottle, but will thicken very quickly when it is left in the open air.

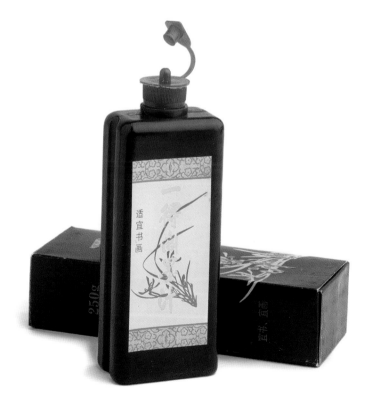

it comes to mounting Chinese Xuan paper artworks in the traditional way, where you have to wet your paintings in the process. English watercolours tend to run when you do this. I use a more modern method of mounting that requires much less water to wet the paintings. In fact all the illustrations in this book are of paintings done with conventional watercolour paints, mounted in this way. You will find instructions on how to mount paintings with this method in my other books, *Chinese Calligraphy Made Easy* and *Chinese Flower Painting Made Easy*.

If you are new to watercolour paints, the following is a list of the colours I've used in this book, although you can add your own favourites as well: sap green, indigo, burnt sienna, gamboge, cadmium yellow, alizarin crimson, cadmium red deep, cobalt blue, mauve and process white. These are the essentials ones, and others, such as cadmium orange and yellow ochre, are also useful. Please feel free to use any Chinese, Japanese or Korean colours but do follow the manufacturer's instructions.

ACCESSORIES

You will need:
- A big jar or a plastic container for water.
- A mixing dish or, alternatively, a big light-coloured dinner plate for mixing colours.
- Lots of newspaper to protect the surface you are painting on.
- Some small weights, such as small stones or paperweights, to keep your painting paper from moving while you are painting.
- A cheap painting brush or an old Chinese brush for mixing colours.
- A few sprays (garden sprays are fine) for doing washes. I usually have four.
- A few wide, shallow containers for mixing washes. These can be shallow bowls or small, wide yoghurt pots. They need to be wider than your hake brush.
- Newsprint paper (blank).

Lay your Xuan paper on top of a large area of newsprint paper that will absorb the excess moisture during painting. When the newsprint gets too wet and muddy, you can replace it with fresh paper. Traditionally, artists use a large piece of flannel for this, and you can buy it in the same art shops that stock Chinese painting materials. But I find flannel too soft and even a hindrance to expressive movement. Newsprint serves the same purpose well, but you will have to change it often. Most art shops and craft shops stock blank newsprint but usually in very small sizes. So look for the A1 size, or buy it in rolls (sometimes it is sold this way as packing paper). If the shop does not have it, they can order it for you, and it is cheaper if you can buy in bulk.

2 TECHNIQUES

Anyone can pick up a brush and paint.
However, if you want to use your brush
effectively, the techniques described in this
chapter will help you to master the basics.
You can then use your skills to create many
different effects on paper.

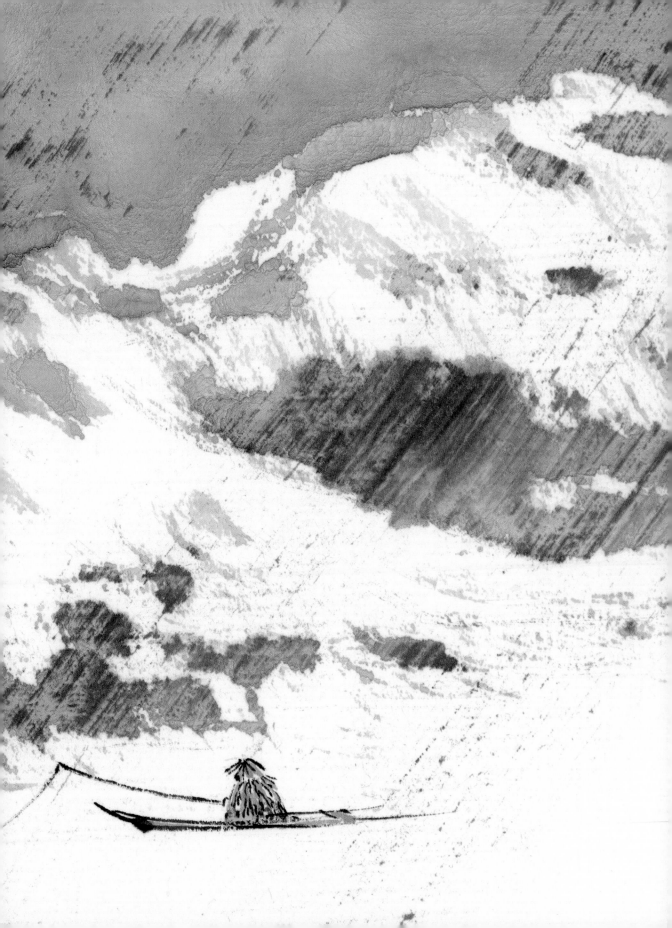

MANOEUVRING THE BRUSH

When it comes to Chinese brush painting, landscape painting is probably the most difficult genre. To paint a feature, you need to use a combination of basic techniques. By themselves these are actually fairly straightforward, but the challenge lies in combining them effectively. It helps to know exactly how each kind of brush behaves because then you have more control over what it can do. But if you are new to using Chinese brushes, you may lack confidence in the beginning. Do not worry, because I shall guide you every step of the way, beginning with how to hold the brush correctly. After that you will learn simple techniques, and can try them out in the section of practice exercises. Even if your brushwork is a bit shaky at first, don't give up: keep practising and you will soon improve your skill. After all, we were all beginners once. The trick to using the brush properly is to get to know it as an old friend, and as a partner in your creative process. My landscape master expected me to use the brush as if it was part of me. For him the brush was an extension of the hand, and the hand an extension of the heart. The only way to arrive at this level is to work hard at understanding how the brush functions, until you've reached a perfect partnership.

HOLDING THE BRUSH

Let us begin with holding a Chinese brush in the proper way. The length of the brush handle is carefully designed to be in proportion to the size of the brush tip, and to be suitable for the brush's usual purpose. For example, a brush made with black hair has a longer handle in comparison to a brush of the same size but made from different hair. This is because the black-hair brush is designed for expressive painting and needs a longer handle so that you can swing the brush during painting to achieve sweeping brushstrokes.

The normal way to hold a brush is at the middle of the handle. Experienced artists sometimes vary this position for special effects, but for new users it is best to begin this way. When you are more comfortable with the brush, you can experiment more. If you hold the brush at the middle of the handle, you arm will always be away from the painting surface. This gives you freedom to move your hand and arm in any direction without restriction, and this is very important for expressive painting.

The simplest way to hold a brush is to grasp it between your thumb and four fingers. Another way is to hold it with two fingers on one side of the brush and the other two fingers on the same side as the thumb. Use the way you find most comfortable since both enable you to hold the brush upright and firmly. In Chinese painting you should always hold the brush in an upright position, and vary the angle of the brush to the paper by rotating your wrist. Hold the brush firmly to produce strong brushwork. During my own lessons my teacher would try to snatch my brush from my hand without warning, and would be very unhappy if he succeeded. He expected me to hold it so firmly that it was almost glued to my hand.

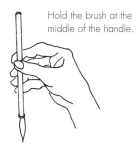

Hold the brush at the middle of the handle.

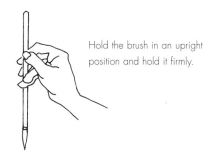

Hold the brush in an upright position and hold it firmly.

One way of holding the brush is with four fingers on one side of the brush and the thumb on the other side.

Another way is to hold the brush with two fingers on one side and the other two fingers on the same side as the thumb.

ANGLE OF THE BRUSH TO THE PAINTING SURFACE

You can hold the brush in a vertical position or you can hold it at an angle to the painting surface. Vary the angle of the brush to the paper by rotating your wrist; this angle often affects the outcome of the brushstroke. For example, if you hold a brush loaded with ink at a high angle and touch the paper the mark it makes will be small because only a small part of the brush will make contact with the paper. Holding a brush at a low angle produces a bigger mark because more of the brush is touching the paper. Always adjust the angle by rotating the wrist. Do not use your fingers to adjust the angle because you will end up holding the brush loosely, and your brushstrokes will be floppy and loose.

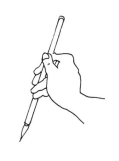

Dip the brush into ink. Hold it at a high angle and touch the paper.

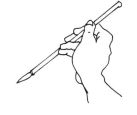

Dip the brush into ink. Hold it at a low angle and touch the paper.

The brush mark is small.

The brush mark is bigger.

DIRECTION OF THE BRUSH HANDLE

The rotation of the wrist not only controls the angle of the brush to the painting surface, but also controls which direction the brush handle points. Here I shall show you the most common directions, in each case indicating what happens for both left-handed and right-handed people. As I am right-handed the other illustrations in this book will just show the right-handed position, and a left-handed reader will need to adjust accordingly. Movements in landscape painting are fluent, swift and sometimes done at speed. It is more natural and actually easier to move the brush quickly in the direction that the handle is pointing. So for more efficient results always point the brush handle in the direction of travel. You do this by rotating the wrist.

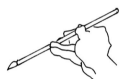

Holding the brush with the handle pointing to the right (right-handed).

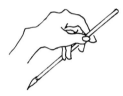

Holding the brush with the handle pointing to the right (left-handed).

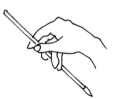

Holding the brush with the handle pointing to the left (right-handed).

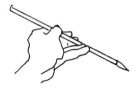

Holding the brush with the handle pointing to the left (left-handed).

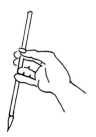

Holding the brush with the handle pointing away from you (right-handed).

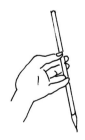

Holding the brush with the handle pointing away from you (left-handed).

Holding the brush with the handle pointing towards you (right-handed).

Holding the brush with the handle pointing towards you (left-handed).

Changing Direction

When you paint a straight line, you can move the brush in the direction that the handle is pointing without changing the position of the handle. But when you paint curves, you need to change the position of the handle as you change the direction of the curve. You change the handle's direction by rotating the wrist.

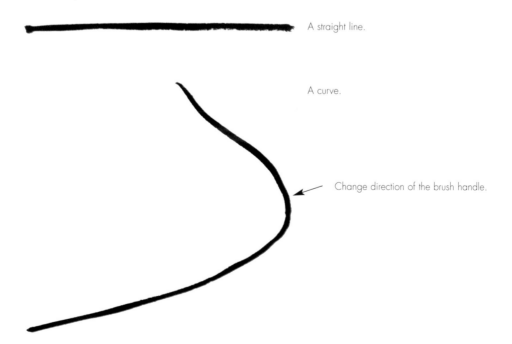

A straight line.

A curve.

Change direction of the brush handle.

LOADING A BRUSH WITH INK AND COLOURS

You have to load a brush with ink or colour in order to paint. Here are explanations of some of the terms I will be using, demonstrated with a small size Orchid and Bamboo brush:

ANATOMY OF A CHINESE BRUSH

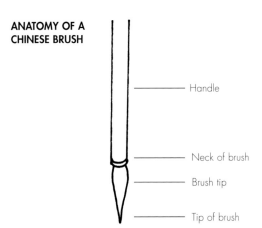

———— Handle

———— Neck of brush

———— Brush tip

———— Tip of brush

'Fully loading a brush' means to dip the whole tip of a brush into ink or a colour, until the tip is saturated. If the colour in the palette is too shallow or the brush is big, you will need to hold the brush on its side, then roll the tip until it is entirely coated. If you hold the brush in a vertical position and touch the paper the paper will absorb the moisture, and the brush mark usually runs.

An ink brushstroke using a fully loaded brush.

'Dipping the tip in colour or ink' means to load only the very tip of the brush with ink or colour. Moisture in the brush is less so the resulting brush mark will be smaller.

A brushstroke using a brush with the tip dipped into ink.

'Two-tone loading' means to fully load the brush with a diluted tone of a colour and then dip the very tip of the brush into a darker tone of the same colour. A brushstroke made in this way will create a gradual toning of the colour.

A brushstroke with two-tone loading. Fully load your brush with diluted ink and dip the very tip of the brush into dark ink. Hold the brush at a high angle to the paper and paint a line.

'Two-colour loading' involves fully loading the brush with one colour and then dipping the tip of the brush into another colour. A brushstroke made in this way will begin with the colour at the tip then gradually change to the first colour loaded onto the brush.

A brushstroke with two-colour loading. Fully load your brush with alizarin crimson and dip the tip of the brush into ink. Hold the brush at a high angle to the paper and paint a line.

'Normal loading' means to fully load a brush with a colour and then gently wipe off excess moisture on the side of the palette before making a mark.

A brushstroke with normal loading. Fully load your brush with ink and wipe off excess moisture at the side of the palette. Hold the brush at a high angle to the paper and draw a line.

'Dry loading' involves loading a brush with a colour and then wiping off excess moisture on a tissue or paper towel. The more moisture you wipe off, the drier the brushwork.

A drier brushstroke.

PRACTICE

Line Drawings

Let us begin with some line drawings. Line drawings are very useful for sketching, and you can record any landscape with sketches. You can also make simple landscapes with lines and informally apply colours on top or draw lines with very diluted ink to outline a composition before painting it in with brushwork. The faint outlines you have drawn in will provide a guide for your construction of the final artwork.

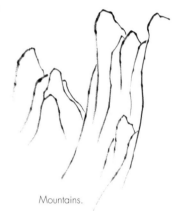

Small branch.

Simple cottage.

Bridge.

Mountains.

Sweeping Curves

Curves are popular in landscape-painting brushwork. If you gradually increase the speed of your painting movement while you are painting a curve, the result will have a sweeping effect. This kind of curve is often used for painting waves and clouds.

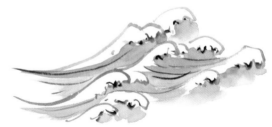

Waves.

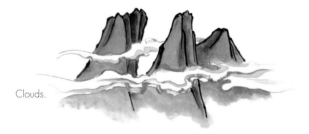

Clouds.

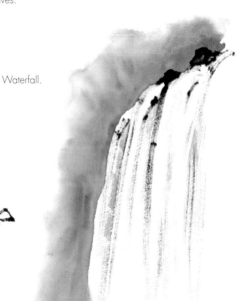

Waterfall.

Dry Brushwork

Load a size 3 Leopard and Wolf or big size Landscape brush with ink. Wipe the brush on absorbent paper to remove excess moisture. Use this dry brush to paint the outlines of a waterfall and rocks.

Rocks.

WRIST MOVEMENT AND ELBOW MOVEMENT

We are not used to actively moving our hands and arms when we paint, and our joints can be very stiff and reluctant about it. But Chinese non-outline painting, especially landscape painting, is a very expressive way to create artworks and requires movements to be flexible and performed without hesitation. In order to get into the right mood for moving freely and actively, let us start with these two movements. I recommend practising with a size 3 Leopard and Wolf or big size Landscape brush unless indicated otherwise.

WRIST MOVEMENT

Wrist movement is achieved by rotating the wrist. I have already mentioned that rotating the wrist is used to vary the angle of the brush to the paper and also to control the painting movement by changing the direction of the handle. In this section we are going to learn how to create small brushstrokes by rotating the wrist. Movements made by rotating the wrist are small, which deliberately restricts the size of the brushstrokes.

WRIST MOVEMENT

You can move your hand up or down, to the right or to the left, by rotating the wrist.

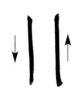

SHORT VERTICAL LINES

Dip your brush into ink and hold it in a vertical position. Draw short vertical lines by rotating the wrist upwards and downwards. Move the brush in the direction indicated by the arrows.

SHORT HORIZONTAL LINES

Dip your brush into ink and hold it in a vertical position. Draw short horizontal lines by rotating the wrist to the right or to the left. Move the brush in the direction indicated by the arrows.

SMALL CURVES

Dip your brush into ink and hold it in a vertical position. Draw small curves by rotating the wrist. Move the brush in the direction indicated by the arrows.

ELBOW MOVEMENT

In this movement, you move your arm by rotating it around the elbow. You can move in a forward or backward direction, and swing to the right of left. This kind of elbow movement enables you to produce longer brushstrokes. When elbow movement is used with speed, the resulting brushstrokes have a sweeping effect that is very characteristic of the expressive style of Chinese landscape painting.

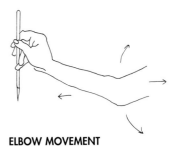

ELBOW MOVEMENT
Move your arm forward or backward, to the right or to the left by rotating the elbow.

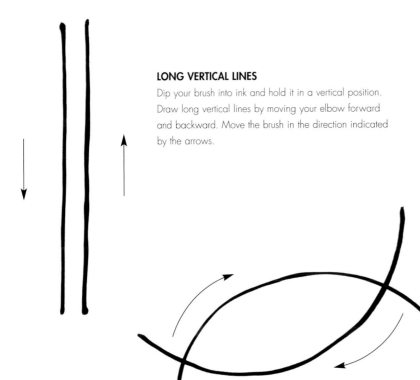

LONG VERTICAL LINES
Dip your brush into ink and hold it in a vertical position. Draw long vertical lines by moving your elbow forward and backward. Move the brush in the direction indicated by the arrows.

LONG CURVES
Dip your brush into ink and hold it in a vertical position. Draw long curves by moving and rotating your elbow following the directions indicated in the illustration.

LONG HORIZONTAL LINES
Dip your brush into ink and hold it in a vertical position. Draw long horizontal lines by rotating your elbow to the right or to the left. Move the brush in the direction indicated by the arrows in the illustration.

FURTHER PRACTICE

Wrist and elbow movements can be used separately to create features. Drawing a tree is a good example of where elbow movements are followed by wrist movements. They can also be used at the same time, as in painting long curves where wrist movement is used to adjust the changing direction of the curve. Here are some examples to help you practise these two movements.

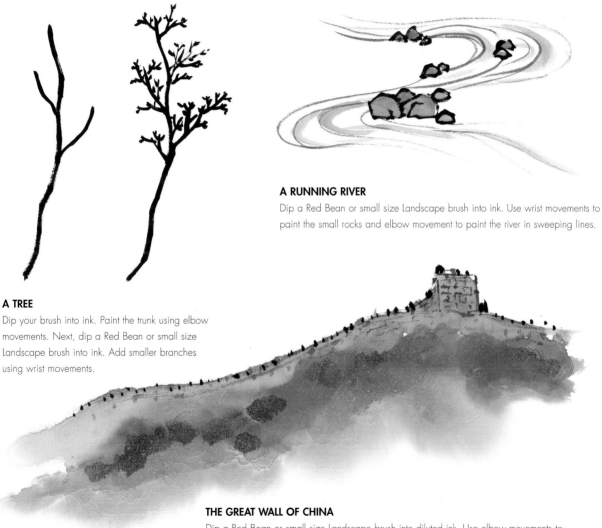

A RUNNING RIVER

Dip a Red Bean or small size Landscape brush into ink. Use wrist movements to paint the small rocks and elbow movement to paint the river in sweeping lines.

A TREE

Dip your brush into ink. Paint the trunk using elbow movements. Next, dip a Red Bean or small size Landscape brush into ink. Add smaller branches using wrist movements.

THE GREAT WALL OF CHINA

Dip a Red Bean or small size Landscape brush into diluted ink. Use elbow movements to draw the long wall. Next, dip it into dark ink. Use wrist movement to paint the small details. Load your size 3 Leopard and Wolf or big size Landscape brush with burnt sienna and colour the wall. Fully load your small size Orchid and Bamboo brush with sap green. Paint sweeping lines with elbow movement to build up the green patches below the wall. Next, dip this brush into indigo and add a few dots along the green patch.

PRESS AND LIFT TECHNIQUE

When you press the brush it will spread and give width to your brushstroke. When you lift the brush it will go back to the original shape and your brushstroke will be thinner. By pressing and lifting the brush you can vary the widths at different parts of a single brushstroke.

By combining the press and lift technique with wrist movement you can create small brushstrokes that will be useful for painting leaves of trees or small objects. By combining press and lift with elbow movement you can create longer brushstrokes that will be useful for painting waves, moving clouds, sweeping wind or storm.

COMBINING THE PRESS AND LIFT TECHNIQUE WITH WRIST MOVEMENT

We are going to paint a shape with its narrow end pointing to the right. Practise painting the shape pointing in different directions. Remember to change the direction the handle is pointing to whenever you move to a new direction.

STEP 1

Fully load the small size Orchid and Bamboo brush with dark ink. Hold the brush at a slightly high angle to the paper. Point the handle of the brush to where your movement will be going, that is, with the handle pointing to the right. Press the brush down at the beginning point of the shape.

STEP 2

Rotate your wrist in an anti-clockwise direction so that the brush tip moves from left to right.

STEP 3

Lift the brush as you move towards the end of the shape.

A brushstroke made by press and lift technique combined with wrist movement.

Small Brushstrokes

Using this press and lift technique with wrist movement produces small brushstrokes. For example, we can use this technique to paint the leaves of a tree. Some examples follow.

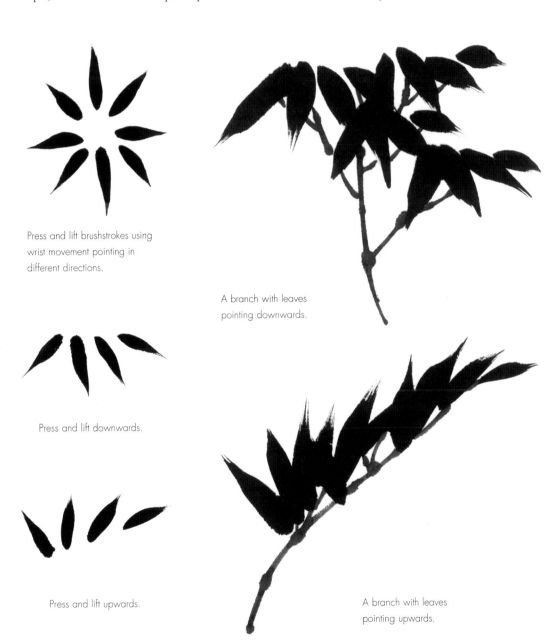

Press and lift brushstrokes using wrist movement pointing in different directions.

A branch with leaves pointing downwards.

Press and lift downwards.

Press and lift upwards.

A branch with leaves pointing upwards.

COMBINING THE PRESS AND LIFT TECHNIQUE WITH ELBOW MOVEMENT

We are going to paint a brush mark starting from the left and extending upwards to the right.

STEP 1
Fully load a size 3 Leopard and Wolf or big size Landscape brush with dark ink. Hold the brush at an angle to the surface, with the handle pointing to the upper right. Press the brush down on the paper to start.

STEP 2
Move by swinging your hand towards the upper right, using elbow movement.

STEP 3
Halfway through the brushstroke, start lifting the brush. Do not rush this, because lifting the brush gradually will achieve a more natural curve.

STEP 4
Continue to move by rotating your elbow, and keep lifting until the brush leaves the surface.

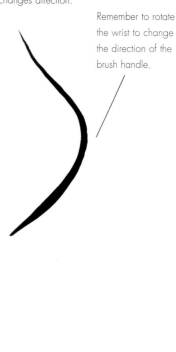

A SWIRL
Move along the swirl using elbow movement. Use wrist movement to paint each press and lift as well as for changing the direction of the painting movement.

P = Press
L = Lift

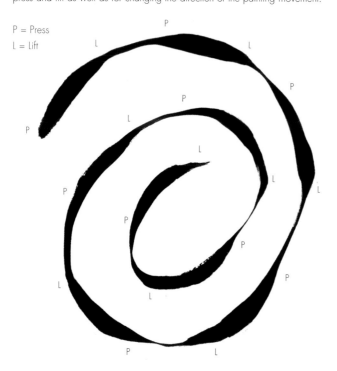

This brushstroke changes direction.

Remember to rotate the wrist to change the direction of the brush handle.

FURTHER PRACTICE

Press and lift brushstrokes are often used in landscape painting because they add more weight and depth to lines and a greater sense of movement, as can be seen in the following examples.

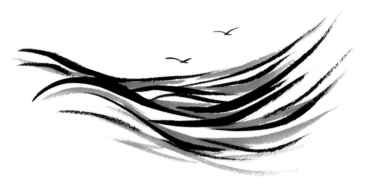

WAVES

Here, I used the press and lift technique when I painted the lines. Compare these waves with those in the previous section, and you will see that these have more volume and sense of movement.

A RAINY STORM

How to paint a storm by using the press and lift technique combined with wrist movements and elbow movements:

STEP 1

Fully load a Goat-hair Hake or Ti brush with clean water. Paint a wet strip from left to right at the top of the paper. Load the brush with clean water again and add another strip close to the first one. Add successive wet strips close to each other until the whole paper is wet.

STEP 2

Fully load a small size Orchid and Bamboo brush with burnt sienna, and paint long brushstrokes using the press and lift technique with elbow movements, right across the paper. Start the brushstrokes from the top and move downwards in a left-to-right diagonal direction. The burnt sienna brushstrokes will start to become fuzzy because of the wetness, and this will give the impression of heavy rain.

STEP 3

While the paper is still wet, dip a size 3 Leopard and Wolf or big size Landscape brush into ink and paint leaves, using a downward press and lift technique with wrist movements. Vary the tones of ink for greater depth and expression.

A dot made by a small size
Orchid and Bamboo brush.

A dot made by a Red Bean or small
size Landscape brush is smaller.

Two tones of ink, sharp images.

Two tones of ink, blurred images.

Two colours, sharp images.

Two colours, blurred images.

DOTS AND LONG DOTS

Although they may be small brushstrokes, dots are an essential part of Chinese landscape painting, often used to provide final touches. They are added to places where features have to be lifted, to give depth, or to give a more rugged appearance to rocks, mountains and trees. Sometimes dots are used to represent shrubs growing on mountains and rocks, or leaves on a tree. Dots added in an informal way can really liven up a painting, but dull and badly placed dots ruin an artwork. And they must be added in moderation: too many dots can suffocate a well-executed painting.

Long dots can also be used to add final touches to a landscape painting but they are usually used to paint trees and shrubs in the distance. When long dots are painted using a dry brush, they can be used to add texture to a plain background. For example, dry long dots are used to represent grass on meadow, vegetation on wetland or moss on rocks.

DOTS

You can use any brush to paint dots. A big brush creates bigger dots and a small brush makes smaller dots, so just use your judgement to choose the appropriate size. For example use a small size Orchid and Bamboo brush for dots on a big rock and use a Red Bean or small size Landscape brush to add dots on distant mountains. The best brush for creating perfect dots is actually a worn out brush because the tip has usually lost its point, making the dots much rounder. A fully loaded brush creates a bigger dot while a drier brush makes a smaller dot.

Painting a Dot

Fully load a brush with dark ink. Hold the brush in a vertical position. Touch the paper to form a dot.

Dots in Two Tones of Ink or in Two Colours

You can paint dots with two tones of a single colour or with two colours. For a two-tone effect, first paint a group of dots, then add a second group of dots in a darker, or lighter, tone of the same colour. Position them on top or near to the first group. If the second group of dots is added while the first group is still wet, dots of both tones will merge, for a blurred effect. If you wait until the first group of dots has dried before adding the second tone, both groups of dots will be sharper. Sharper images are best for painting foreground objects while blurred images are good for objects in the distance.

FURTHER PRACTICE

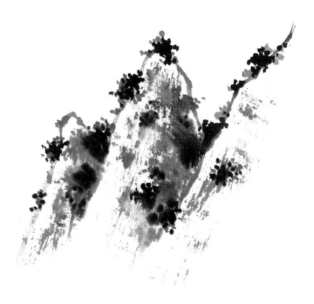

DOTS ON A ROCK TO CREATE A MORE RUGGED LOOK

Dots are added to places that depict shadow or indentation and also add highlights to the foreground surfaces that would catch the light.

DOTS ON MOUNTAINS

Dots are used to represent shrubs and small trees on mountains.

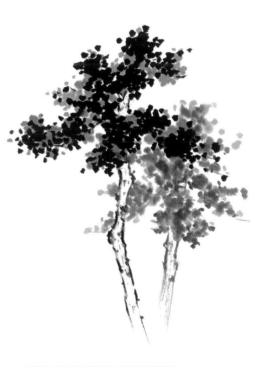

DOTS ON A TREE TRUNK FOR A MORE RUGGED LOOK

Besides creating a more rugged look, dots are useful for places where you have to differentiate a branch in the front from one at the back, or part of the trunk in the front from a part at the back.

TWO TREES PAINTED WITH DOTS

Here we use dots to paint the leaves of two trees. The leaves of the foreground tree use sharper dots than the blurred dots used for the tree in the background.

LONG DOTS

If you hold the brush at an angle to the paper and paint a dot, the dot will have a longer shape that we call a 'long dot'. When the handle of the brush is pointing to the right or to the left, horizontal long dots are produced, while if the handle is held pointing away or towards you, the long dots will be vertical. A bigger brush, such as a small size Orchid and Bamboo brush, creates bigger dots than those made by a small brush, such as a Red Bean or small size Landscape brush. A fully loaded brush also makes bigger long dots than a brush that is not fully loaded. You can also create dots with two tones of a single colour or with two separate colours if you load the brush as previously described under Loading a Brush with Ink and Colours (pages 34–35).

PAINTING A LONG DOT
Fully load a brush. Hold the brush at an angle to the paper. Press and paint a long dot.

HORIZONTAL LONG DOTS
Fully load a small size Orchid and Bamboo brush with ink. Hold the brush at a low angle with the handle pointing to the right and paint a long dot. Then rotate your wrist so that the brush handle points to the left. Paint another long dot.

VERTICAL LONG DOTS
Fully load the same brush with ink. Hold the brush at a low angle with the handle pointing towards you and paint a long dot. Then rotate your wrist so that the handle of the brush points away from you. Paint another long dot.

A DRY DOT
Load a small size Mountain and Horse brush with ink. Dry the brush on a piece of tissue or a paper towel. Press the brush on the tissue until the hair separates. Paint a long dot. The dot has a broken effect and is often used to add texture to a plain background.

LONG DOTS IN TWO TONES OF INK WITH SHARP IMAGES
Paint a group of long dots with one tone of ink and let them dry. Then add another group of long dots with another tone of the same colour.

LONG DOTS IN TWO COLOURS WITH BLURRED IMAGES
Paint a group of long dots with one colour. Add another group of long dots in another colour while the first group is still wet.

FURTHER PRACTICE

USING LONG DOTS TO PAINT TREES

We usually use long dots to paint trees in the distance. Load a size 3 Leopard and Wolf or big size Landscape brush with dark ink. Hold the brush in a vertical position and use the tip of the brush to draw some short vertical lines. Reload with dark ink and paint long dots along these lines to form trees at a distance. Add more trees in diluted ink using the same techniques.

SHRUBS ON MOUNTAINS

Long dots are very effective for painting shrubs on distant mountains. I used two tones of ink for these shrubs.

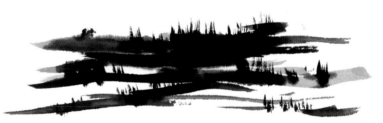

VEGETATION ON WETLAND

Dry long dots are used to add finishing touches to a piece of wetland. I shall demonstrate how to achieve this later, in the section Wet Effect and Dry Effect (see page 52).

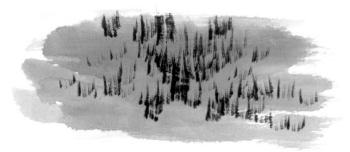

GRASS ON A MEADOW

Dry long dots in ink are used to paint grass on a green meadow.

SIDE BRUSHSTROKES

Side brushstrokes are used more often in landscape painting than in flower painting, and also with more variation. Although pressing a brush down produces a wider brushstroke, side brushstrokes are useful when you want one that is even wider. The most common use of the side brushstroke is with a dry brush. They are perfect for creating textures on rocks and mountains, waterfalls, clouds, water and earth.

CREATING A VERTICAL SIDE BRUSHSTROKE

STEP 1
Fully load a small size Orchid and Bamboo brush with dark ink.

STEP 2
Hold the brush at an angle to the paper with the handle pointing to the right. (Left-handed readers may choose to hold the brush with the handle pointing to the left if this feels more natural.) All that matters is keeping the brush tip in a horizontal position. Press on the paper.

STEP 3
Move the brush upwards or downwards at right angles to the position of the handle of the brush. The mark will be similar whether you are moving the brush up or down, and the direction is really more for convenience than for producing different shapes.

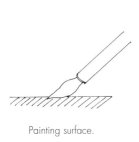

Painting surface.

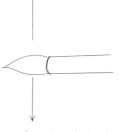

View from above the brush. Move the brush upwards or downwards at right angles to the brush handle.

A side brushstroke made by moving the brush upwards.

A side brushstroke made by moving the brush downwards.

CREATING A HORIZONTAL SIDE BRUSHSTROKE

Hold the brush at an angle to the paper with the brush handle pointing either away or towards you. The brush tip should be at a vertical position when you view it from above. Move the brush to the left or right to produce horizontal side brushstrokes. You can create side brushstrokes pointing at different angles as long as you always move the brush tip at a right angle to the direction of the handle.

A horizontal side
brushstroke.

A side brushstroke at
an angle.

SIDE BRUSHSTROKE WIDTH

You can vary the width of a side brushstroke by varying the angle of the brush to the paper. When the brush handle is held at a low angle to the paper, the brushstroke is wider. When the brush handle is held at a high angle, the brushstroke is thinner.

A side brushstroke with the
handle of the brush held at a
low angle to the paper.

A side brushstroke with the
handle of the brush held at a
high angle to the paper.

SIDE BRUSHSTROKE LENGTH

A short side brushstroke is created when you use wrist movement and a longer one when you use elbow movement.

A horizontal side
brushstroke using wrist
movement.

A horizontal side
brushstroke using
elbow movement.

SIDE BRUSHSTROKES USING THE PRESS AND LIFT TECHNIQUE

Press the brush to begin a side brushstroke, then lift it towards the finish.

A VERTICAL SIDE BRUSHSTROKE USING WRIST MOVEMENT WITH THE PRESS AND LIFT TECHNIQUE.

Hold the brush at an angle to the paper with the handle pointing to either the right or left. Press and move up or down using wrist movement. Then lift towards the finish. This example is created by moving the brush downward.

A HORIZONTAL SIDE BRUSHSTROKE USING WRIST MOVEMENT WITH THE PRESS AND LIFT TECHNIQUE.

Hold the brush at an angle to the paper with the handle pointing towards or away from you. Press and move to the right or left using wrist movement. Then lift towards the finish. This example is painted by moving the brush to the right.

A horizontal side brushstroke using elbow movement with the press and lift technique.

DRY SIDE BRUSHSTROKES

If you wipe off excess moisture on a piece of paper towel after loading a brush it becomes a dry brush. Using a dry brush to paint a side brushstroke results in 'broken line' effects. Brushes with black hair like the Mountain and Horse brush are good for this.

A vertical side brushstroke using a Mountain and Horse brush with elbow movement.

A vertical side brushstroke using a Mountain and Horse brush with elbow movement and the press and lift technique.

FURTHER PRACTICE

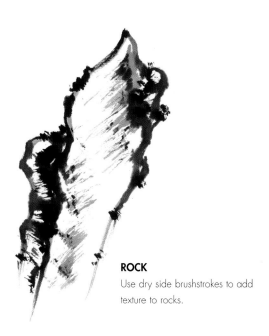

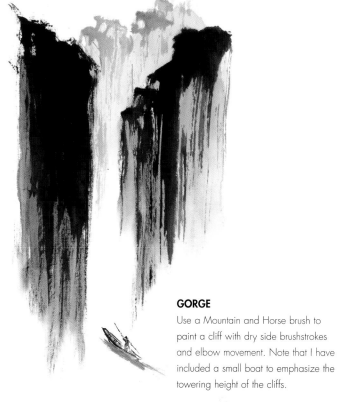

ROCK

Use dry side brushstrokes to add texture to rocks.

GORGE

Use a Mountain and Horse brush to paint a cliff with dry side brushstrokes and elbow movement. Note that I have included a small boat to emphasize the towering height of the cliffs.

WATERFALL

Previously we used dry lines to create a waterfall (see page 36). Now use dry side brushstrokes with a Mountain and Horse brush instead to give a more turbulent appearance.

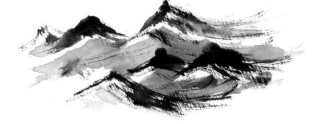

WAVES

Previously we painted waves with lines (see page 36), and also with the press and lift technique (page 43). Lines create calmer waves, while press and lift techniques produce more movement. Here you can see that side brushstrokes make the water look very choppy.

WET EFFECT AND DRY EFFECT

By now, you will have experienced some wet brushwork and some dry brushwork. I have mentioned them a few times so far. In this section we shall deal with these two effects more thoroughly. The best way to show you the different effects you can achieve is with examples.

WET AND DRY BRUSHSTROKES USED SEPARATELY

When you fully load a brush with colour and paint on absorbent paper, the resulting brushstroke will run. We refer to the fully loaded brush as a 'wet brush' and the resulting brushstroke as a 'wet brushstroke'. When you load a brush with wet paint and wipe off excess moisture on a tissue or a paper towel, the brush then becomes a 'dry brush', and the brushstrokes that result are 'dry brushstrokes'. When two types of brushstrokes are used together and one is wet, the two diffuse into one another. If you do not want that to happen, make sure that the first brushstroke dries thoroughly before you apply the second.

HOUSES

Here I began with dry brushstrokes and let them dry before applying wet brushstrokes.

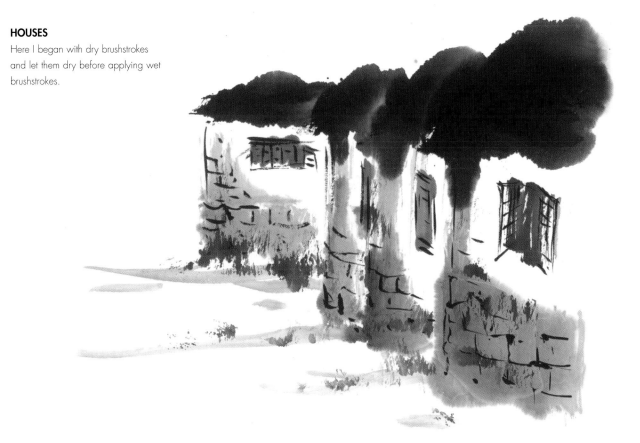

WET BRUSHSTROKES ON DRY BRUSHSTROKES

When a wet brushstroke is painted over a dry one that has not fully dried, the dry one will blur. How much depends on how long you leave the dry brushstroke before adding the wet one. The bamboo example shows this.

BAMBOO IN THE RAIN

I painted the bamboo with a Mountain and Horse brush using two tones of ink. Then I immediately used a Goat-hair Hake brush to apply a wash over it. The blurring effect creates an atmosphere of heavy rain.

DRY BRUSHSTROKES ON WET BRUSHSTROKES

Again, you can control the 'fuzziness' of the dry brushstroke by changing how long you let the wet one dry first. The effect is similar to the wet-on-dry method, but the advantage of painting dry brushstrokes onto wet ones is that you can paint them at different stages, while the wet brushstroke is still drying, and this gives different degrees of fuzziness. The example below uses this feature.

SKY

An initial wash provides the background for the sky. Dry brushstrokes made with diluted ink are added next to form the clouds, while the wash is still wet, and then others are added in dark ink. While the background is still drying, dry brushstrokes made with darker ink are added to give the clouds more structure.

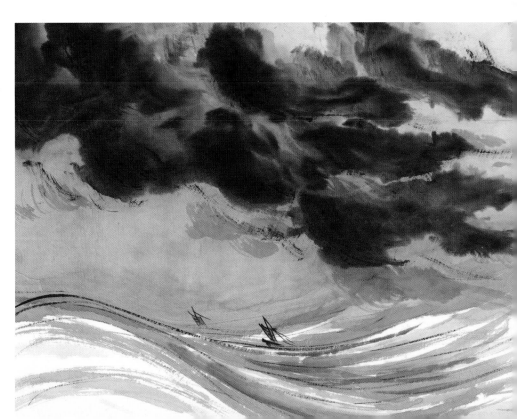

OVERLAPPING

You can create yet another effect by only allowing some of the wet brushstrokes to overlap the dry ones.

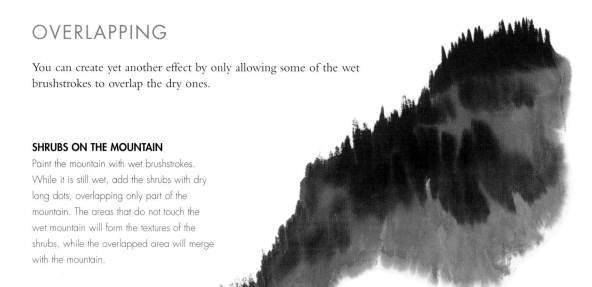

SHRUBS ON THE MOUNTAIN

Paint the mountain with wet brushstrokes. While it is still wet, add the shrubs with dry long dots, overlapping only part of the mountain. The areas that do not touch the wet mountain will form the textures of the shrubs, while the overlapped area will merge with the mountain.

FURTHER PRACTICE

Wet and dry brushstrokes bring out particular characteristics of a subject. For example, you can paint a vigorous young tree with wet brushstrokes, while dry brushstrokes can depict a more rugged old tree. You can get a very dramatic composition by using dry brushstrokes to paint an old tree trunk and wet brushstrokes to show new growth sprouting from it, as the next example shows.

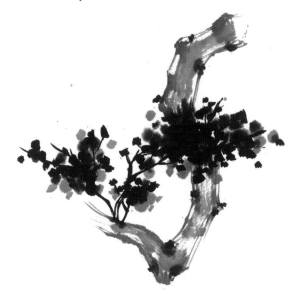

AN OLD TREE SPROUTING NEW GROWTH

I used a dry small Mountain and Horse brush to paint the old tree trunk with diluted ink and side brushstrokes. Then I used a size 3 Leopard and Wolf or big size Landscape brush fully loaded with dark ink to paint the young branches. For the leaves I used the same brush fully loaded with diluted ink to paint the lighter colour leaves, then fully loaded the same brush with dark ink to add more leaves. I let some of these touch the light-coloured ones, so that they would run into each other.

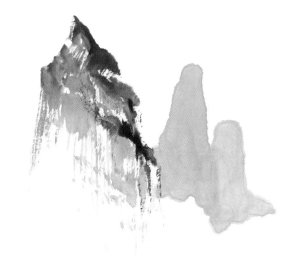

MOUNTAINS

Using dry and wet brushstrokes in the same painting offers more contrast. For example, mountains in the foreground can be painted with dry brushstrokes to show off their texture and ruggedness, while distant mountains can be painted with wet brushstrokes, as detail is unnecessary.

I painted the mountains in the front with a dry small Mountain and Horse brush. When these had dried, I added the more distant mountains with a wet small size Orchid and Bamboo brush. Combining wet and dry brushstrokes can also bring a more effective mood to a painting.

WETLAND

Fully load a small Orchid and Bamboo brush with diluted burnt sienna and paint a few thick lines using the press and lift technique. Paint the lines freely so that some are closed together and some are separated. Load a small Mountain and Horse brush with ink and wipe off the excess ink on the side of the palette. Paint dry lines among the wet burnt sienna lines using the press and lift technique. Some of the dry lines will remain dry if they are in gaps between the wet areas, while some will blur. This creates an interesting variety in the composition. Then take a dry Mountain and Horse brush loaded with dark ink and press it on a paper towel so that the hairs separate. Now use it to paint scattered vertical long dots to represent wetland vegetation.

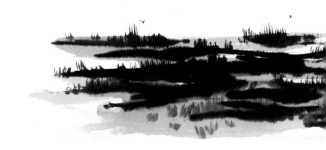

When you get used to the various properties of wet and dry brushstrokes you can use them freely, in any order and combination, to create your composition. But always test out your ideas before trying them in your masterpiece. I shall end this section with a painting that uses the techniques we have used so far in different combinations.

FISHING IN BLEAK WINTER

First I sketched the hills with a dry small Mountain and Horse brush in a diluted indigo. I used a mixture of wet and dry side brushstrokes. Next I drew the fisherman with a Red Bean or small size Landscape brush and coloured him in with burnt sienna. Then I applied a blue wash (see next page) to the sky and waited for it to dry a bit. While the wash was still damp, I used a dry small Mountain and Horse brush to sweep a few side brushstrokes across the sky using medium ink. The dry brushstrokes made the wintry atmosphere look more dramatic and severe.

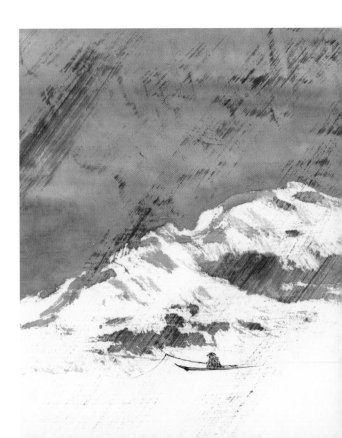

WASHES

A wash is basically a large patch of wet colour. It can be used as part of a background feature like the sky, the sea, mist or the ground, or to enhance a feature and give it depth and mood. A wash can use one colour, several tones of a single colour or be multi-colour, and can be applied to all or part of the painting. Each kind produces a different effect, and there is no fixed rule as to what kind of wash is suitable for what kind of feature or mood. This can be confusing for beginners, but I shall provide many examples, here and later on in the book, for you to have a look at. The most important rule is that you should never be afraid to experiment. Try out a few different kinds of washes for a particular idea, and compare the results. The more you try, the sooner you will gain the confidence to develop your own ideas.

I am simply going to concentrate on showing you the basic techniques. There are all sorts of special effects you can use in washes, from sprinkling salt to get a marbled look to using washing-up liquid and milk as barriers. But I am not going to worry about those here. When you are more comfortable with the basics, you can try them out yourself.

A PLAIN WASH

A plain wash is a uniform wash made with a single colour. It is commonly used for tinting a piece of paper to provide a background colour. In landscape painting it can create the whole mood of the artwork. For example, a burnt sienna background wash gives an autumnal atmosphere while a pale indigo wash enhances an early winter scene. A dark wash using indigo and ink is perfect for a winter night.

If the paper is absorbent, the wash can be applied after the rest of the painting is finished. In this case it is better to wait for the painting to dry before applying the wash. It is also advisable to apply the wash to the back of the picture, so that it will not mess up the painting. If the paper is absorbent, the colour wash will show through from the back. Alternatively, you can apply the wash to a fresh piece of absorbent paper before painting on it. In this case you can apply the wash on either side of the paper.

If the paper is alum-sized, wash can only be applied on the same side as the picture because the alum and gum in the paper prevent the wash showing through from the back. For this reason it is normal practise using a wash to tint a piece of alum-sized paper before commencing with a painting.

A plain wash can be applied with a hake brush or a very big brush, or you can use a spray (landscape painters tend to use a combination of both).

IF YOU ARE USING A HAKE BRUSH, YOU WILL NEED:

• A hake brush with a width of preferably 5 cm (2 in) or more.
• A shallow bowl, or something similar. (The container should be wide enough for your hake brush to dip in comfortably.)
• Ink or colour – I am using indigo for this illustration.
• Water.
• Two pieces of clean, blank newsprint paper, preferably of A1 size.
• Your finished painting on an absorbent paper.
• An old brush for mixing colours.

APPLYING A PLAIN WASH USING A HAKE BRUSH:

STEP 1

Prepare a wash in the shallow bowl by mixing water with indigo. The best way to do this is to put the colour in the bowl and then add clean water little by little. Use an old brush to mix it thoroughly as you add water, and make sure there are no lumps of colour left because these can carry on to the paper and spoil the wash. Keep adding water and mixing until the mixture reaches the tone you prefer.

STEP 2

Place a piece of blank newsprint paper on a level surface. Put your painting paper on the newsprint. If the painting paper already has a picture on it, place it face down.

STEP 3

Dip the hake brush into the wash and fully load the brush. Start with one upper corner. Touch the paper with the brush and move all the way across to the other side to produce a strip of colour. Do not press too hard or you will create creases on the paper.

STEP 4

Reload the brush and paint another strip underneath the first. Continue this process until the whole paper is covered with wash. Always go in the same direction for the strips or you will crease the paper.

STEP 5

Place the other piece of clean, blank newsprint on top of the painting paper. Turn the whole pile (painting paper and the two pieces of newsprint) upside down so that the bottom piece of newsprint is now on top. Peel it off carefully and let the painting paper dry.

Sometimes the wash is too wet, and the newsprint that is now under the painting paper will become uneven. If this happens, repeat step 5 with another piece of clean, blank newsprint. In doing so you will find that your artwork will finish face down. Turn the artwork over if you prefer it to dry the right way up.

STEP 3

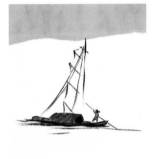

STEP 4

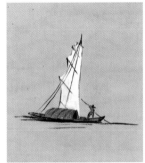

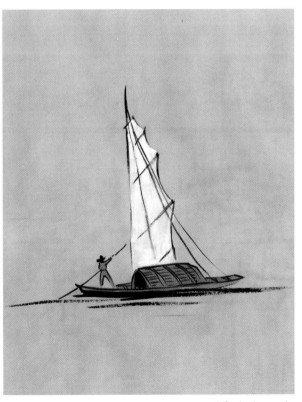

A finished example.

Using a Spray

If you are using a spray to apply the wash, mix together 8 ml (0.3 fl oz, or a full small tube) of watercolour paint and 250 ml (9 fl oz) water in a large container. Make sure that the colour and water are mixed thoroughly because any little lumps will block the spray. Pour the mixture into the spraying bottle and screw together with the nozzle. This much wash may seem like a lot, but you do need a larger quantity in a spray bottle to make it spray effectively. The colour wash you don't use up can stay in the bottle for a long time as long as you clean the nozzle at the end of a day's use. Dried up watercolours in the nozzle may eventually block it. The way to clean a nozzle you have been using is to screw it on to a spraying bottle filled with clean water and spray water through it repeatedly until only clean water comes out. Do not screw the nozzle back on the bottle containing wash until you are going to use it again. Before you use a spray bottle again, stir the contents thoroughly with an old brush before screwing the nozzle on.

If you are using a spray, follow step 1 and step 2 on page 57, and then spray the entire paper with the wash. Finish with step 5, as before.

MULTI-COLOUR WASH

A wash is multi-coloured when washes of more than one colour are applied on different parts of the painting paper. There are many ways to apply a multi-colour wash, and I shall introduce you to two. One way is to use the hake brush and the other is to use sprays. I am going to use sap green, indigo and burnt sienna for these examples, and both thick and thin washes. A thick wash is prepared by mixing 250 ml (9 fl oz) of water with at least 8 ml (0.3 fl oz) of watercolour. A thin wash uses at least double the amount of water.

Using the Hake Brush or a Big Brush

If a thick colour wash is applied with a brush to a dry piece of Xuan paper, it will form hard edges that do not blend well with the adjacent colour. To overcome this tendency, a multi-colour wash is done in two stages. In the first, thin washes in different colours are applied to provide a damp surface. There are two reasons for using thin washes at this stage: first, all colours blend better in thin washes; second, they provide a wet preparatory surface for the thicker washes that are applied next, which makes the strips of thick wash diffuse, instead of forming a hard edge. In the second stage, the thick wash is applied and darkens the tones. If you want to intensify the colours even further you can apply more layers of thicker washes.

If thick washes are applied side by side on dry absorbent paper, the edges do not blend smoothly.

Make thin washes of sap green, burnt sienna and indigo. Apply each one separately on different parts of the paper. Washes blend better when they are thin.

While the thin washes are still wet, apply thicker coloured washes in the same colours. This will create new tones and darken the colours.

Further layers of thicker wash can be applied to intensify the colours. It is more effective to do this while the paper is wet. If the wash has dried you can wet the whole paper with clean water, using a brush or a spray. Then apply further colours while the paper is still wet.

Using Several Sprays

Here I am using the same three colours: sap green, indigo and burnt sienna. Prepare the washes with 8ml (0.3 fl oz, or a small full tube) of watercolour mixed with 250ml (9 fl oz) of water. Each colour wash should be stored in a separate spray bottle, and you will also need a spray bottle filled with clean water. Apply each colour separately, allowing areas to overlap at the edges to encourage the colours to merge. Spraying clean water along the edges also helps the colours to merge and blend for a diffuse effect.

Many different kinds of washes can be made either by using brushes or sprays, but if the designs are complex it is easier and quicker to use sprays.

A finished work with three coloured washes applied by spraying.

A wash of sap green was sprayed on the entire paper. Then clean water was sprayed on the upper part of the paper. The water dilutes the green wash.

Clean water was sprayed on the paper in wide stripes. Then washes of indigo were sprayed in the gaps between them. You can use another colour instead of water.

A thick indigo wash was applied to the paper with the spray. Then a wash of sap green was sprayed sparingly on the paper.

PARTIAL WASHES

This kind of wash is commonly used for any painting where part of an artwork needs to be enhanced. It is more convenient to use the hake brush or a big brush to apply a partial wash but you can also use a spray.

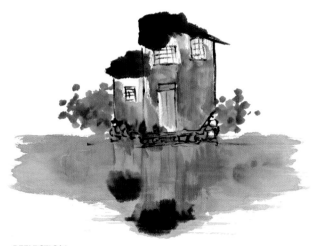

REFLECTION

Here the wash was applied before the reflection was added, making the reflection fuzzy.

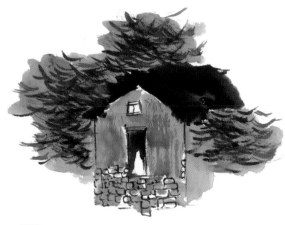

TREE

This wash enhances a tree, making the foliage look thicker.

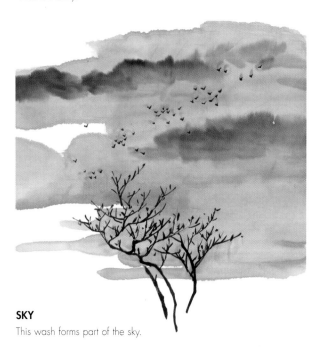

SKY

This wash forms part of the sky.

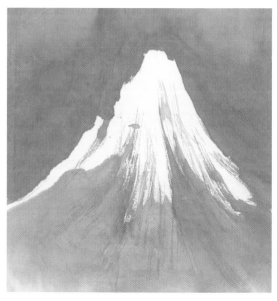

SNOW

This wash leaves space to form the snow at the top of the mountain.

A Wash with Soft Edges

This wash has a softly gradated edge and is a technique often used for painting mist and fog. Use a brush or a spray to apply water for softening the edges of a colour wash.

STEP 1

Load the hake brush with clean water and paint a clean wet strip where you want the colour to be graduated. (I have used pencil lines simply to indicate the part of the paper where the water is applied.)

STEP 2

Now apply the coloured wash right to the edge of the clean water strip and let the colour overlap the water a little bit. The colour wash will run on the wet surface, creating gradual tones.

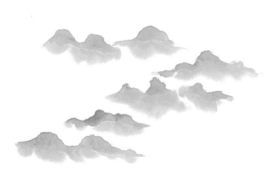

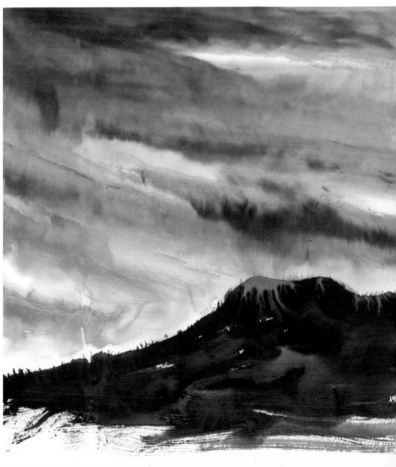

CLOUDS AND DISTANT MOUNTAINS

You can create mist or clouds using this technique.

SKY

Here I used the same technique to create the sky. Clean water strips are applied before paints are added. The water strips give parts of the sky soft edges and also leave some clear patches, making the effect more dramatic.

WASH ON ALUM-SIZED PAPER

A wash applied to alum-sized paper will not run, so its edges will be sharp. This kind of wash is ideal for painting features with sharp edges, such as cliffs and high mountains. Wash is absorbed into alum-sized paper at a very slow rate and you can make use of this to spread the wash around to create gradual tones.

SHARP EDGES ON ALUM-SIZED PAPER

A wash on alum-sized paper has sharp edges compared to the fuzzy edges of a wash on absorbent paper (see pages 60–61).

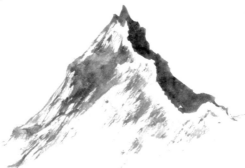

A wash on absorbent paper.

A wash on alum-sized paper.

Mountains with sharp edges.

CREATING SOFT EDGES ON ALUM-SIZED PAPER

To create a soft edge on alum-sized paper, you need two brushes: one for applying the wash and one for spreading the wash.

STEP 1
Fully load a large brush with a thick colour wash. Paint on a piece of alum-sized paper.

STEP 2
Wet the second brush in clean water and wipe off excess moisture on a tissue or paper towel. The brush should be clean and damp but not wet. Use this brush to spread the wash slowly before the colour dries. The size of this brush should be smaller than the one in step 1 so that you can spread the colour a little at a time. For example, if you are using a size 3 Leopard and Wolf or big size Landscape brush to apply the colour, then use a Red Bean or small size Landscape brush to spread the colour.

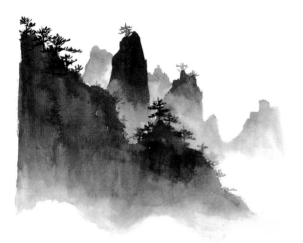

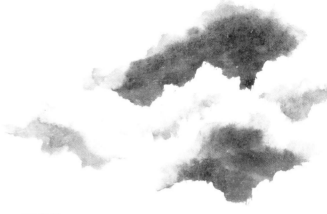

MOUNTAINS

Each of these mountains has a single soft edge. The empty spaces are left ready for creating mist or clouds.

CLOUDS

Some of these clouds have double soft edges.

Here I created clouds and mountains. The illustration shows the first stage of the painting process. Further applications of colour will be needed to build up tones and intensity for the mountains.

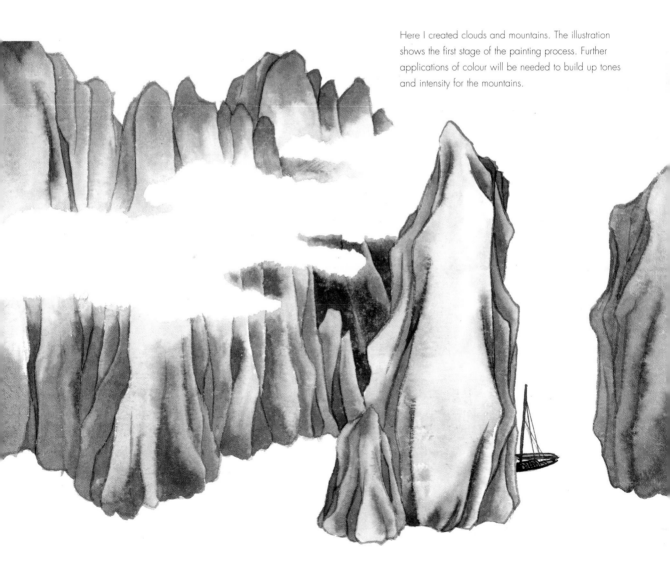

SPLATTERING TECHNIQUE

Like washes, splattering produces large wet patches of colour. But washes are intended for painting backgrounds while splattering is used for painting features in an expressive, almost abstract manner. Usually only the most experienced landscape artists use the splattering technique in their paintings, but with step-by step guidance I think you will enjoy learning this wonderful technique. Brushwork with more controlled detail is usually painted either before or after the splattering to create contrasting effects. Because splattering effects can be unpredictable, artists usually wait for the splattered patches to settle before adding other details. The effect of splattering on absorbent paper can be different from that on alum-sized paper: images are stronger and more explosive on absorbent paper and more unpredictable, while alum-sized paper provides time for the paper to absorb the moisture, which means you can use a brush to guide the spreading wet colours before they finally settle down, giving a bit more control.

Painting with splattering is not easy. You have to be adventurous and be prepared to try again and again. But you will be rewarded with many surprises and lots of fun.

SPLATTERING ON ABSORBENT PAPER WITH A BRUSH

A big brush is used for small-scale features, although when the area to be covered is large, you can use a spray. If you are using a big brush, load it heavily with ink or colour until the brush is dripping. Splash the dripping brush against a piece of absorbent paper. Colour runs madly to form unpredictable patches. More controlled brushstrokes can then be added later as a contrast.

LOTUS

This is a simple work using the splattering technique. I used smaller and more controlled splatters to form the lotus leaves, first with dark ink, then with diluted ink.

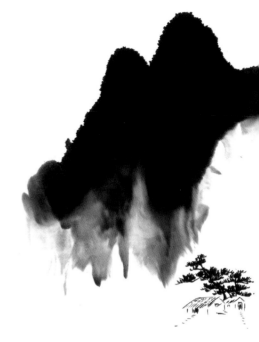

Water on the Edges of a Splattered Patch

After colour is splattered on an absorbent paper, clean water is applied to the edges to encourage the brushwork to diffuse further, producing a seeping effect at the edges. I used this effect to produce Morning Mist.

Splattering on a Wet Surface

This is the most common use of splattering. Partial washes with water and diluted colours are painted onto absorbent paper. Then dark ink is splattered on to the wet surface. At the Moors (below) uses this technique.

AT THE MOORS

In this example I splashed very diluted indigo across the paper for the background. Then I splattered dark ink and diluted ink on the wet surface to form the clouds. The grassy hill and galloping horse provided the final touches.

MORNING MIST

Here I painted the mountains with ink splattering. Then I sprayed clean water at the lower edges of the mountains to make the ink run. The result is dramatic and gives a wet, mysterious effect.

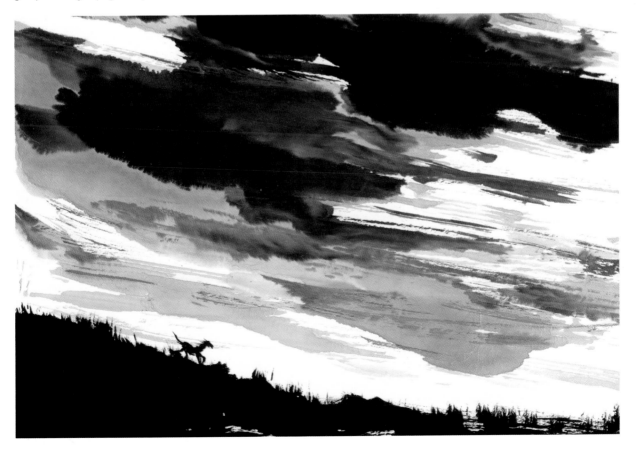

SPLATTERING ON ALUM-SIZED PAPER

You can use the same technique on alum-sized paper. Alum-sized paper does not absorb moisture in the same way as the absorbent paper, so if you splatter on it, pools of colour will form. You have to be patient because these pools usually take longer to dry. The dry patches have natural marble patterns that can add interesting texture to the features you are going to paint.

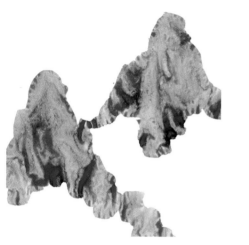

TWO MOUNTAINS

I used a mixture of one part cobalt blue and one part indigo to paint the mountains. A small size Orchid and Bamboo brush was used for the splattering. Pools of colour formed and became darker when dry, resulting in a marbled effect, and there was no need to add further brushwork to the mountains. All you need to do is add some features, such as trees and a cottage.

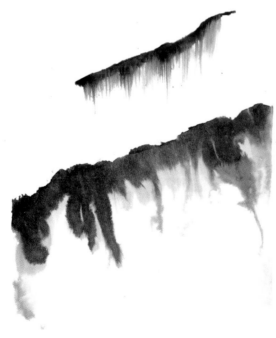

TILTING EFFECT

After splattering onto a piece of alum-sized paper, you can tilt the paper to allow the wet patch to run in a pre-planned way, or you can just shake and tilt the paper and see what happens. You can also use a brush to guide the wet patches in a more controlled manner.

Alternatively, for a more controlled effect, use clean water to paint a wet patch on a piece of alum-sized paper. Load a small size Orchid and Bamboo brush heavily with dark ink and apply it along the upper edge of the wash. To achieve the effect of the upper illustration, use a small brush to guide the ink. To achieve the effect of the lower illustration, tilt the paper and let the ink run free.

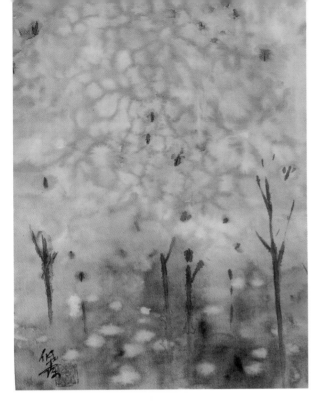

EXPLOSION OF SPRING

Splattering on alum-sized silk behaves in the same way as splattering on alum-sized Xuan paper. This artwork is painted on alum-sized silk. Permanent rose colour was splattered generously onto the silk. I let the colour dry a little and then I loaded a size 3 Leopard and Wolf or big size Landscape brush with thick process white tinted with alizarin crimson to add dots on the damp surface. The process white ran, forming the marbled effect that gave the look of blossoms. The other details were added later when the blossoms were dry. The same technique was used for painting the ground. This time different tones of green were used for the background and process white tinted with alizarin crimson was dotted about informally while the green was still damp.

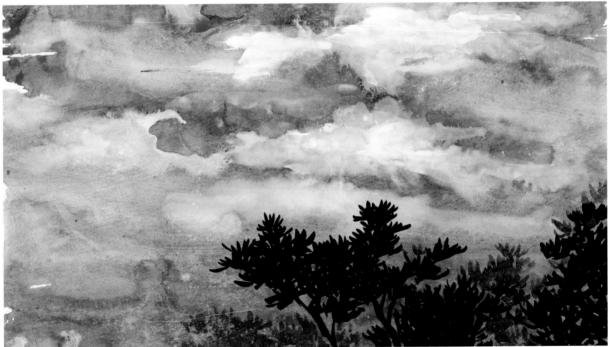

A CLOUDY DAY

Here I am using all the techniques just described. For the background, I used a Goat-hair Hake or Ti brush to paint wide strips of clean water across a piece of alum-sized paper, leaving gaps between strips. A blue mixture (one part cobalt blue and one part of indigo) was splashed in between the strips of water so that they ran into each other. Next, thick process white was splattered onto the wet wash with a small size Orchid and Bamboo brush. I tilted the paper to let the colour run. Then I used a Red Bean or small size Landscape brush to guide some of the white colour to form smaller lines. When the first splatter of process white was a bit drier, I used process white to highlight parts and create depth. After the splatter was dry I added the trees using two different ink tones.

SPRINGTIME IN GUILIN

COLOURS

Ink

Sap Green

Burnt Sienna

Process White

BRUSHES

Red Bean or small size
Landscape brush

Orchid and Bamboo
brush

Small Mountain and
Horse brush

Size 3 Leopard and
Wolf or big size
Landscape brush

This step-by-step painting guides you through all the techniques we have covered. This painting is of Guilin, a place poets and artists have long regarded as their ultimate inspiration.

STEP 1
Use a Red Bean or small size Landscape brush and very diluted ink to sketch a plan of the painting. It is a good habit to sketch out a rough plan with light ink before you start. I outlined the positions of the mountains: there are three groups that overlap each other.

STEP 2
The foreground mountains are painted with dark ink. I used diluted ink for the middle group and then, after I had painted them, I diluted the ink even further to paint the group at the back. We shall begin with the group in the middle. Dilute some ink and heavily load a small size Orchid and Bamboo brush until it is dripping. Splatter the diluted ink onto the paper to form the mountains in the middle.

STEP 3
Now dip the same brush into dark ink and load it heavily. Splatter the dark ink on the foreground with part of it overlapping the mountains in the middle group. Clean your brush. Dilute the diluted ink even further than before and use it with the brush to paint the distant mountains.

STEP 4
We are going to paint the waterfront at the foot of the mountains next. The dark ink brushstrokes are painted first and should still be wet when the green brushstrokes are painted among them, so it is best to have the green colour ready before you start. Mix one part sap green with one part water to make the green. Dip a small Mountain and Horse brush into dark ink and paint thick lines for the wetland. Vary the thickness of the lines by using the press and lift technique, and vary their lengths as well. Paint some with wrist movements and some with elbow movements, making some lines close together and others further apart.

STEP 5
Before the dark ink is dry, fully load a small size Orchid and Bamboo brush with the sap green you have already prepared and add more thick lines between the dark ink ones. Use a dry small Mountain and Horse brush and dark ink to paint some vegetation with long dots.

STEP 6
Mix a tiny bit of sap green with process white. Fully load a clean small size Orchid and Bamboo brush with this mixture and add dots to the waterfront. Vary the size of dots, applying more pressure to the brush to paint larger ones. You can also heavily load this brush with the mixture and flick the brush across the painting. Use a Red Bean or small size Landscape brush and dark ink to draw the boats. Colour them with burnt sienna using a size 3 Leopard and Wolf or big size Landscape brush.

STEP 1

STEP 2, 3

STEP 4, 5

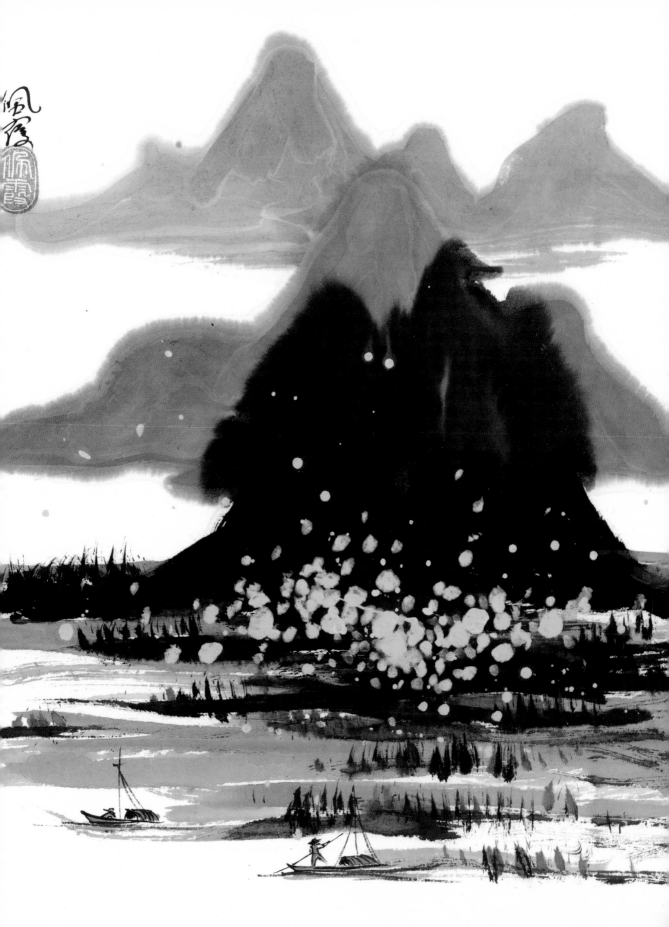

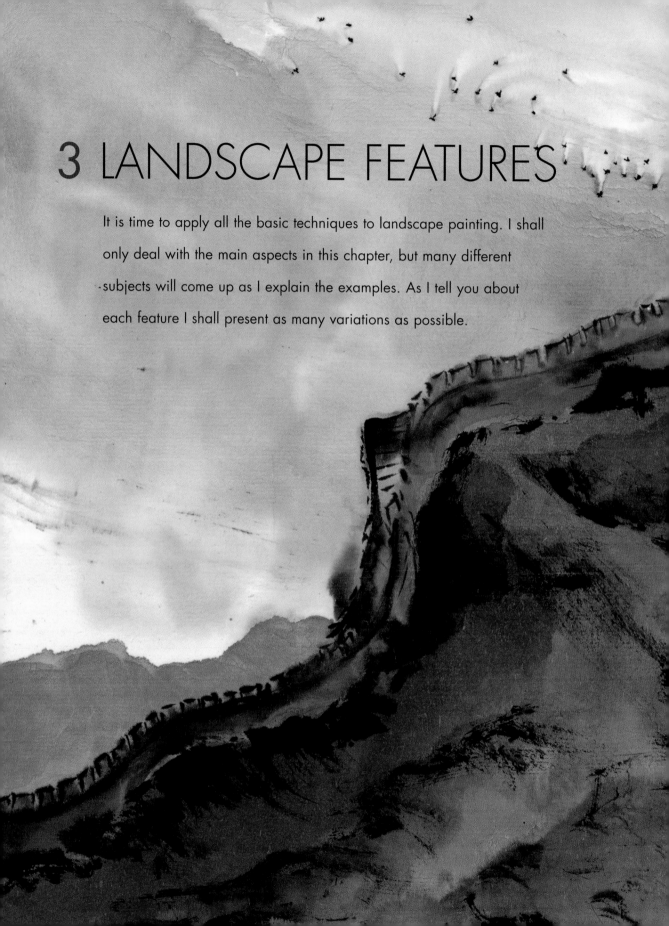

3 LANDSCAPE FEATURES

It is time to apply all the basic techniques to landscape painting. I shall only deal with the main aspects in this chapter, but many different subjects will come up as I explain the examples. As I tell you about each feature I shall present as many variations as possible.

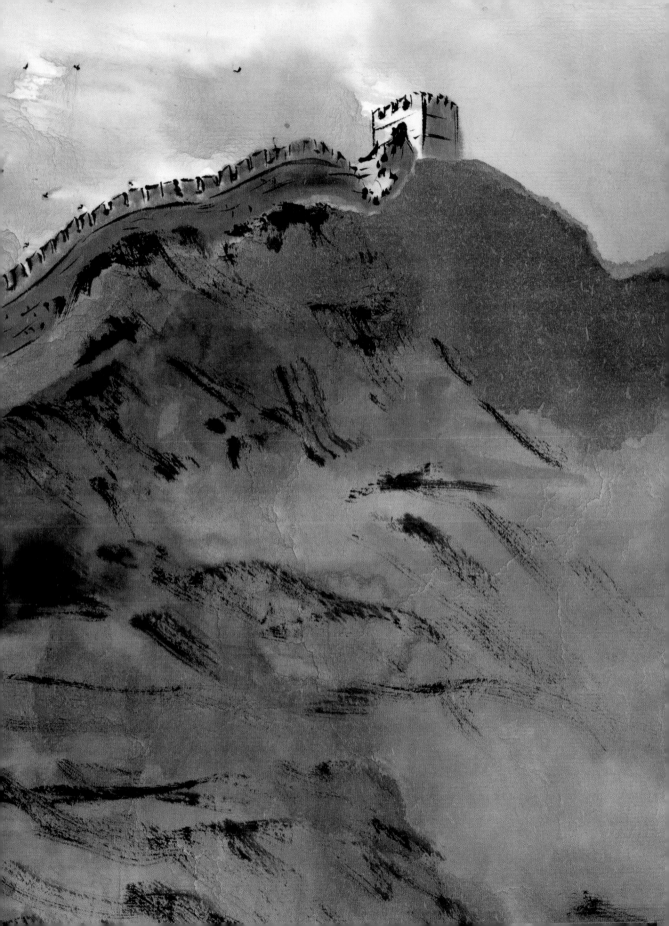

TREES

You could say that trees are nature's way of enhancing the landscape, since they come in such a variety of shapes and colours. Compositionally, a tree has two parts – the framework of the trunk and branches, and the leaves. Using the non-outline technique is a popular way of painting trees in landscape paintings. However, if a tree is the focus of a painting, you can elaborate it with more detailed outline brushwork. A tree at the front of a composition should be painted with stronger features, while those towards the back can be simpler and softer. I cannot possibly include all existing trees in my examples, but the techniques I describe can be applied to painting almost any kind.

TREE TRUNKS AND BRANCHES

In painting you can vary the thickness of a trunk or a branch by using different brush sizes. You can also vary the thickness by the way you use the brush. Try painting a thin branch using the tip of a brush held vertically. When you press the brush, the branch becomes thicker. For painting wider trunks, you can use side brushstrokes. Old tree trunks are rougher and have more texture and it will be more effective to use a dry brush to paint these. However, younger trunks and branches are smoother and have more strength, so paint these with a fully loaded brush.

Using Lines

Here I have used a size 3 Leopard and Wolf or big size Landscape brush and dark ink. Hold the brush vertically and draw a line to represent a branch. Every so often, stop the brush for a moment on the paper before continuing: these stops make the branch look stronger. Do not stop for too long or the paper will absorb too much moisture and the marks will become too big. If you press the brush harder, the branch will be thicker. Use thicker brushstrokes for a trunk and thinner ones for branches. You can vary the brush pressure to build up a framework of a tree with a thick tree trunk and a mix of bigger branches and thinner, smaller branches. It is best to start painting with the main trunk and bigger branches before adding the smaller ones.

Stop at intervals as you paint.

A THIN BRANCH
Hold the brush vertically.

A THICKER BRANCH
Press the brush down.

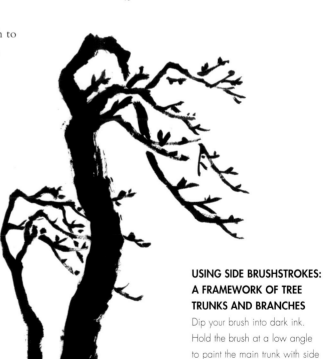

USING LINES: A FRAMEWORK WITH VARIED THICKNESS

Dip the brush into dark ink. Hold the brush vertically. Paint the thicker branches by pressing the brush. Add the smaller branches using only the tip of the brush.

Using Side Brushstrokes

Hold the brush at an angle and use side brushstrokes to paint thicker trunks and branches. The thickness of the trunk depends on the angle at which you hold the brush to the paper. The lower the angle, the wider the tree trunk.

Stop at intervals as you paint

BRUSH HELD AT HIGH ANGLE

Remember to stop the brush every so often while painting the branch.

BRUSH HELD AT LOW ANGLE

USING SIDE BRUSHSTROKES: A FRAMEWORK OF TREE TRUNKS AND BRANCHES

Dip your brush into dark ink. Hold the brush at a low angle to paint the main trunk with side brushstrokes. Hold the brush at a high angle and paint the thicker branches with side brushstrokes. Hold the brush at a vertical position and use the tip of the brush to paint the thinnest branches.

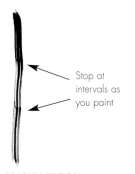

Stop at
intervals as
you paint

**SINGLE VERTICAL
DRY LINE**

Press down the brush as
you paint the trunk.

A WISTERIA VINE

Here I turned the dry line
into a curve. Note the stops
at intervals.

**DOUBLE DRY
LINES FOR A
THICKER TRUNK**

Using Dry Brushstrokes

A dry brush adds texture to a tree trunk. It is especially effective for painting old trees. I used a dry small size Orchid and Bamboo brush with medium ink to paint the illustrations on this page. Alternatively use a small Mountain and Horse brush, which is designed for dry brushstrokes.

BRUSH HELD VERTICALLY

Hold the brush vertically. Press the brush down as you paint. The hair of the brush separates when it is dry and is pressed and the brushstroke produces parallel dry lines. Some trees, such as the willow, wisteria, fir and spruce, have this kind of texture. If the trunk of the tree is thick you can paint two or three brushstrokes side by side to form the trunk.

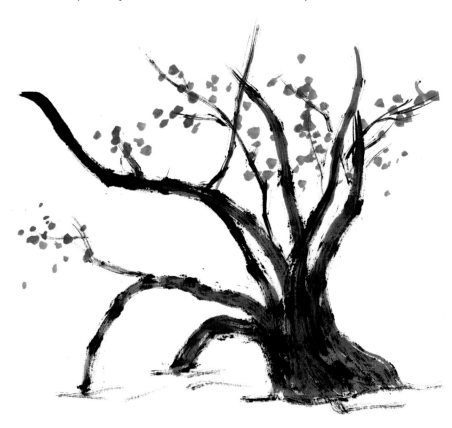

A BANYAN TREE

A banyan tree has a very unusual structure. The trunk is covered with old rugged fibres. Long thin branches very often touch the ground and root to become smaller trees, attached to the enormous main trunk. To look at it, the whole thing is a tangled mass. Banyan trees can live for a very long time, with some in China today that are hundreds, even over a thousand, years old. People worship them because they think that trees that old must have evolved into immortal spirits. In this illustration I have used multiple long dry brushstrokes to paint the trunk.

Using Dry Side Brushstrokes

A tree trunk painted by using dry side brushstrokes looks very rugged. If you make the occasional stops more frequent it adds the appearance of great age.

PAINTING A TREE TRUNK WITH DRY SIDE BRUSHSTROKES
Hold a dry brush at an angle to the paper. Paint the trunk with side brushstrokes. I painted the trunk (shown right) with diluted ink. I then loaded the brush fully with dark ink to add some dots to the trunk. The dots add ruggedness to the tree. I also used dark ink to add smaller branches with the tip of the brush.

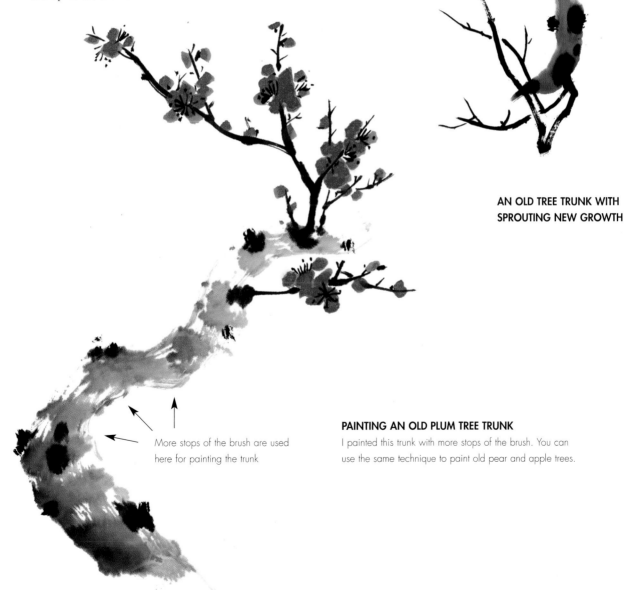

AN OLD TREE TRUNK WITH SPROUTING NEW GROWTH

More stops of the brush are used here for painting the trunk

PAINTING AN OLD PLUM TREE TRUNK
I painted this trunk with more stops of the brush. You can use the same technique to paint old pear and apple trees.

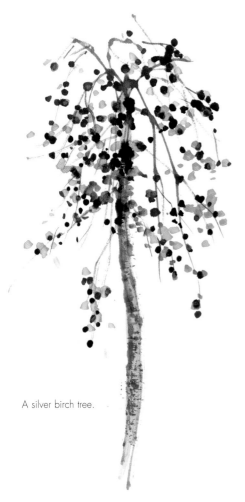

A silver birch tree.

LEAVES

You can use dots, long dots, lines, the press and lift technique and side brushstrokes to paint leaves. You can also draw the outlines of leaves first and then informally dot them with colours. In the examples that follow I will be using these various brushstrokes and techniques to paint different kinds of trees, and show various ways of painting leaves. Obviously, I cannot include examples of all types of trees, but the techniques used in these examples can be extended to paint almost any type.

Using Dots

A SILVER BIRCH

Silver birch bark has a distinctive texture. Other trees with similar textures are cherry and the Chinese parasol trees (*Firmiana Simplex*). To paint this kind of texture, start the trunk with an outline and then use dry horizontal side brushstrokes to add the texture. The size of the tree will dictate what size brush to use. Add the thinner branches using the tip of the brush. Here I used dots for the leaves, first with ink then with sap green.

Dry horizontal side brushstrokes.

A silver birch tree trunk.

JIË () LEAVES

A group of leaves painted in this way is called this because it resembles the Chinese word Jïi (分). The number of leaves in a group is not limited to four, and can be three, five or more. This is actually a common and popular way to paint leaves in a Chinese painting and you can paint many trees with these kinds of leaves. Start the tree with the trunk and branches, and leave gaps for leaves. I painted the leaves first with ink and then with a dark green, but you can use any combination of colours. Using two tones of ink or using light green and dark green are just a couple of other options. For an autumnal feeling you can use combinations of gamboge, cadmium red, cadmium orange, alizarin crimson and burnt sienna.

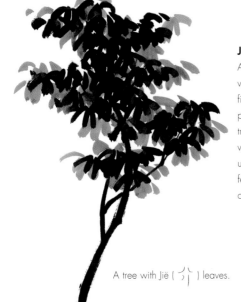

A tree with Jïe (分) leaves.

Jïe (分) leaves.

Using Side Brushstrokes

A BANANA TREE

Banana leaves are made up of many wide and flat leaflets and are best represented using side brushstrokes. Fully load a small Mountain and Horse brush with two tones of sap green or a mixture of sap green and burnt sienna. Paint the leaves with side brushstrokes placed close together, using one brushstroke for each leaflet. Use a Red Bean or small size Landscape brush and dark ink or burnt sienna to add the main stalk and veins. You can paint the trunk with burnt sienna or a mixture of sap green and burnt sienna depending on your preference.

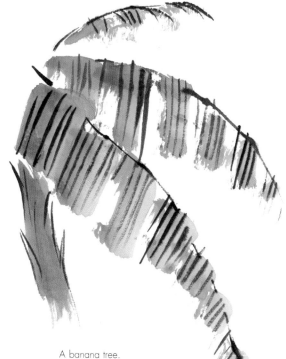

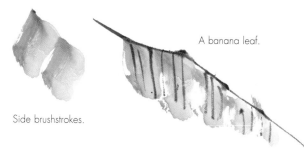

A banana leaf.

Side brushstrokes.

A banana tree.

Using Short Side Brushstrokes

A FIR TREE

Using a small Mountain and Horse brush or a dry small size Orchid and Bamboo brush, paint the tree trunk with the brush held vertically. Press the brush to make wider brushstrokes. Start from the top and go downwards. For a very thick tree trunk you may have to paint two or more brushstrokes side by side to build up the width. Add thinner branches with the tip of the brush. I used a dry small Mountain and Horse brush and short side brushstrokes to paint the leaves, first with dark ink, then with dark green.

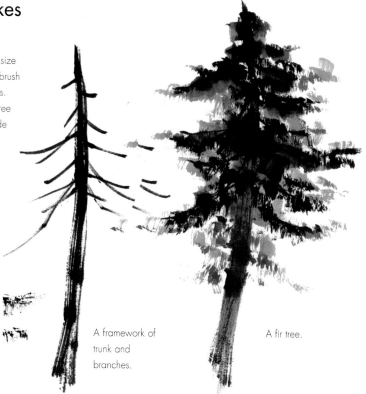

Use short vertical side brushstrokes for the leaves of a fir tree.

A framework of trunk and branches.

A fir tree.

Using the Press and Lift Technique

A MAPLE TREE

A single maple leaf is made up of five press and lift brushstrokes. Let us begin with painting the tree trunk. Load a small Mountain and Horse brush with diluted ink and dip the brush tip into burnt sienna. Hold the brush at an angle to the paper and paint the trunk with side brushstrokes, leaving gaps for the leaves. Load a size 3 Leopard and Wolf or big size Landscape brush with alizarin crimson and paint the leaves. Paint five brushstrokes using the press and lift technique to form a leaf. Add further leaves with diluted alizarin crimson.

Other trees, like the chestnut, also have similar leaf shapes. In fact, many trees have leaves that can be painted using the press and lift technique. Each leaf of the tree can be depicted by a single brushstroke, or by using two or more.

Maple leaves using press and lift technique. Use five brushstrokes for a single leaf.

A maple tree.

A parasol tree.

Using Outlines

A PARASOL TREE

Parasol trees (*Firmiana Simplex*) are very tall. Their leaves are broad and turn yellow or brown in autumn, which makes them a favourite subject for painting and poetry. Parasol trees are usually the last to shed their leaves in late autumn, and artists sometimes compare them to friends or loved ones who are leaving, or have left. The trees appear to hang on to their leaves until the very last moment, just like a friend or lover who cannot bear the emotion of parting. Start the trunk by drawing an outline, and also draw the outlines of the leaves. Paint the texture of the tree trunk with the same technique used on page 76 for painting the silver birch. Now colour the tree trunk with a mixture of ink and burnt sienna. Fully load a size 3 Leopard and Wolf or big size Landscape brush with burnt sienna and informally dot some of the leaves. Colour the remaining leaves with gamboge.

Outline of leaves.

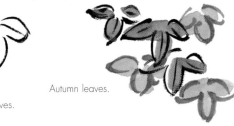

Autumn leaves.

PAINTING DISTANT TREES

Trees in the distance should be kept simple. Use only a few lines for the trunks; there is no need to paint an elaborate framework. Keep the foliage simple, too – dots or long dots are more suitable for painting leaves in this situation. Use a lighter tone of ink or colour than you would for foreground trees. Fully load the brush to paint the dots. You will get a softer mood from the light colour, fuzzy image and running brushstrokes.

Using Dots

DISTANT TREES USING DOTS

Dip a Red Bean or small size Landscape brush into diluted ink. Start the trees with a simple framework. Now fully load a size 3 Leopard and Wolf or big size Landscape brush with diluted ink and paint dots for foliage.

Using Long Dots

DISTANT TREES USING LONG DOTS

Use a Red Bean or small size Landscape brush and diluted ink to paint a simple framework. Fully load a size 3 Leopard and Wolf or big size Landscape brush with diluted ink. Paint long dots to suggest the foliage.

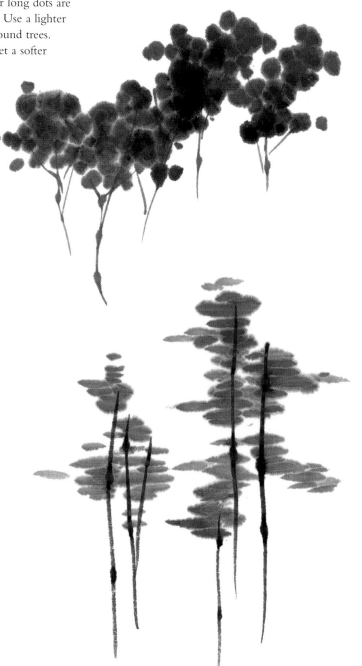

PAINTING A TREE IN ELABORATE STYLE

When a tree is the focus of a painting, it is worth painting it in a more elaborate style, with detailed brushwork. You will very often find trees painted in both an expressive style and an elaborate style within a single painting. The following is an example of a pine tree. The majestic posture of an old pine tree is a very beautiful sight. Some of the most breathtaking pine trees in China are located in the peaks of Huangshan, where years of extreme weather have moulded them into the most unusual postures. Many of them are several hundred years old.

Pine Needles

There are many ways to paint pine needles, as there are many varieties of pine trees. Here are some of the most popular examples. Leaves are usually painted in groups. Groups overlap each other.

SIMPLE PINE NEEDLES
The pine needles are arranged in a semi-circle as a group. Start each needle from the outside and move towards the centre of the semi-circle.

ROUND WINDMILL TYPE
The needles of each group are in a circle with an opening where one or two needles are missing. Again, start the needles from the outside and converge at the centre.

OBLONG WINDMILL
An oblong group usually has no opening.

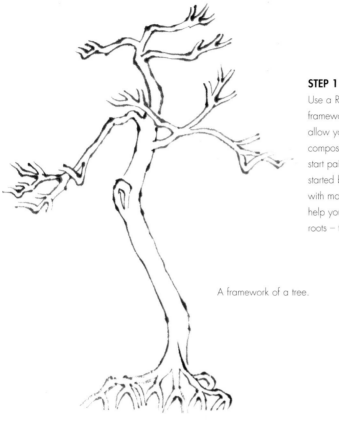

STEP 1

Use a Red Bean or small size Landscape brush and diluted ink to outline the framework of the tree trunk. The purpose of using diluted ink at this stage is to allow you to make corrections in case you change your mind about the composition. In painting, whether it is a landscape or flower, it is better to start painting a feature in the front and work towards the back. In this case, I started by painting the leaves in the front, followed by the trunk and finishing with more leaves at the back. Having an outline of the trunk from the start will help you to plan the overall spread of the leaves. Note also the exposed roots – they are a favourite feature in Chinese landscape painting.

A framework of a tree.

STEP 2

Dip your brush into dark ink and paint the pine needles with short lines. I used the simple pine leaves, arranged in a semi-circle, here.

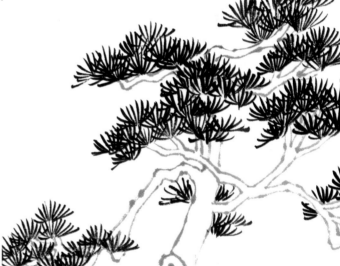

Adding the pine needles using ink.

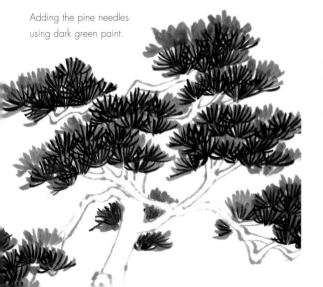

Adding the pine needles using dark green paint.

STEP 3

Prepare a dark green by mixing one part indigo with two parts sap green. Load your brush with this dark green and paint the pine needles again. Follow the overall shape of the foliage already painted in ink. Add some extra needles this time to expand the spread. I am using two colours – ink and dark green – to paint the pine needles in this illustration. Some artists prefer to use three colours, as follows: dark ink, then dark green and finishing with sap green or, alternatively, dark ink, then light ink and finishing with dark green. The three-colour approach makes the foliage look denser.

Textures

Again, there are many ways to express the texture of the trunk of a pine. Here are a few examples. The techniques of painting these textures can be applied to painting other trees.

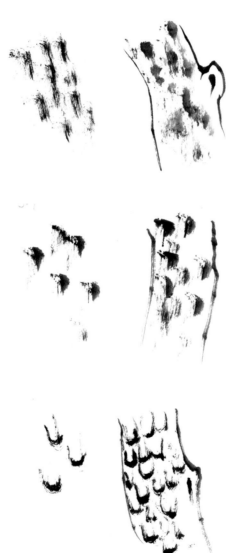

RUB

Load a brush with dark ink or medium ink. The size of the brush depends on the size of the trunk. Prepare a dry brush by wiping it off on a paper towel. Hold the brush at an angle and rub it on the tree trunk.

PRESS AND LIFT TECHNIQUE

Prepare the brush as above. Hold the brush at an angle and use downward side brushstrokes with the press and lift technique along the tree trunk.

RING

Prepare a dry brush as above. Hold the brush vertically and draw rings as illustrated.

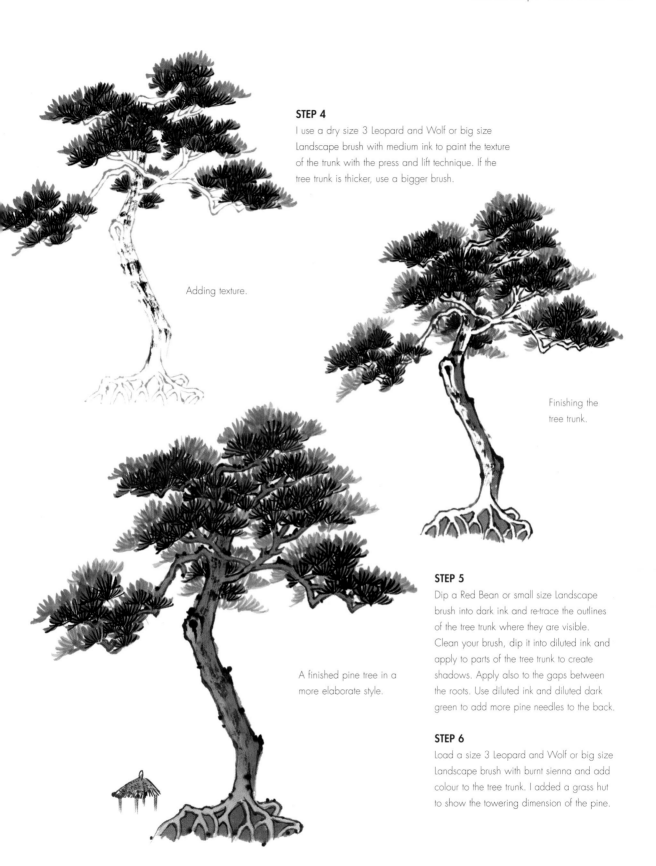

Adding texture.

Finishing the
tree trunk.

A finished pine tree in a
more elaborate style.

STEP 4

I use a dry size 3 Leopard and Wolf or big size
Landscape brush with medium ink to paint the texture
of the trunk with the press and lift technique. If the
tree trunk is thicker, use a bigger brush.

STEP 5

Dip a Red Bean or small size Landscape
brush into dark ink and re-trace the outlines
of the tree trunk where they are visible.
Clean your brush, dip it into diluted ink and
apply to parts of the tree trunk to create
shadows. Apply also to the gaps between
the roots. Use diluted ink and diluted dark
green to add more pine needles to the back.

STEP 6

Load a size 3 Leopard and Wolf or big size
Landscape brush with burnt sienna and add
colour to the tree trunk. I added a grass hut
to show the towering dimension of the pine.

WILLOW TREE

COLOURS

Ink

Sap Green

Indigo

Burnt Sienna

BRUSHES

Red Bean or small size Landscape brush

Size 3 Leopard and Wolf or big size Landscape brush

Mountain and Horse brush

Orchid and Bamboo brush

Here is a massive willow with tangling branches. I have seen a lot of them in Hangzhou, in China, but I also have seen many in Cambridge, England. I used thin lines for the slender, drooping branches and side brushstrokes for the main tree branch. Leaves were painted using the press and lift technique.

STEP 1
Use a Red Bean or small size Landscape brush and diluted ink to sketch the position of the main trunk. Then dip a size 3 Leopard and Wolf or big size Landscape brush into dark ink and paint the thin sweeping branches with the tip of the brush.

STEP 2
Load a size 3 Leopard and Wolf or big size Landscape brush with dark ink. Add the leaves with the press and lift technique.

STEP 3
Use a dry small Mountain and Horse brush and dark ink to add parts of the main branch, where they are visible, using side brushstrokes. Colour the branch with burnt sienna.

STEP 4
Use a size 3 Leopard and Wolf or big size Landscape brush and diluted ink to add more thin branches and leaves.

STEP 5
Prepare sap green and a darker green with two parts sap green and one part indigo. Use a small size Orchid and Bamboo brush to apply partial washes to the composition as follows: dark green to thicken the foliage and sap green to enhance the background.

STEP 6
Dilute the burnt sienna and add more slender branches in the background with a size 3 Leopard and Wolf or big size Landscape brush.

STEP 7
Paint a boat and a fisherman with a Red Bean or small size Landscape brush using dark ink, and colour the boat and its reflection with a touch of burnt sienna.

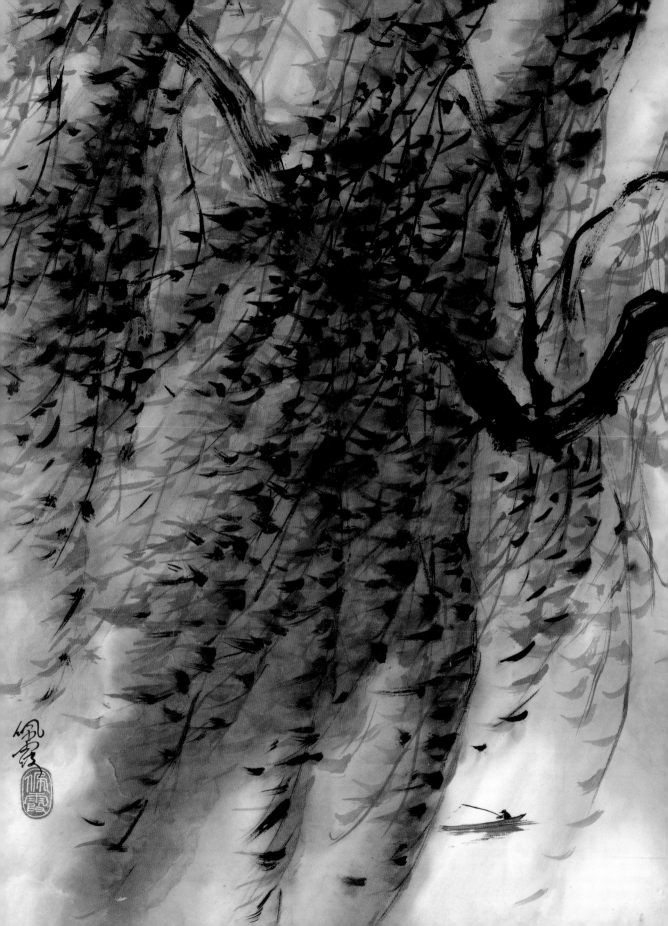

GINGKO TREES

Ink

Cadmium Orange

Gamboge

Process White

BRUSHES

Red Bean or small size
Landscape brush

Orchid and Bamboo
brush

Small Mountain and
Horse brush

Anybody familiar with health supplements knows about gingko trees. Gingko supplements are made from the extracts from the leaves. However the nuts are more widely used in Asia, both for medicine and for cuisine. When I was in Guilin, I went to Haiyang, which is traditionally called the home of ginkgo trees. I found these towering examples in a courtyard surrounded by many tiny, century-old houses. It was autumn and the leaves had turned a colourful orange and yellow. I used dots to paint the leaves here.

STEP 1
Use a Red Bean or small size Landscape brush and diluted ink to sketch the main elements of the composition, such as the roofs, trunks and branches.

STEP 2
Prepare three colours: gamboge, cadmium orange and a mixture of one part gamboge and one part cadmium orange. Paint the leaves with a small size Orchid and Bamboo brush using dots, and each of the three colours in turn. Add more dots with process white to highlight the leaves in the front. Use a small Mountain and Horse brush and dark ink to paint the visible parts of the trunks and branches of the two trees in the foreground.

STEP 3
Paint the frameworks of the trees in the background and add leaves to these trees using a small size Orchid and Bamboo brush and dots with the three colours described in step 2.

STEP 4
Highlight the roofs of the houses with lines and side brushstrokes using a Red Bean brush or small size Landscape brush and dark ink. Fully load a small size Orchid and Bamboo brush with diluted ink and colour the houses. Then wipe the excess moisture off this brush on to a paper towel and paint side brushstrokes to represent the yard.

STEP 5
Finish by painting the sky with a wash of diluted ink. Load the same brush with diluted gamboge and cadmium orange in turn and add more leaves to the yard and on the rooftops.

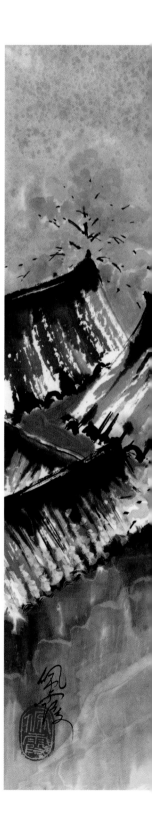

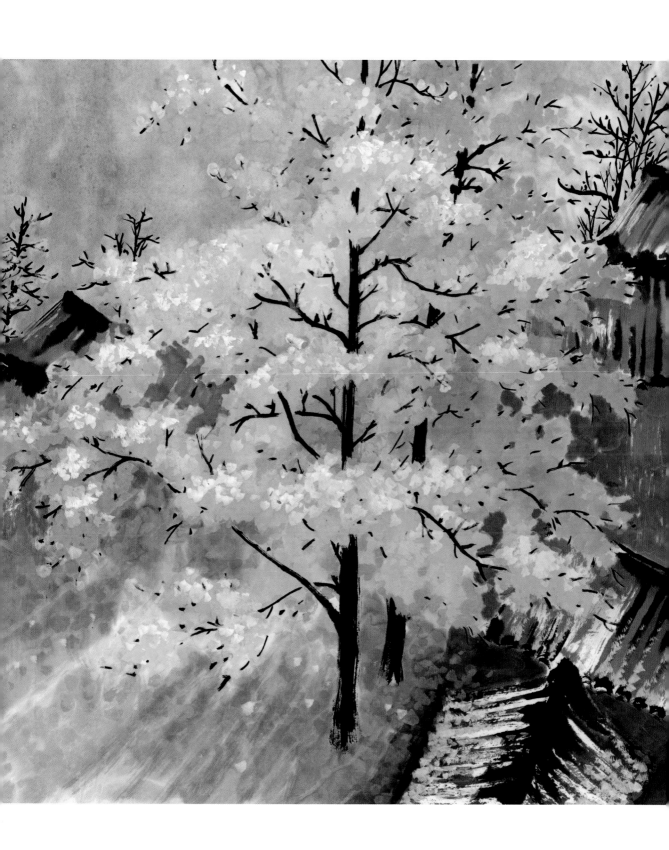

ROCKS AND MOUNTAINS

The simplest way to paint a rock or a mountain is to draw it as an outline and then paint it in with colour. If you want the result to be more expressive, you can use a partial wash in the shape of the rock or even use the splattering technique. I have already shown you some examples in the sections 'Partial Washes' and 'Splattering Technique' (pages 60 and 64). Such a simple approach is especially effective if the focus of your painting has a more complicated structure and has been done in a more elaborate way. For example, if the composition has a pagoda, a bridge, a junk or a tree painted in the elaborate style (see page 80), simply executed mountains and rocks will offer a contrast that will enhance the structure rather than compete with it.

Painting a rock or a mountain in the more refined Chinese way involves a lot more work because we have to consider its shape, size, colour and texture. The most important aspect is its character. For example, Huangshan Mountain is awesome, and towers up to the sky. Mountains cut by ice and snow have angular peaks. Rocks by the water are smooth, while those eroded by weather and tree roots have many dents. Accompanying features can help as well: for example, mist around the mountain adds a distant, majestic character, while a small cottage at its foot makes the mountain look even more imposing.

Dry long dots.

Traditionally, a master will teach you the five steps necessary to paint a rock or a mountain. It is in fact a very reliable technique, and you will always get good results by following it. I shall cover these steps in this chapter but, before that, I shall introduce some techniques for painting the texture of a rock. Texture usually shows the character of a rock. It is also the most difficult and confusing technique to master. Throughout the history of Chinese painting, artists have invented many brushstrokes for painting the textures of rocks and mountains. The full list would probably be longer than this book. However, if you closely examine all the brushstrokes, every one of them is actually derived from one of the three basic strokes: dots, lines and side brushstrokes.

DOTS

Long dots are usually used. It is better to use a dry brush to paint dots, by wiping the brush on a paper towel to remove excess moisture after loading the brush with ink or colour. Apply dots to places where there are shadows and dents, first with medium ink and then with diluted ink. Using two ink tones creates a three-dimensional effect. Dots are used to paint rocks and low hills that have been deformed by years of tree-root activity.

Dry extended long dots.

You can use long dots vertically, horizontally or diagonally to create different textures. The size of a long dot varies depending on the size of brush you use. A Red Bean or small size Landscape brush produces smaller long dots than a size 3 Leopard and Wolf or big size Landscape brush. The rule is to use a smaller brush to paint a small rock and a bigger brush to paint larger rocks. You can also extend the length of a long dot by sliding the brush in the direction you are painting.

Painting the Texture of a Rock Using Dots

STEP 1

Use a Red Bean or small size Landscape brush and diluted ink to draw the outline of a rock. Use the press and lift technique to vary the thickness of the lines.

STEP 2

Using the same brush, or a a size 3 Leopard and Wolf or big size Landscape brush depending on the size of the rock, load the brush with medium ink and wipe off the excess on a piece of paper towel. Start painting long dots on the parts of the rock which are in shadow or indented. Wait for the brushstrokes to dry.

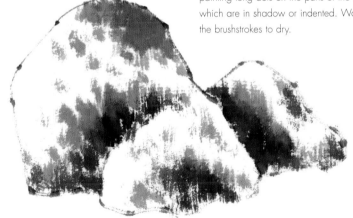

STEP 3

Clean the brush and load it with diluted ink. Wipe off excess ink on paper and expand the area of dots. As you can see here, using two ink tones creates depth.

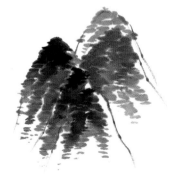

WET HORIZONTAL LONG DOTS

Wet horizontal long dots can represent spreading vegetation. In this case the vegetation forms the texture of the mountains.

EXTENDED HORIZONTAL LONG DOTS

Using the extended long dots in horizontal curves will create a more rounded texture.

LINES

Mountains eroded by centuries of melting ice and snow have smoother tops and regular cut lines. Rocks near the water are also smooth because of constant washing. Both these textures can be created by using lines, which are also useful for painting the texture of distant mountains.

Again, use a dry brush and medium ink to paint lines for the texture of a rock. Hold the brush vertically to paint the lines. Vary the thickness with the press and lift technique. Stop slightly at intervals to make the lines more rugged. Use small brushes for smaller rocks and big brushes for larger ones.

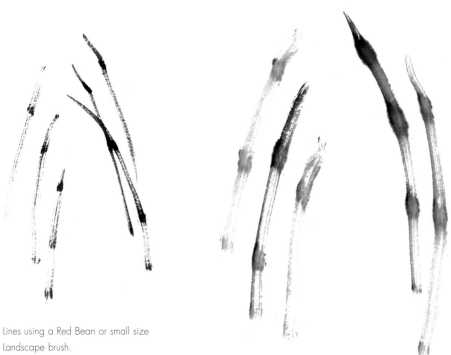

Lines using a Red Bean or small size Landscape brush.

Lines using a small Mountain or Horse brush.

Painting the Texture of a Rock Using Lines

STEP 1

Use a size 3 Leopard and Wolf or big size Landscape brush and diluted ink to draw the outline of the mountain. Use the press and lift technique to vary the thickness.

STEP 2

Load the brush again with medium ink and wipe it on a paper towel. Draw lines on the parts of the mountain that are in shadow or indented. Let dry.

STEP 3

Use a dry brush with diluted ink and apply more lines to the mountain.

HORIZONTAL LINES

Here I used horizontal lines for the texture to emphasize the shape of the rocks.

CROSSING LINES

Here I have painted the lines curving and crossing each other to emphasize the curved surfaces of the rocks.

SIDE BRUSHSTROKES

Side brushstrokes are the most popular brushstrokes to use for painting the textures of rocks and mountains because of their variability. They can vary in size and angle to adapt to the contours of the mountain. Let us start with some practice exercises. These cover different sizes and directions of side brushstrokes, combining the press and lift technique, wrist movements and elbow movements.

Small Side Brushstrokes

- Small side brushstrokes are used more often than the big ones for painting the texture of rocks and mountains.
- Hold the brush at a high angle and use wrist movements to paint the side brushstrokes. You can vary the angles of the side brushstrokes.
- You can also combine side brushstrokes with the press and lift technique.

A vertical side brushstroke.

A short vertical side brushstroke.

A horizontal side brushstroke.

A side brushstroke at an angle.

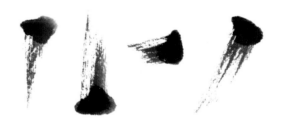

SMALL SIDE BRUSHSTROKES WITH THE PRESS AND LIFT TECHNIQUE

You can vary the direction of the lifting.

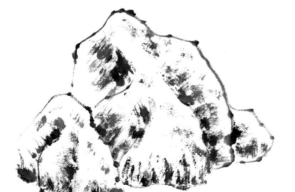

ROCKS PAINTED WITH SMALL SIDE BRUSHSTROKES

I used a mixture of side brushstrokes to paint this rock. I used vertical brushstrokes for the base of the rock, then adjusted the angles of different side brushstrokes to correspond with the contours of the rock, varying between the usual ones and those with the press and lift technique.

Wide Side Brushstrokes

Wide side brushstrokes, with the brush held at a low angle, can add dramatic effect to the texture of a mountain. The result is more effective if you use a small Mountain and Horse brush. This brushstroke is very popular for painting cliffs.

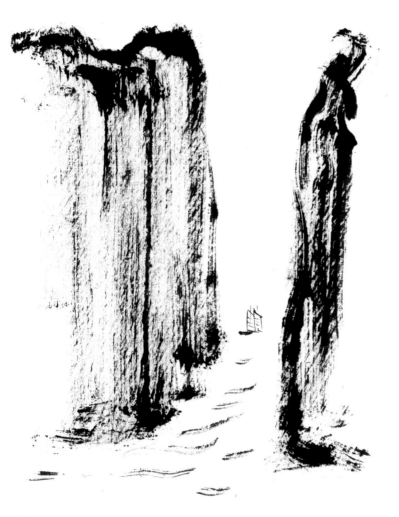

ANGLED CLIFF
This cliff is at an angle. It is more effective to use the press and lift technique, with the brush held at a low angle, combining it with elbow movements.

FLAT ROCKS
I used short, vertical wide side brushstrokes for these rocks. You need to combine wrist movements with a low angle of the brush.

CLIFFS
Vertical cliffs like those on the two sides of a gorge can be represented by long side brushstrokes painted side by side. Hold the brush at a low angle and use elbow movement to paint the long brushstrokes for the cliff.

SHARP SURFACE OF A MOUNTAIN
I used long side brushstrokes at an angle to show the sharp surface of the mountain here.

PAINTING THE GREAT WALL OF CHINA

COLOURS

Ink

Burnt Sienna

Indigo

BRUSHES

Red Bean or small size
Landscape brush

Orchid and Bamboo
brush

Size 3 Leopard and
Wolf or big size
Landscape brush

No.1 small Wolf-hair
brush

The mountain is basically painted with a three-colour partial wash. Some texture is applied but is kept to a minimum in order not to spoil the simple structure of the Great Wall.

STEP 1

Load a Red Bean or small size Landscape brush with diluted ink. Wipe off excess moisture on a paper towel. Draw a rough sketch of the Great Wall.

STEP 2

Load the same brush with dark ink. Outline the Great Wall again. Use the brush and dark ink to paint the texture of the mountain with lines and side brushstrokes. Keep the texture to a minimum so that the focus of the painting is the Great Wall.

STEP 3

Prepare three colours – indigo, burnt sienna and a darker burnt sienna tinted with a tiny amount of ink. Fully load a small size Orchid and Bamboo brush with these three colours in turn to colour the mountain. Wet the lower edge of the mountain to create soft edges or gradual toning (see page 61). Dip a size 3 Leopard and Wolf or big size Landscape brush into indigo and carefully colour the Great Wall.

STEP 4

Dilute the darker burnt sienna and indigo washes. Paint the sky.

STEP 5

When the painting is dry, use a No.1 small Wolf-hair brush and dark ink to paint a flock of birds across the sky.

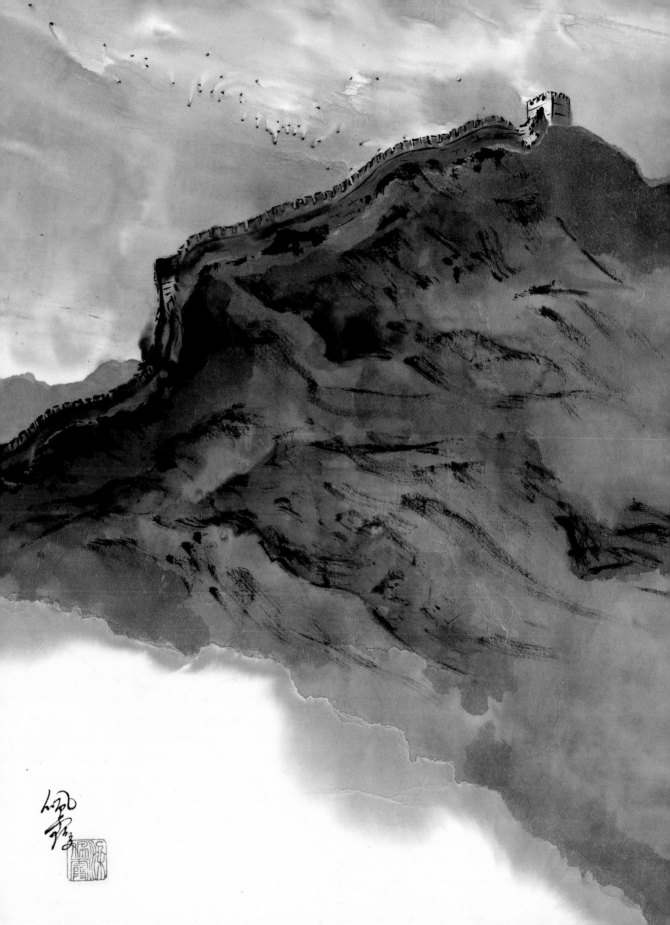

THE GORGE OF CHINA

COLOURS

Ink

Indigo

Cobalt Blue

Burnt Sienna

BRUSHES

Red Bean or small size
Landscape brush

Small Mountain and
Horse brush

Size 3 Leopard and
Wolf or big size
Landscape brush

One can never forget the experience of sailing through the great Gorge of China with the towering cliffs on both sides.

STEP 1
Use a Red Bean or small size Landscape brush and diluted ink to sketch the outline of the composition.

STEP 2
Load a small Mountain and Horse brush with dark ink. Use long and wide side brushstrokes to paint the textures of the mountains in the front. Keep the brush at a low angle and use elbow movements. Clean the brush and load it with diluted ink. Paint the textures of the mountains at the back of the composition.

STEP 3
Use a size 3 Leopard and Wolf or big size Landscape brush and dark ink to paint some trees on top of the mountains. Add more trees with diluted ink on the mountains at the back.

STEP 4
Prepare a blue colour mix of one part indigo and one part cobalt blue. Use this mix and burnt sienna to colour the foremost cliffs. Do not cover the mountains completely with colours. The empty spaces showing through create the sharpness of the cliffs. Dilute the colour mix and burnt sienna. Use these diluted colours for the cliffs at the back.

STEP 5
Use a Red Bean or small size Landscape brush and dark ink to draw the boats. Colour them with burnt sienna.

STEP 6
Wet the foot of the cliffs with clean water. Use a small Mountain and Horse brush and side brushstrokes to paint the reflections, first with the diluted blue colour mix, then with diluted ink. Use a size 3 Leopard and Wolf or big size Landscape brush to paint the reflections of the boats in the same way.

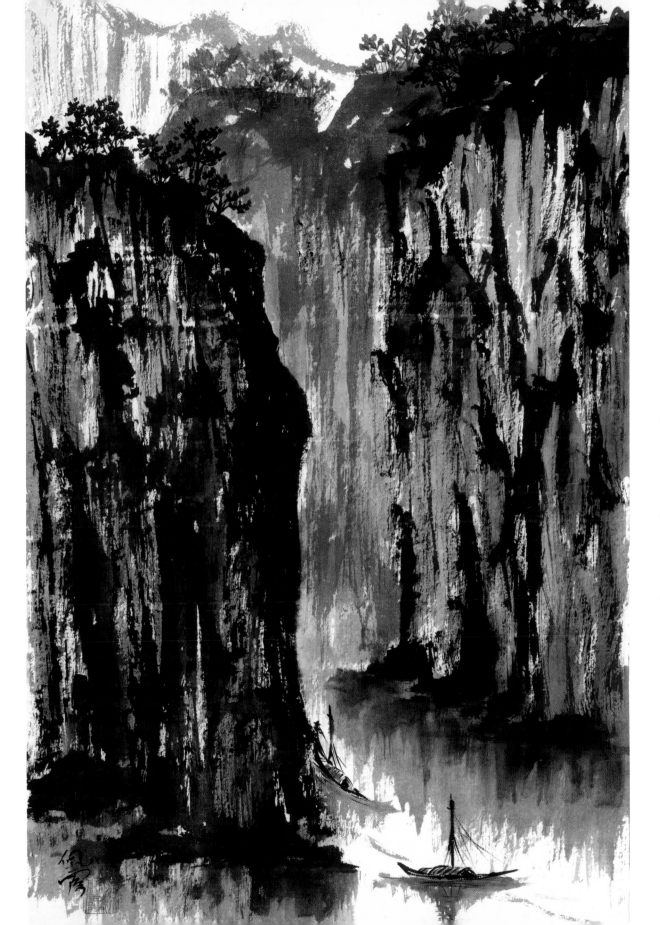

THE TRADITIONAL FIVE STEPS FOR PAINTING ROCKS AND MOUNTAINS

The whole idea of painting in five steps is to ensure that you never rush when painting a rock or a mountain. It is actually a very reliable technique and you usually get good results. Established landscape artists each have their own way of painting rocks and mountains but, like everybody else, we all went through this traditional training once. The five steps get you to understand more about painting rocks and mountains, which is the first step to effective painting.

The traditional steps are:
1. Outline
2. Texture
3. Rub
4. Diluted ink and colour
5. Outline and dots

My advice for beginners is to follow these five steps as often as possible until you establish your own way. I have used painting a rock in the examples here, but you can apply the same principle to painting a mountain.

STEP 1: OUTLINE

Use diluted ink to draw the outline of a rock. Use the press and lift technique to vary the thickness of the lines. I used a Red Bean or small size Landscape brush for drawing the outline of this rock.

STEP 2: TEXTURE

Use a dry size 3 Leopard and Wolf or big size Landscape brush to paint long dots for the texture, first with medium ink, then diluted ink. If the rock is large, you can use a small Mountain and Horse brush to paint the long dots.

STEP 3: RUB

Load a Red Bean or small size Landscape brush with diluted ink. Wipe off excess moisture on a paper towel. Hold the brush at a low angle to the paper on the surface of the rock. Rub the brush on the place where the textures are. This helps to emphasize the parts in the shadow and the indented parts. The rubbing also adds ruggedness. Many artists use just rubbing to create the textures of a rock.

STEP 4: DILUTED INK AND COLOUR

If you feel that the parts in the shadow or the indented parts need to be emphasized further, you can use very diluted ink to do so before the colours are added. Let the diluted ink dry thoroughly. The rock has to be dry before diluted colours are added, otherwise you will spoil the brushwork that creates the delicate textures. Use diluted colours; strong colours will mask the effect of the textures.

STEP 5: OUTLINE AND DOTS

Use dark ink to emphasize the outline. Use broken lines, just sufficient to emphasize the shape and sharpness of the rock. Load a brush fully with dark ink and add dots, with the brush held vertically so that the dots are round in shape. Add dots sparingly. Too many dots will ruin the rock. Use a size 3 Leopard and Wolf brush or a Red Bean brush, depending on the size of the rock.

SPLATTERING MOUNTAINS

You can always use a controlled simple partial wash to paint a mountain. It is a safe way because you can control the shape and colour of the result. Splattering, on the other hand, often ends up with unexpected outcomes. However, splattering is a popular technique favoured by experienced landscape artists. The effect of splattering makes the mountains look awesome, dominating the composition, and almost abstract. Usually the other accompaniments like trees or houses will be painted in a more detailed way so as to create a contrast between the mountains and the rest. Such contrast emphasizes even more the massiveness of the mountains. We can use ink, different tones of ink or colours to splatter. I am including two examples here. One is painted with splattered ink, and the other uses a mixture of different colours.

Splattering Using Ink

A splattering can form the entire mountain or part of a mountain. I prefer to wait for the ink to settle before deciding what the mountains will be like and what accompaniments to add for the more detailed touches.

STEP 1
I used dark ink and diluted ink to splatter on the absorbent paper here.

STEP 2
When the ink was dry, I then added other features. I also added a controlled partial wash of diluted indigo to finish the painting.

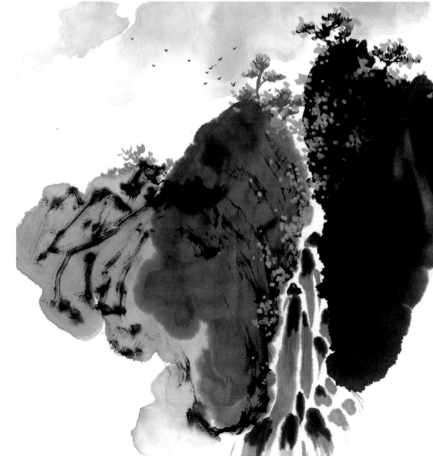

Splattering Using a Mixture of Colours

In this illustration, the colours run into one another. Sometimes the mountains become one massive range without defining lines.

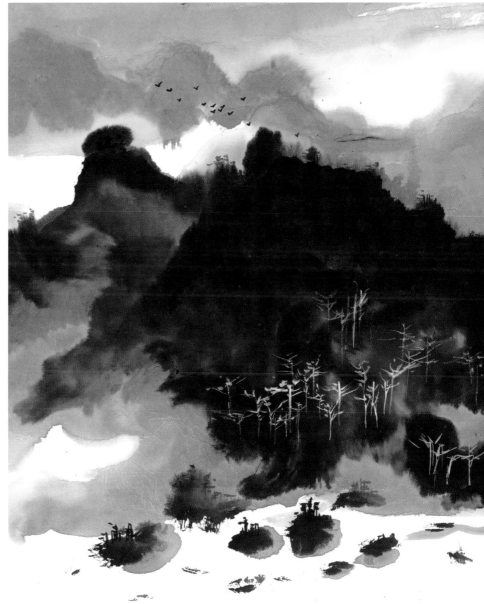

STEP 1
Burnt sienna and indigo were splattered heavily on absorbent paper.

STEP 2
Then I splattered dark ink and diluted ink on to the wet colours. I waited for the paper to dry before adding other features.

PAINTING THE AVEBURY ROCKS

COLOURS

Ink

Indigo

Burnt Sienna

Sap Green

BRUSHES

Red Bean or small size
Landscape brush

Small Mountain and
Horse brush

Orchid and Bamboo
brush

Goat-hair Hake or
Ti brush

The Avebury Rocks are located in Wiltshire, England.
These huge rocks were placed in a ceremonial circle in
ancient times, and some believe they have healing power.
Every year they are visited by many people from all over
the world.

I am using dots for the texture of the rocks in this example.

STEP 1
Use a Red Bean or small size Landscape brush and diluted
ink to sketch the outlines of the rocks.

STEP 2
Use the traditional five steps to paint the rocks (see page
98). Use a small Mountain and Horse brush to paint dots
for the textures and then the rubbings, a small size Orchid
and Bamboo brush to add the colours and the dots at the
end, and a Red Bean or small size Landscape brush to paint
the outlines to finish. The rocks were coloured with indigo
and burnt sienna.

STEP 3
Darken the indigo with a little bit of ink. Paint the shadows
of the rocks.

STEP 4
Use a dry small Mountain and Horse brush to paint the
grass with long dots, first with ink, then sap green and
finally with dark green. Dark green is a mixture of two
parts sap green and one part indigo.

STEP 5
Fully load a Goat-hair Hake or Ti brush with indigo. Paint
a few sweeping brushstrokes across the sky. Then use a dry
small Mountain and Horse brush and dark ink to add a few
more sweeping side brushstrokes.

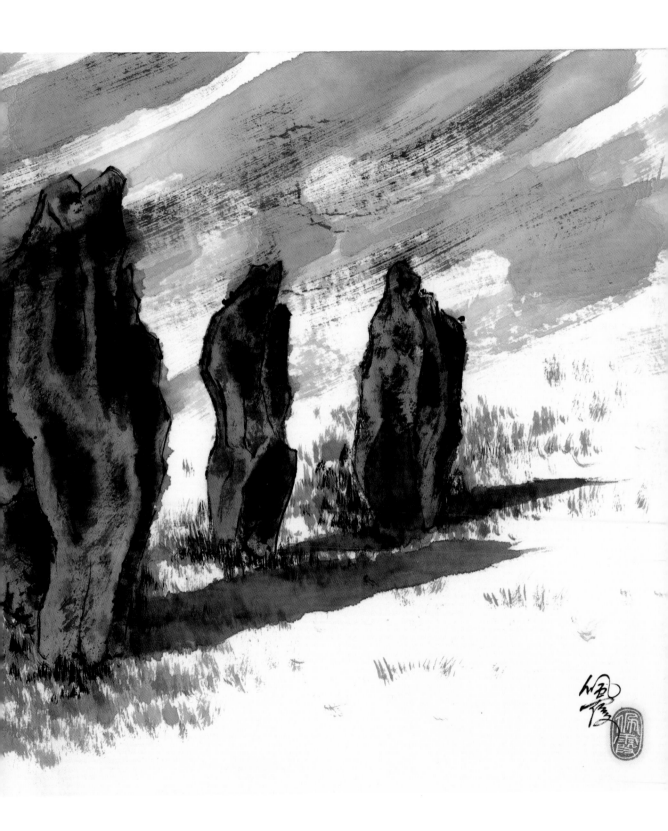

SNOWY MOUNTAINS

COLOURS

Ink

Indigo

Cobalt Blue

BRUSHES

Red Bean or small size
Landscape brush

Small Mountain and
Horse brush

Goat-hair Hake or
Ti brush

These snowy mountains were painted on alum-sized Xuan paper. I used long side brushstrokes painted at an angle. Images on alum-sized paper are sharper because the colours do not run as in absorbent paper. Also a fully loaded brush goes a long way because the colour is not absorbed by the paper. The nature of the paper allowed me to spread the colours that were heavily loaded on the brush, in order to form the wide cliff face in the shadow.

STEP 1
Use a Red Bean or small size Landscape brush and diluted ink to sketch the outline of the mountains on a piece of alum-sized Xuan paper.

STEP 2
Start with the mountains in the front. Use a small Mountain and Horse brush and dark ink to paint the top parts of the mountains with a mixture of side brushstrokes at different angles. Add some textures. Wait for the dark ink to dry before the next step.

STEP 3
Clean your brush. Fully load it with clean water and wet the lower edges of the mountains. Then fully load it with a mixture of one part indigo and one part cobalt blue. Hold it at a low angle and paint long side brushstrokes on the cliff in the front right to the edge of the part wetted by the clean water.

STEP 4
Next, paint the mountains at the back. Again, use the same brush, dark ink and a mixture of side brushstrokes at different angles. Wet the lower edge of the mountains with clean water. Then add a few patches of colour to meet the wet part.

STEP 5
Use the gradual toning or soft edge technique (see page 61) to paint the sky with the blue wash from Step 3. Begin by wetting the lower part of the sky with a Goat-hair Hake or Ti brush loaded with clean water. Then dip it into the blue mixture and add the upper part of the sky, right to the edge of the clean wet patch.

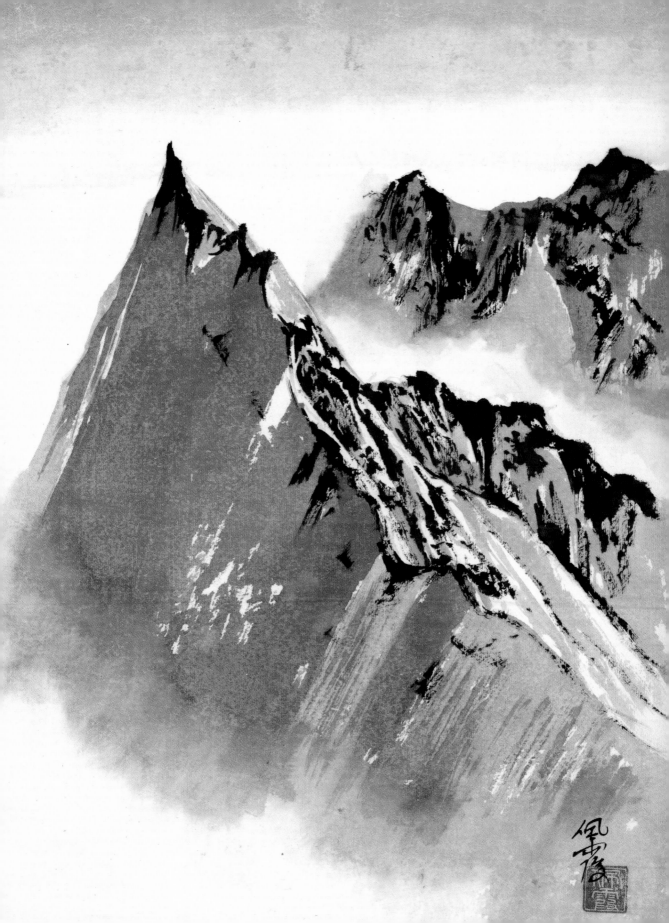

WATER

Water is always on the move. To paint water, it is important to express the movement, whether it is a slow-moving stream, a fast-running river, a tumbling waterfall or a choppy sea. In this chapter we will learn to control our movements to express different features of water. Washes or blank spaces are more effective for painting a slow-moving stream or a calm sea. Swing your arm with elbow movement to achieve a decisive curve when you paint a rapidly moving river. Express a waterfall with firm and swift downward side brushstrokes. Combine all these brushstrokes with the press and lift technique to create variations. When expressing the movement of water, dry brushstrokes are more effective than wet. We shall look at a few main types of water: stream, river, waterfall, sea, waves and reflection. Chinese landscape artists usually paint the features directly onto the paper. For landscape painting beginners it is best to start with a rough drawing, until you are more experienced.

CALM WATER

The most effective way to paint calm water, whether it is a slow moving stream or a calm sea, is to leave blank spaces to represent them. You can add a few simple brushstrokes to indicate some slow activity in the water. For example, you can use short lines to paint the ripples in the sea. You can also apply a simple partial wash to enhance the mood. The rule is not to add too much; otherwise you will ruin the calmness you wish to achieve.

Slow-moving Stream

When you paint a slow-moving stream with blank spaces, you can use the surrounding features to make the composition more interesting. You can colour the stream with a partial wash, but if you are using bright or deep colours for the surrounding features, it is better to keep the partial wash diluted. This way you create contrast between the surrounding features and the stream and add depth to the composition (see below).

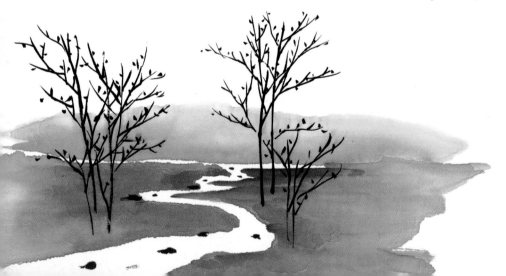

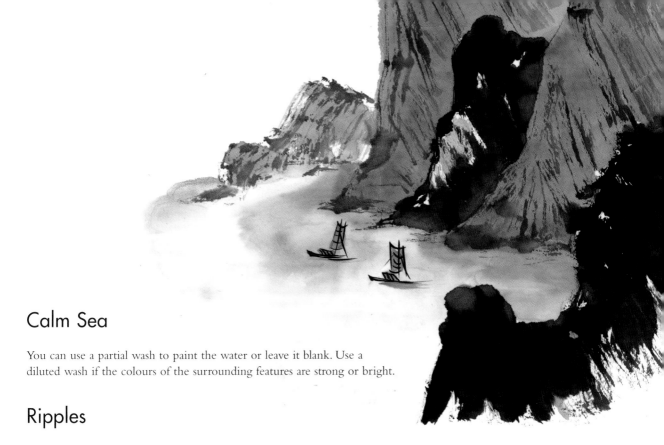

Calm Sea

You can use a partial wash to paint the water or leave it blank. Use a diluted wash if the colours of the surrounding features are strong or bright.

Ripples

Short brushstrokes can be used to create limited movements in calm water, such as ripples, especially when the ripples create broken reflections of the surrounding features (see Reflections on the next page).

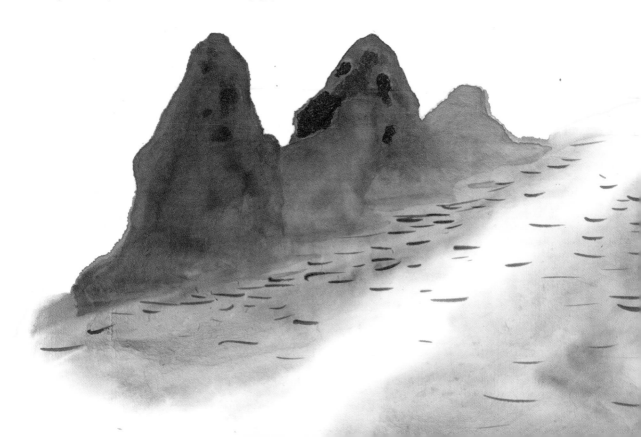

Reflections

Reflections usually occur in calmer water. In choppy water, reflections are diffused and there will be no definite forms. All you will probably get are patches of colours. If the reflection is the focus of the painting, it is worth painting it according to the following steps. The real features are painted when the paper is dry. Paint the reflection on a wet background of either clean water or a partial wash so that the images in the reflection become blurred.

REFLECTION IN CALM WATER

If the reflection is a main feature in the composition, more painting work is involved. Let us do this step by step:

STEP 1

Paint the features above water, in this case a sailboat. When the sailboat is dry, add a light colour wash at the back to show off the white sail.

STEP 2

Apply a partial wash on the water. Here I used a slightly darker tone of the colour of the sky. If you want the background of your painting to be blank, you can use clean water instead to wet the space for painting the reflection.

STEP 3

Use dry brushstrokes to paint the reflections on the wet wash so that the brushstrokes become blurred. Remember to paint the reflection to correspond to the features above it.

Simple Reflections

If the reflection is not a main feature, you can use simple brushstrokes or colour patches to represent it.

USING BRUSHSTROKES

Small brushstrokes add limited movements to the water, creating broken images of reflection. I did not use a wash behind the brushstrokes because then they would become blurred and fuse together and you would lose the effect. If you prefer to add colour to the water, do it afterwards when the reflections are dry.

USING SIDE BRUSHSTROKES

Again, I did not use a wash behind the side brushstrokes. The side brushstrokes in this case are sharp. However, in some cases I do paint the side brushstrokes on a wet surface when I want more diffused reflections.

USING COLOUR PATCHES

In situations where there are too many objects above the water, using only simple colour patches for the reflection prevents the composition from becoming too congested. Colour patches are also used for reflections where there are fast movements in the water, in which case there are no definite forms in the reflections.

PAINTING WOODS IN THE AUTUMN

COLOURS

Ink

Indigo

Burnt Sienna

Gamboge

Process White

The stream running through this wood was painted by leaving the space blank. A very diluted wash was added later after the surrounding features had been painted with strong colours.

STEP 1
Use a Red Bean or small size Landscape brush and diluted ink to sketch the outlines of the trees and the banks of the stream.

STEP 2
There are three groups of trees. Paint the framework of the trees with a size 3 Leopard and Wolf or big size Landscape brush. Paint the front group with dark ink and in detail. The trunks are painted with lines, with stops at intervals, and the textures with side brushstrokes. Use medium ink for the middle group and diluted ink for those at the back. Prepare a mix of three parts process white and one part gamboge. Use gamboge and the paler mix to paint the leaves of the trees in the front using dots. Use diluted burnt sienna for those in the middle. Wait for the trees to dry.

STEP 3
Load the same brush with dark ink to add a few rocks along the stream. Paint some dark patches along the bank. While the dark ink is still wet, use a small size Orchid and Bamboo brush loaded with diluted ink to expand the banks. While the diluted ink is still wet, expand the banks further with indigo. Continue to add more indigo and burnt sienna to paint the sky.

BRUSHES

Red Bean or small size Landscape brush

Size 3 Leopard and Wolf or big size Landscape brush

Orchid and Bamboo brush

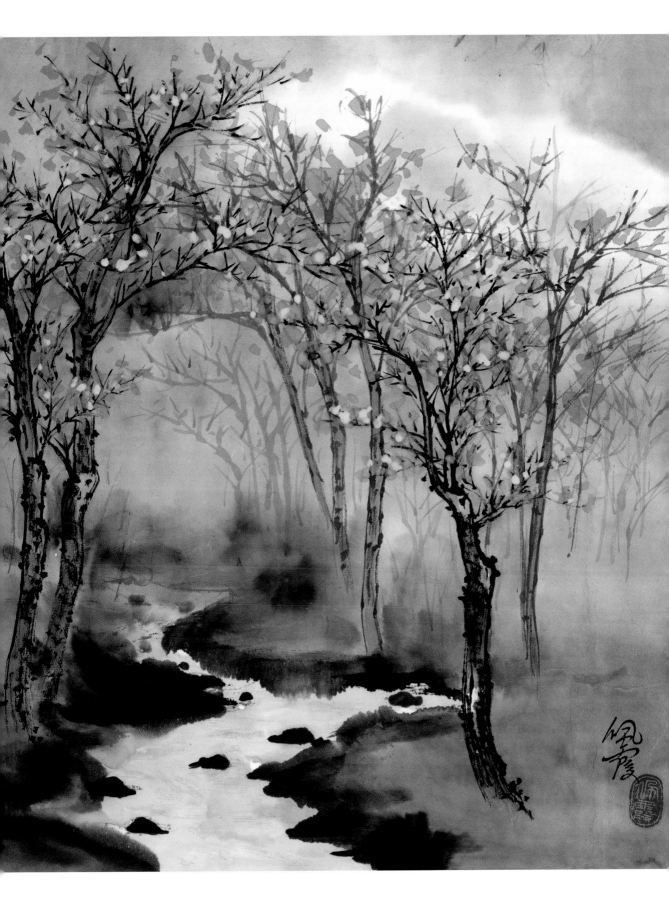

SUZHOU

COLOURS

Ink

Indigo

Burnt Sienna

BRUSHES

Red Bean or small size
Landscape brush

Size 3 Leopard and
Wolf or big size
Landscape brush

Goat-hair Hake or
Ti brush

Suzhou is known as the 'Venice of China' because many areas are flooded. Waterways are common features and boats are the only transport in the flooded areas. Merchandise, from food to clothing, is brought door to door by traders who use their boats as shop fronts.

This painting portrays one of the main streets in Suzhou. I did not include a boat in the composition because I want to show you the reflections properly.

STEP 1
Use a Red Bean or small size Landscape brush and diluted ink to sketch the houses.

STEP 2
Paint the houses with a size 3 Leopard and Wolf or big size Landscape brush and dark ink. Use a mixture of lines, the press and lift technique and side brushstrokes. Use indigo, diluted ink and burnt sienna to colour the houses.

STEP 3
Wet the area along the base of the houses with clean water using a Goat-hair Hake or Ti brush. Then use a size 3 Leopard and Wolf or big size Landscape brush to paint the reflections with the same colours that were used for the buildings. Clean the brush and dip it into diluted ink to add the ripples.

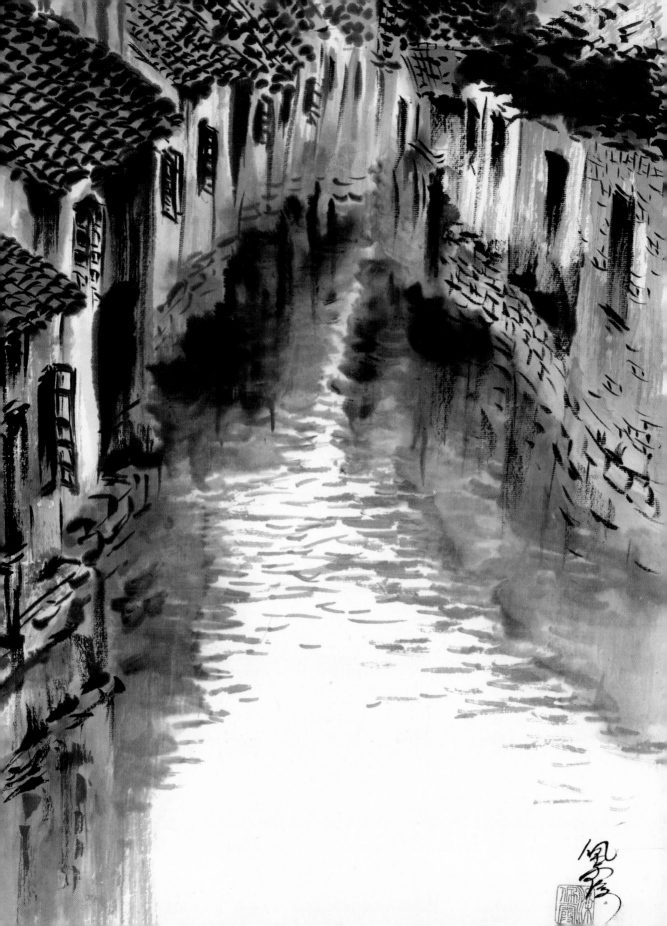

FAST-MOVING WATER

Sweeping brushstrokes are a safe and effective way to express the activity of fast-moving water. Other features are better painted with expressive brushstrokes so that it will match the mood of the composition. You can paint the movement of the water with lines or lines with press and lift technique, using ink or colour.

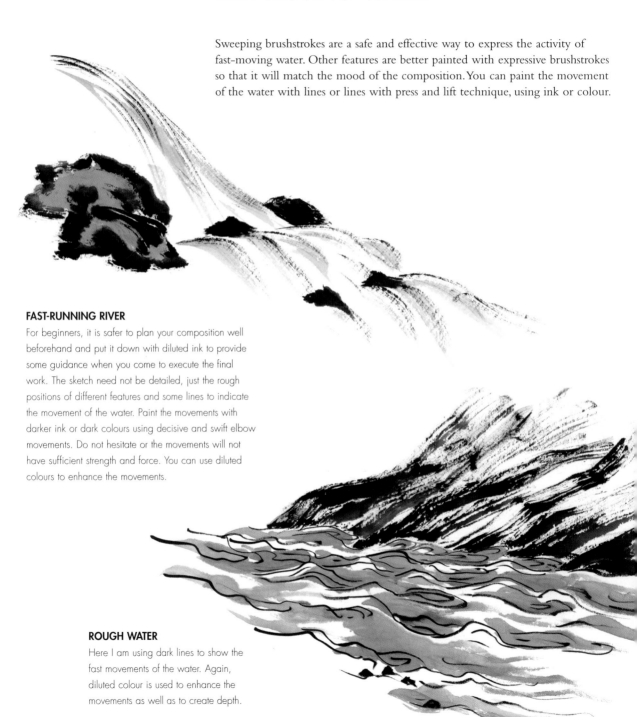

FAST-RUNNING RIVER

For beginners, it is safer to plan your composition well beforehand and put it down with diluted ink to provide some guidance when you come to execute the final work. The sketch need not be detailed, just the rough positions of different features and some lines to indicate the movement of the water. Paint the movements with darker ink or dark colours using decisive and swift elbow movements. Do not hesitate or the movements will not have sufficient strength and force. You can use diluted colours to enhance the movements.

ROUGH WATER

Here I am using dark lines to show the fast movements of the water. Again, diluted colour is used to enhance the movements as well as to create depth.

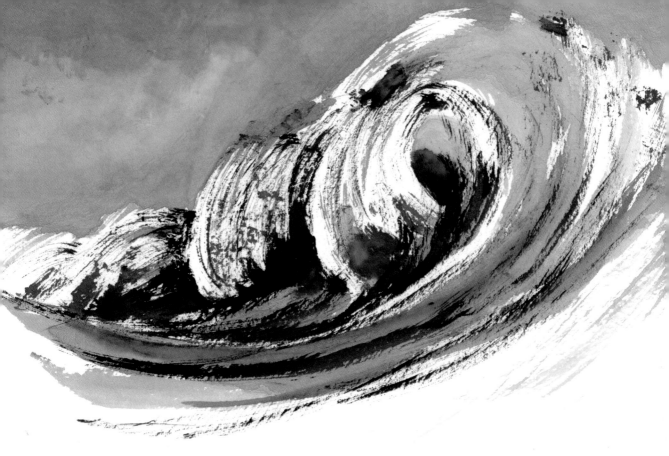

CHOPPY SEA

Choppy sea comes with choppy waves. You can paint waves using lines (see page 36), the press and lift technique (see page 43) and side brushstrokes (see page 51). Whichever way you use, it is more effective to use dry brushstrokes. A small Mountain and Horse brush will serve this purpose very well. I am using a combination of all three techniques in the illustration above. For beginners, it will be helpful to sketch your idea on the painting paper before putting down the brushstrokes, especially when attempting features with lots of sweeping movements. If you have a visual indication of what you are doing and where your brush is supposed to go, your movement will be more confident. I started with the sweeping curve in the front with my brush and dark ink. Then I added the peaks of the waves. Combinations of indigo, cobalt blue and diluted ink are used to create depth.

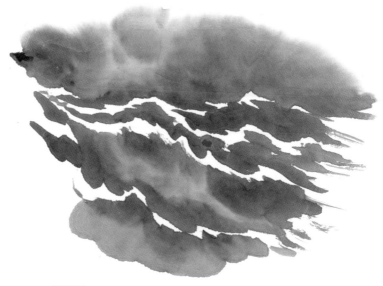

WAVES

You can also paint waves without lines, just using patches of colour. Leave the peaks blank to create a sense of movement.

Tumbling Waterfall

If you are painting a waterfall as the main feature, try to show the tumbling effect of the water pouring down with dry side brushstrokes and swift elbow movements. Vary the length of the side brushstrokes to make it more natural. A small Mountain and Horse brush is a perfect tool to use here.

HANGING WATERFALL

Use a dry small Mountain and Horse brush with dark ink. Paint the waterfall with dry side brushstrokes using swift elbow movement from top to bottom. Be firm with your brush. Do not hesitate. Lift the brush when you are approaching the end to give a hanging effect. Leaving the bottom part empty without any additional features will also create a hanging effect. You can use diluted colour to enhance the movement of the waterfall.

WATERFALL CONTINUES TO BECOME A FAST-MOVING RIVER

Now you can combine the two features, waterfall and river, together.

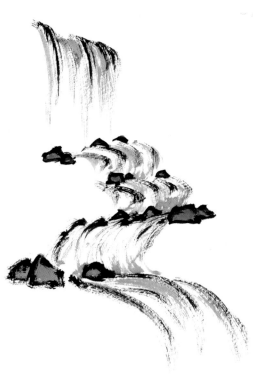

WATERFALL WITH TWISTS AND TURNS

When a waterfall has twists and turns, express this using levels interspersed with rocks. Usually big rocks cause the water to change course, creating the turns. Draw each twist and turn separately.

WATERFALL IN THE DISTANCE

A waterfall in the distance, in the background of the artwork, does not contribute movement to the overall composition so you can leave it blank and not add details.

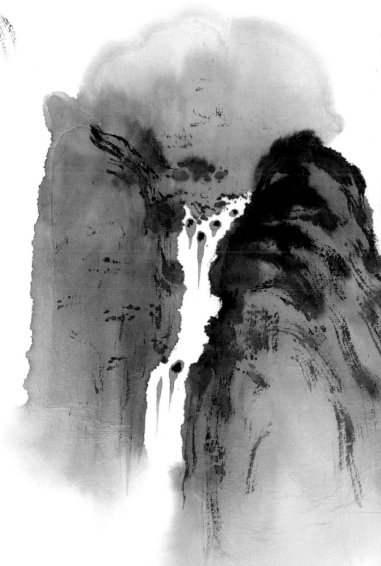

PAINTING A ROUGH SEA

COLOURS

Ink

Indigo

Cobalt Blue

Burnt Sienna

BRUSHES

Red Bean or small size Landscape brush

Small Mountain and Horse brush

Size 3 Leopard and Wolf or big size Landscape brush

Orchid and Bamboo brush

Here the rock was painted before the waves and then I used side brushstrokes to paint the waves. I used a mixture of diluted ink, indigo and cobalt blue to colour the sea. If you mix the three colours together in different proportions, you can create different shades of them, with even more interesting results. Leave some spaces without colour to create depth as well as the effect of light.

STEP 1
Use a Red Bean or small size Landscape brush and diluted ink to sketch the outline of the composition. Carefully draw the waves hitting the rock. This is important because when you start painting the rock, you have to know exactly where to leave blank space to create the water splashing against the rocks.

STEP 2
Use a small Mountain and Horse brush and dark ink to paint the rock. Be careful to work around the empty space representing the splashing water. Colour the rock with burnt sienna using a size 3 Leopard and Wolf or big size Landscape brush.

STEP 3
Load a small Mountain and Horse brush again with dark ink. Use sweeping lines and side brushstrokes to create the waves. Load a size 3 Leopard and Wolf or big size Landscape brush with diluted ink and add shading to those parts where the water levels are lower. This will enhance the rocking effect of the waves. Colour the water with a mix of indigo and cobalt blue. Leave some spaces blank to create the effect of light.

STEP 4
Start painting the sky by wetting the spaces you want to leave blank with clean water. Use a small size Orchid and Bamboo brush to apply partial washes between the wet blank spaces, using a mixture of diluted ink, indigo and cobalt blue.

STEP 5
When the painting is dry use a Red Bean or small size Landscape brush and dark ink to paint a few seagulls.

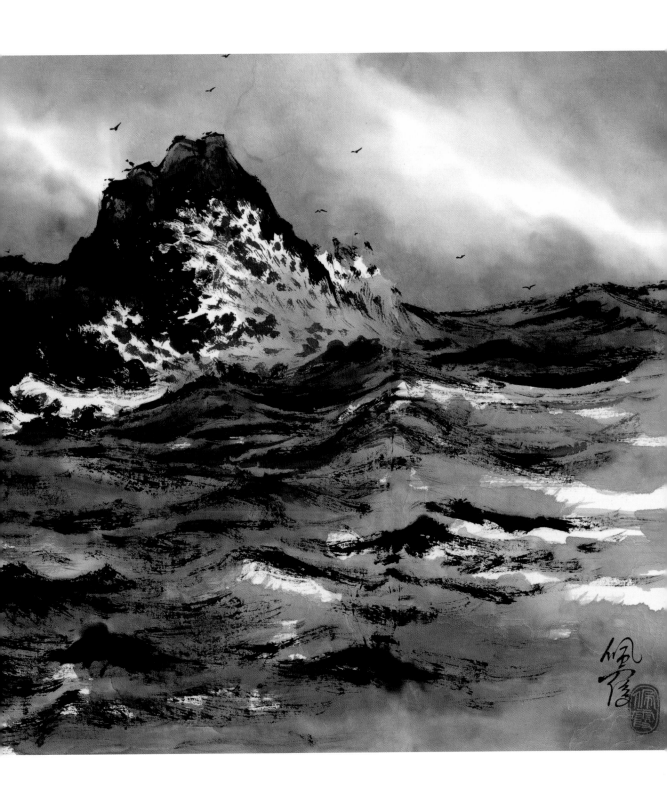

WATERFALL WITH TWISTS AND TURNS

Ink

Indigo

Burnt Sienna

BRUSHES

Red Bean or small size Landscape brush

Size 3 Leopard and Wolf or big size Landscape brush

Small Mountain and Horse brush

Painting this waterfall requires a light hand – if you put too many strokes into the water you will lose the sense of translucency and flow. The rocks can be given a heavier touch, with plenty of dry brushstrokes to capture their textures.

STEP 1
Use a Red Bean or small size Landscape brush and diluted ink to sketch the outline of the rocks and movement of the water. There are five levels in the waterfall.

STEP 2
Use a mixture of dry lines and side brushstrokes to paint the movement in the water. You can use a dry size 3 Leopard and Wolf or big size Landscape brush. Paint the movement of the waterfall level by level, starting from the top and moving downwards. Add the rocks along the waterfall with dark ink. Next use diluted ink and diluted indigo to enhance the movement. You can use the same brush for this purpose.

STEP 3
Use a small Mountain and Horse brush and dark ink to paint the big rocks on both sides and also in the middle of the waterfall. I used a mixture of long dots and short lines to paint the textures. Add vegetation wherever you feel it is appropriate. I used dots and brushstrokes with the press and lift technique for the vegetation. Colour the rocks with burnt sienna and indigo.

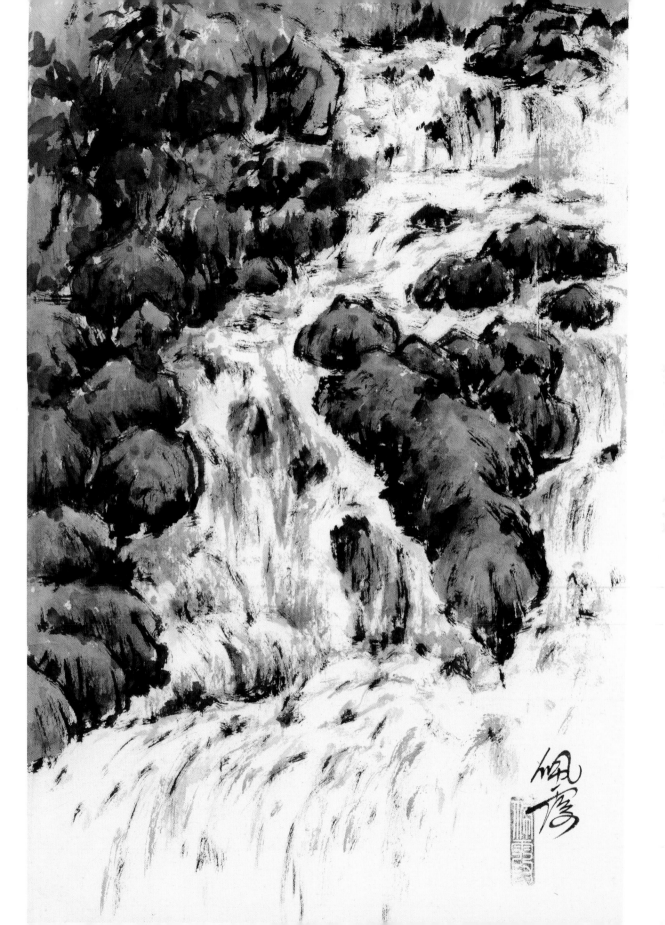

SKY, CLOUDS AND MIST

Although in most landscape paintings the sky is an accompaniment, its effect on the final presentation is important. The mood, the colour and the structure of the sky not only have to match the composition but also create the atmosphere. For example, a clear blue sky with a uniform wash matches a bright summer day while one with partial washes of grey and burnt sienna inspires a feeling of dull autumn. A few dry sweeping brushstrokes gives the sense of a breezy day while ink splattered on wet washes can convey an imminent storm.

Try to control the amount of effort you put into painting the sky in a composition. Overdoing it will throw the composition off balance. The principle is, if the other features are the focus of the composition, keep the sky simple – say, with a basic wash. If the sky is the dominating feature, paint the accompanying features in a simple style and reserve more elaborate brushstrokes, such as multi-colour washes and splattering techniques, for the sky. Mist is a popular feature in Chinese landscape painting. Many people think that Chinese artists have romanticized clouds and mist in their landscape paintings, but anyone who had seen the natural wonder of the skies in Guilin and Huangshan would become equally obsessed with painting them.

In this section I shall explain some basic techniques for painting sky. There are many more techniques, but you can start from these and use them to create your own ideas.

CLEAR SKY

Simply leaving the sky blank is one way to represent a clear sky, especially if the other features in the painting are colourful and strong. If you would like to colour the sky, a smooth wash is the best way. It need not to be a uniform wash. In fact, you can vary the tones of the colour or use two or more colours. Refer back to the section about washes for instructions (see page 56).

A Uniform Wash

In this example I use a mix of one part cobalt blue and two parts indigo for the wash. Leave blank space to create the moon or use process white to add it after the wash is dry.

Let me describe a very old technique for painting the moon, practised by most of the old masters. Traditionally artists use bowls or teacups, depending on the size of the moon in their painting. Chinese teacups come in a variety of sizes, with some as small as 4 cm (under 2 in) in diameter. The teacup is turned upside down on the paper in the position where the moon will be. The wash is applied to the paper in the normal way. The cup acts as a barrier to the wash, leaving a blank space to form the moon.

For this example I actually used a thin card circle instead of a teacup. I secured the circle on the paper with a tiny bit of plasticine. The piece of plasticine has to be tiny; otherwise there will be a gap between the card and the painting paper that allows the wash to run underneath. Apply the wash with a Goat-hair Hake or Ti brush. (Follow the instructions for creating a plain wash in the section on washes on page 56.) Press down the circle (or the teacup, if you are using one) as you apply the wash, and remove it when you have finished. You may have to touch up the edge of the circle, in this case with process white. You can also use this method to paint the sun, or to create blank spaces of any shape and size.

A Wash with Varied Tones

You can use several tones of a single colour to create this effect. Prepare all the different tones of the colour before you start painting the wash. The easiest way to do this wash is to start with a strip of wash made with clean water on the lower part of the painting. Then add a strip of the most diluted colour above the clean water, followed by a strip of the next most diluted colour. Continue in this manner, overlapping the strips slightly. If you do the strips in this order you will not have to clean the brush after each application. (If you had started with the darkest tone, you would have to rinse your brush clean every time you changed to a more diluted tone.) A Goat-hair Hake or Ti brush is the perfect brush for this kind of wash.

Alternatively, you can use the gradual toning technique described previously. Here you apply a partial colour wash next to a clean wet surface and allow the colour to blend and bleed into the wet area.

Multi-colour Wash

I used indigo, gamboge, burnt sienna and cadmium orange for the background wash here. A sunset sky always has a variety of colours like these. Either a small size Orchid and Bamboo brush or a Goat-hair Hake or Ti brush is fine for this job. Please refer to the instructions on creating a multi-colour wash on page 58.

Adding Movement

Even on a calm day there can be a slight movement in the sky. You can give the feeling of a breeze with a few side brushstrokes, using a dry Mountain and Horse brush or a dry Goat-hair Hake or Ti brush.

CLOUDS

There are three basic ways to paint clouds: with lines, by leaving empty spaces and by using brushstrokes.

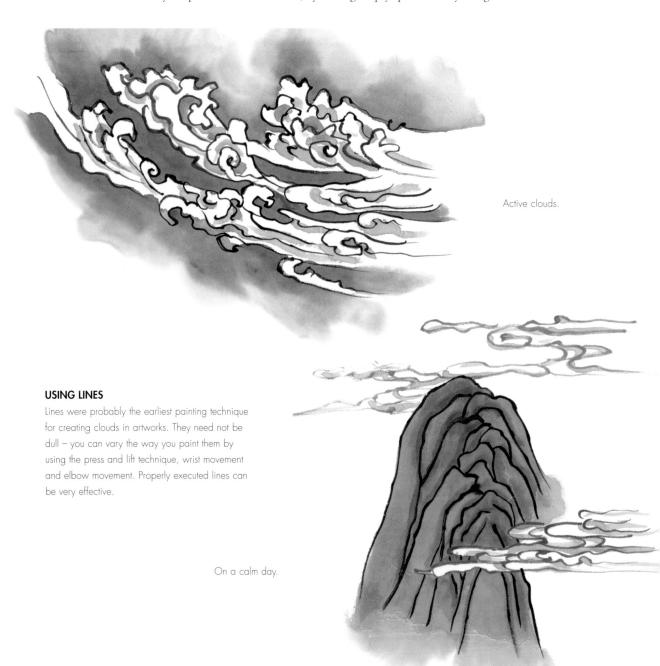

Active clouds.

USING LINES

Lines were probably the earliest painting technique for creating clouds in artworks. They need not be dull – you can vary the way you paint them by using the press and lift technique, wrist movement and elbow movement. Properly executed lines can be very effective.

On a calm day.

LEAVING SPACES

The simplest way to depict clouds is to paint the other features in the composition, leaving empty spaces on them that will be interpreted as covering clouds. Although simple, this technique can be dramatic as well. In this example, I wetted some of the edges of the empty spaces so that the wash could seep through. This gave a more interesting effect than solid blocks of clouds. I used a wash with many different blues. The different tones create a sense of movement in the sky.

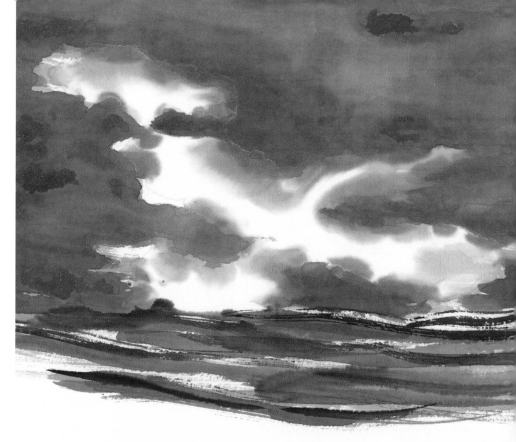

USING BRUSHSTROKES

This is the most popular way to paint clouds. You apply brushstrokes either when the paper is dry or on top of wet washes. I began by painting the sky with various tones of indigo. Then I heavily loaded a small size Orchid and Bamboo brush with dark ink to create the clouds, and then added more using diluted ink. The moon was added after everything was dry.

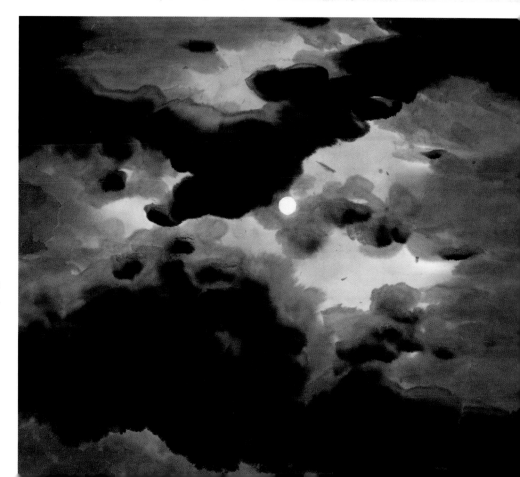

More Dramatic Techniques

You have to be adventurous to create dramatic effects, but you have to use your techniques well in order to make them work. The more techniques you know, the more effects you can create – there is no limit to what you can do. Here are just a few of the many ways of creating dramatic cloudscapes:

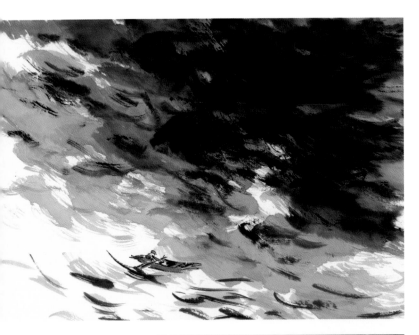

USING SHORT BRUSHSTROKES

I used a mixture of dry and wet brushstrokes with different tones of ink and different tones of burnt sienna here. The brushstrokes are heavier in the sky, forming the massive clouds, and run down into the lower part of the painting where the brushstrokes become fewer and more scattered to create the sea.

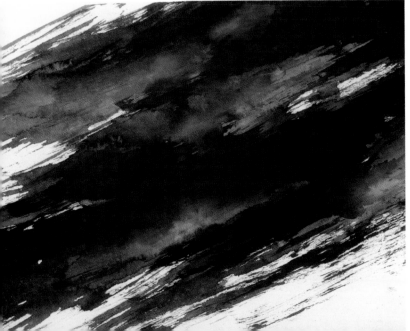

USING SWEEPING BRUSHSTROKES

Sweeping brushstrokes are very effective in creating a dramatic cloudscape. In this illustration I also used a unique technique that only works on alum-sized paper. I painted the clouds with sweeping brushstrokes using a small Mountain and Horse brush, first with diluted ink, then with dark ink. While the ink was still wet, I sprayed clean water lightly on a few spaces. When the water started running, I used a piece of tissue to wipe off the moisture on these spaces, creating this unique effect of mist among the clouds. The sweeping brushstrokes give the appearance of a blustery, stormy sky. The diluted ink and the dark ink merging into each other on alum-sized paper give the impression of heavy rain gathering in the clouds. Wiping off some of the ink creates a misty effect, giving a humid feeling that adds to the atmosphere of a storm brewing.

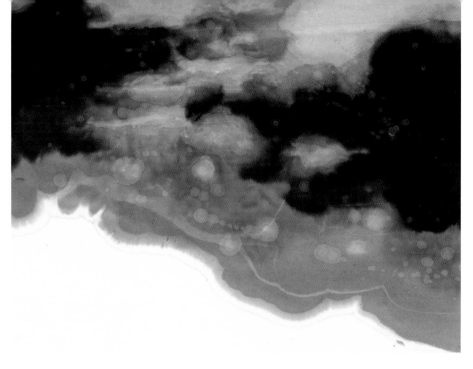

USING PROCESS WHITE

I used the splattering technique to paint the clouds, using two tones of ink. Then I loaded a small size Orchid and Bamboo brush heavily with process white and sprinkled it randomly on the wet areas. The effect is very dramatic, as if bright weather is going to break shortly, and the moon is hiding somewhere.

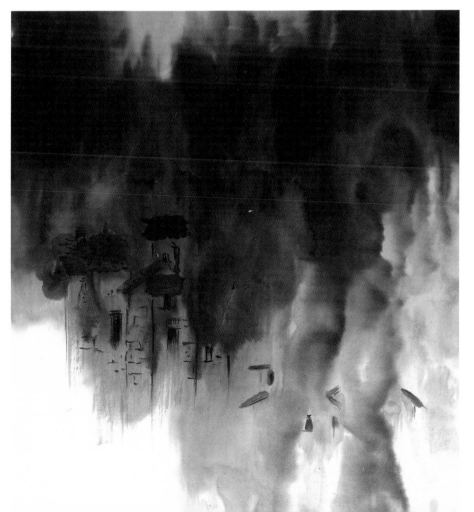

VERY WET BRUSHSTROKES

Here I wetted the upper part of the paper with diluted ink and the lower half with clean water. Then I splattered dark ink heavily onto the upper part of the painting to create the dark clouds. Clean water was sprayed along the lower edges of the dark ink. I then tilted the paper with the dark clouds on the upper side of the paper. This encouraged the dark ink to run down, creating this very wet and fuzzy atmosphere. Black clouds and pouring rain were indistinguishable from one another in this dramatic composition. The houses were added after everything was dry.

PAINTING A THREATENING SKY

COLOURS

Ink

Indigo

Burnt Sienna

Cadmium Red

BRUSHES

Red Bean or small size
Landscape brush

Small Mountain and
Horse brush

Size 3 Leopard and
Wolf or big size
Landscape brush

Orchid and Bamboo
brush

No.1 Wolf-hair brush

I used dry side brushstrokes to paint the raging clouds here.

STEP 1

Use a Red Bean or small size Landscape brush and diluted ink to sketch the outlines of the shore and the boats.

STEP 2

Use the same brush and dark ink to draw the boats.

STEP 3

Paint the shore with a small Mountain and Horse brush and dark ink using the press and lift technique. Clean this brush and load it with medium ink. Add patches of brushwork with side brushstrokes.

STEP 4

Load the same brush with diluted ink and paint sweeping side brushstrokes on the sky. Clean the brush and load it with indigo to add more sweeping side brushstrokes. Dip the brush into dark ink. Dry excess ink on a piece of paper towel and add a few side brushstrokes to the sky.

STEP 5

Colour the Chinese boats with burnt sienna. Add a few patches of indigo to the water to reflect the colour of the sky, and also colour the shore with indigo. Use a size 3 Leopard and Wolf or big size Landscape brush to apply these colours.

STEP 6

Make up two tones of cadmium red, one diluted and one darker. Paint the lower sky with these two tones. Add some diluted cadmium red to the water to reflect the colour of the lower sky. Use a small size Orchid and Bamboo brush to apply these colours. Use a No.1 small Wolf-hair brush and undiluted cadmium red to add some final touches to the boats.

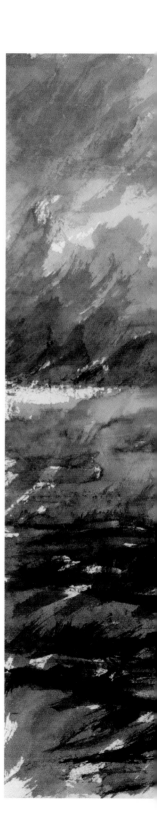

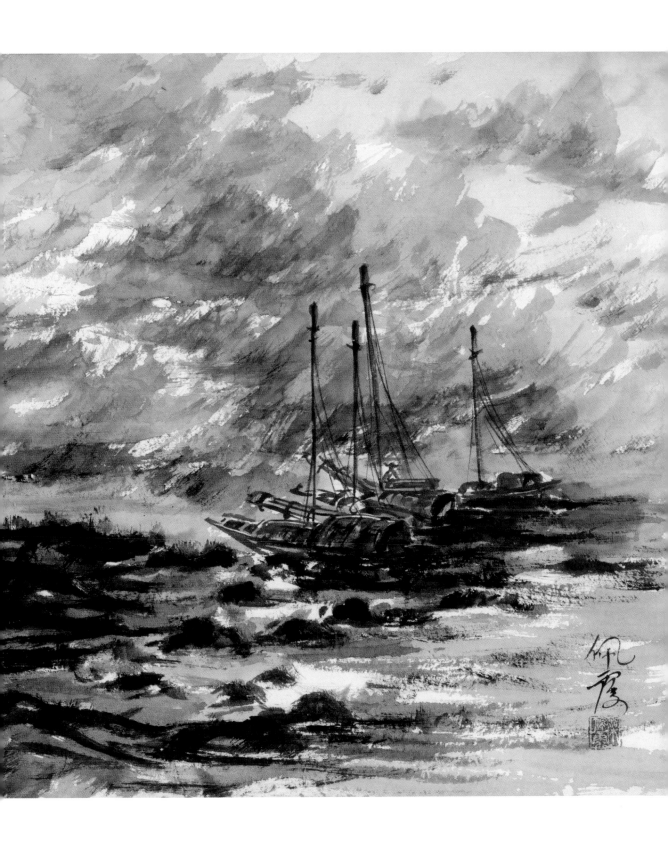

SUNSET

Ink

Indigo

Gamboge

Cadmium Orange

BRUSHES

Goat-hair Hake or
Ti brush

Orchid and Bamboo
brush

Size 3 Leopard and
Wolf or big size
Landscape brush

This painting looks very complicated but is in fact very easy and fun to paint.

STEP 1
Prepare gamboge, cadmium orange and a diluted indigo. The colours should be ready before you start the painting. Use a Goat-hair Hake or Ti brush to apply partial washes of these three colours to the entire paper.

STEP 2
Prepare three tones of ink: dark, medium and diluted. Use a small size Orchid and Bamboo brush to splatter diluted ink onto the wet washes. Repeat with medium ink. The ink will run and form the fluffy clouds. Finally splatter dark ink to add more clouds.

STEP 3
Wait for the painting to dry. Now use a size 3 Leopard and Wolf or big size Landscape brush and dark ink to add the birds.

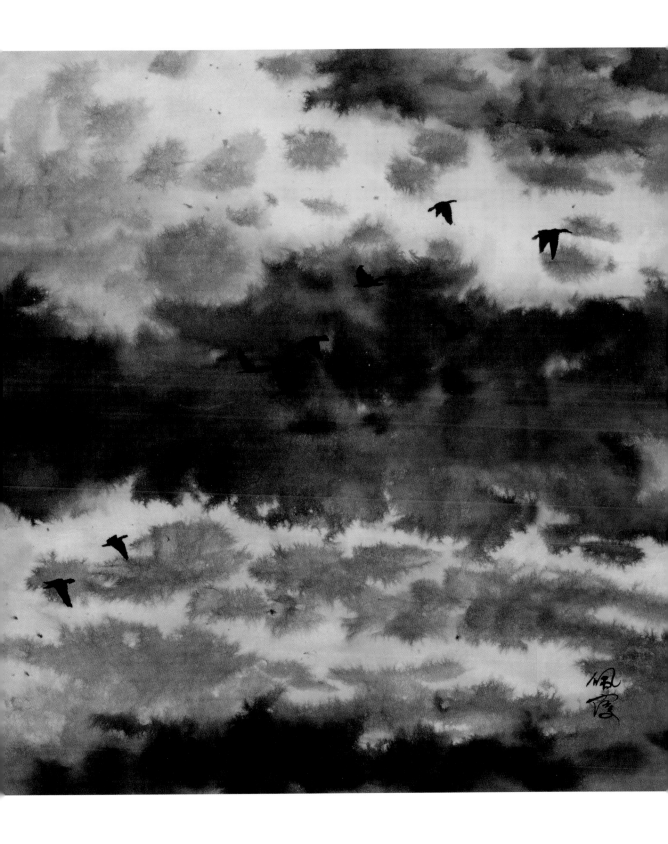

MIST

When clouds get very thick and low they form a mist. As with clouds, you can paint mist with lines or by leaving blank spaces. You can combine lines or empty spaces with using a gradual toning technique to paint the mountains, as the following example illustrates. However, most artists favour the use of the dry brush technique to paint mist. This technique requires more work, and I will guide you through it later on.

Leaving Empty Spaces

The simplest approach to using this technique is to simply paint the features, such as the mountains and cottages, leaving spaces on them to be interpreted as foreground mist or fog. You will need to plan this carefully before you start painting the features.

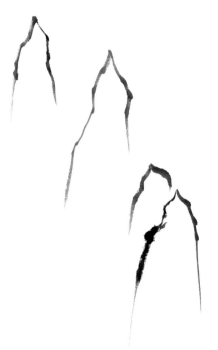

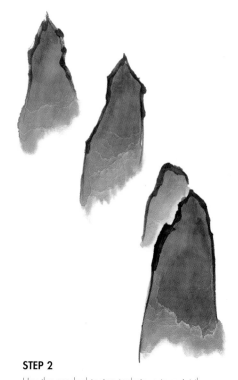

STEP 1

Use a Red Bean or small size Landscape brush and ink to start by drawing the outlines of the mountains. You can add texture to the mountains if you want.

STEP 2

Use the gradual toning technique to paint the mountains or features, one at a time. I usually start from the foreground features and work backwards. If the mountains are close together, wait for the one in the front to dry before painting the one behind it.

Dry Brush Technique

This is the method most artists use for painting mist. The advantage of this technique is that you can control the development of the composition. Using a dry brush to rub or to paint long dots along the edge of the misty areas produces a soft and fluffy appearance. We generally use two tones of ink, or ink and a colour. Use a colour that matches the mood of the painting – for example, burnt sienna for sunset and indigo for a colder atmosphere. For a more refined and elaborate approach, we use ink and two colours, usually burnt sienna and indigo, because these two colours are the colours used to paint mountains, where mist is always found.

USING DRY BRUSH WITH INK

You can use the brush to rub or to paint long dots along the edges of the mist. Use a dry brush for either of these techniques. When you are rubbing, hold the brush slightly at an angle, and rub the dry brush against the paper where you want the brushwork to be.

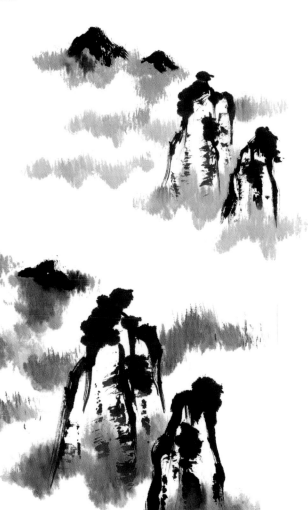

STEP 1

Use a dry size 3 Leopard and Wolf or big size Landscape brush and diluted ink. Use long dots to build up the edges of the mist. Alternatively, rub with a dry brush and diluted ink to build up the edges of the mist. Work the edges a bit further into the mountains.

STEP 2

Add a tiny bit of dark ink to darken the diluted ink. Use this mix to add more dots on the lower edges and paint the inner parts of the long dots with diluted ink. Alternatively, use rubbing. This will create a two-tone effect.

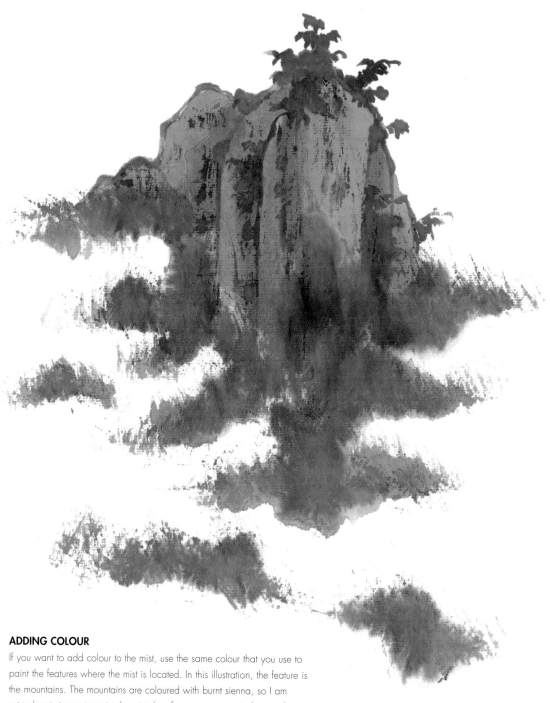

ADDING COLOUR

If you want to add colour to the mist, use the same colour that you use to paint the features where the mist is located. In this illustration, the feature is the mountains. The mountains are coloured with burnt sienna, so I am using burnt sienna to paint the mist, but if you were using indigo as the dominant colour for the mountains, you would use indigo for the mist. I am using rubbing instead of long dots in this example. After the two steps of rubbing with diluted ink and medium ink, repeat the same process using a diluted colour.

Elaborate Style

For a more elaborate style, use two or three colours instead of one. A painting with mist as the dominating feature deserves this treatment.

The colours used in steps 2 and 3 can be interchanged, depending on the dominant colour in your painting. For example, if the overall mood of the painting is warm, use indigo in step 2 and burnt sienna in step 3 so that the resulting mist will have more burnt sienna than indigo. If you want to have a cooler atmosphere, then use burnt sienna in step 2 and indigo in step 3.

STEP 1

Using a dry size 3 Leopard and Wolf or big size Landscape brush and diluted ink, sketch the position of clouds with long dots instead of lines. These dots will form the peaks and troughs within the contours of the mist. Use a slightly darker ink to add more long dots to the troughs. This darkening pushes them into the shadow to provide more depth to the mist.

STEP 2

Using the same dry brush and diluted burnt sienna, add long dots to expand the edges of the existing dots a bit more.

STEP 3

In the same manner, use your brush and diluted indigo to add long dots to expand the edges of the clouds even further.

MOUNTAINS IN THE MIST

COLOURS

Ink

Indigo

Burnt Sienna

Sap Green

Gamboge

BRUSHES

Red Bean or small size
Landscape brush

Orchid and Bamboo
brush

Size 3 Leopard and
Wolf or big size
Landscape brush

I made this sketch when I visited Guilin.

STEP 1
Use a Red Bean or small size Landscape brush and diluted ink to sketch the rough outline of the composition.

STEP 2
Use your brush and dark ink to draw the houses at the front. Add more houses in diluted ink. Colour the houses with burnt sienna. Clean your brush and paint some trees with sap green. Add more trees with diluted sap green.

STEP 3
Draw the cows and shepherd with dark ink and the same brush. Colour the cows with burnt sienna. Colour the shepherd with burnt sienna, indigo and gamboge.

STEP 4
Prepare indigo and a diluted indigo, and a slightly less diluted indigo. Paint the mountains starting with the one at the front, just behind the houses. Use the technique of gradual toning along the edge of the mist. Wait for the mountain to dry then add the mountain immediately behind it. Continue to add successive mountains from the front to back using the gradual toning technique. Vary the tones of indigo on different mountains. If the area of the mountain is big, use a small size Orchid and Bamboo brush. Alternatively, you will find that it is easier to control the application of colour using a size 3 Leopard and Wolf or big size Landscape brush.

STEP 5
Use the gradual toning technique to paint the shores and the water in the lower half of the painting with a size 3 Leopard and Wolf or big size Landscape brush. Use a dry Red Bean or small size Landscape brush to add a few sweeping lines to finish.

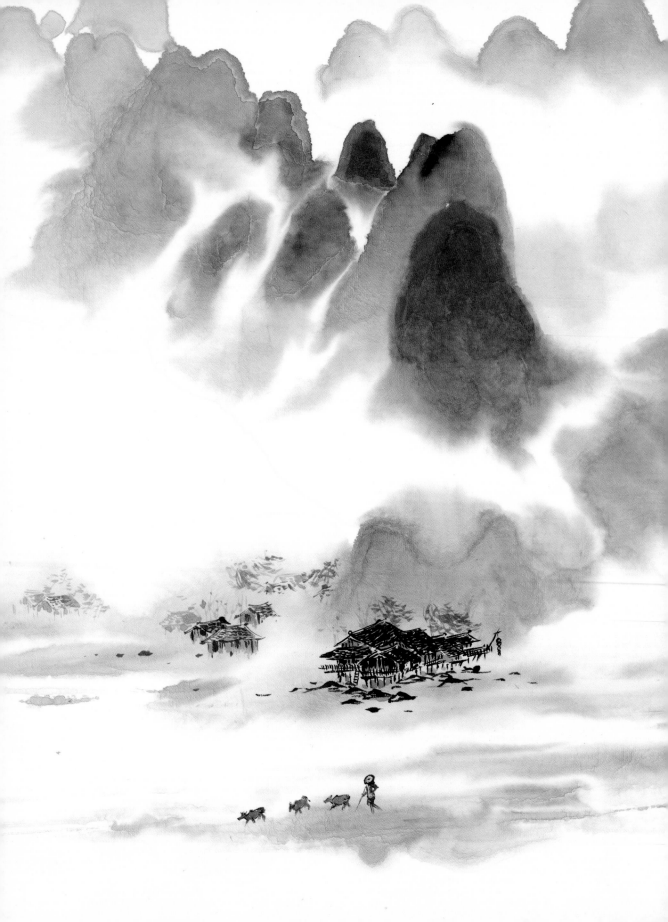

PAINTING A SEA OF CLOUDS

COLOURS

Ink

Indigo

Burnt Sienna

BRUSHES

Red Bean or small size
Landscape brush

Orchid and Bamboo
brush

Goat-hair Hake or
Ti brush

STEP 1
Use a Red Bean or small size Landscape brush and diluted ink to sketch the mountains. Dry the brush. Use the brush with diluted ink to sketch the outline of the clouds with long dots.

STEP 2
Paint the mountains with the traditional five steps for painting rocks and mountains (see page 98).

STEP 3
Paint the sea of clouds with the elaborate three-colour method (see page 135) using ink, indigo and burnt sienna in that order.

STEP 4
Paint the sky with burnt sienna using the gradual toning technique. It is more practical to use either a small size Orchid and Bamboo brush or a Goat-hair Hake or Ti brush to paint the sky.

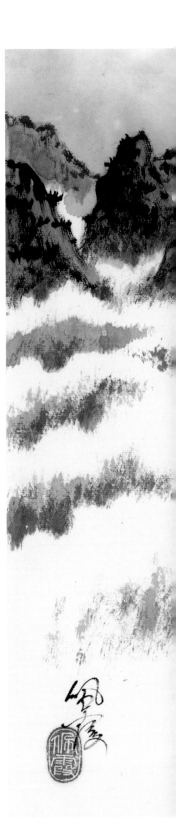

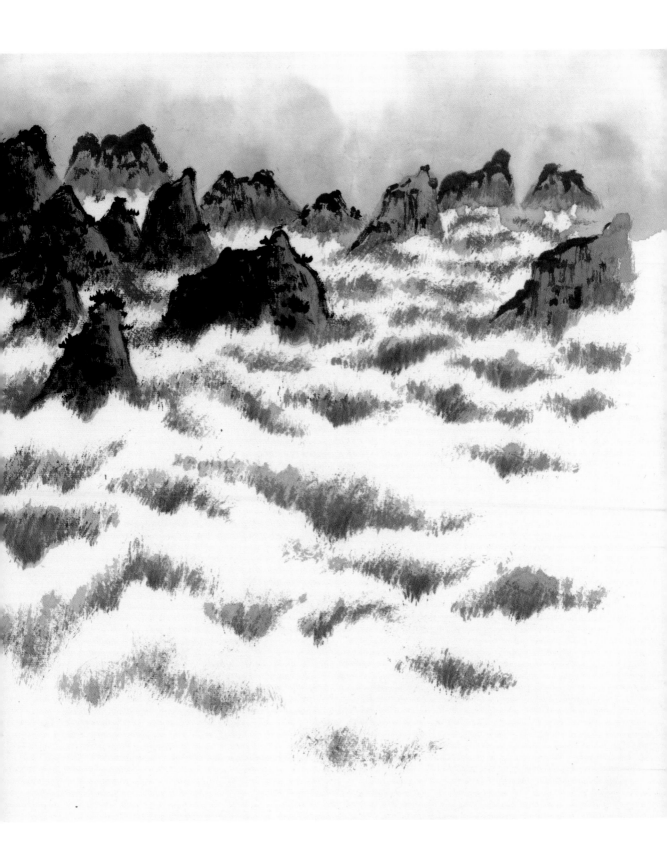

4 MOODS AND SEASONS

Moods and seasons have already come up a great deal as we have covered the various techniques and approaches, but in this chapter I will deal with some specific scenarios. Eight topics will be discussed here, each accompanied by a painting. I shall use what you have learned so far to tackle each painting and outline all the necessary steps.

It is always good practice to start a painting with a rough sketch so that everything will be in the right position. The sketch need not be in detail. You can use a small brush and diluted ink to sketch or alternatively use light pencil lines, but do avoid rubbing the paper too often with an eraser because you can damage the delicate surface of Xuan paper by repeated rubbing.

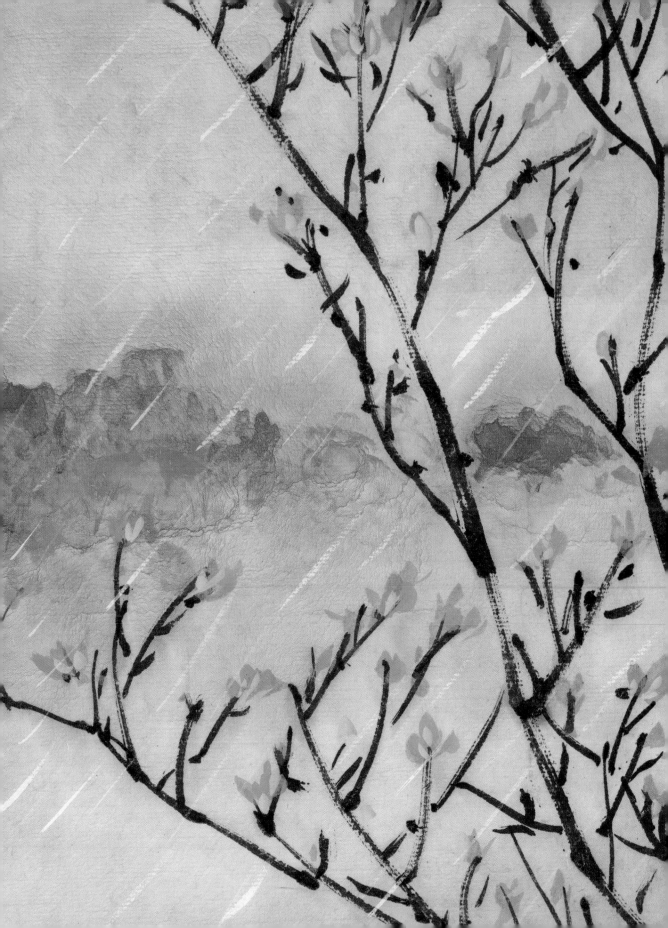

WIND

COLOURS

Ink

Indigo

Burnt Sienna

Gamboge

Cadmium Red
Process White

BRUSHES

Red Bean or small
size Landscape brush

Orchid and Bamboo
brush

Small Mountain and
Horse brush

The simplest way to paint wind is to use dry brushstrokes to suggest movement in the sky, but using features to create the movement of wind is equally effective. In this painting I use the movements of the trees to create the impression of a windy autumn day.

STEP 1
Start with a sketch of the houses using a Red Bean or small size Landscape brush and diluted ink. Dip the same brush into dark ink and paint the trees. Use sweeping movements to indicate the trees being blown by the strong wind.

STEP 2
Paint the houses at the front with medium ink. Then use diluted ink to paint those in the distance on the right-hand side (see below). I used medium and diluted ink to paint the houses and dark ink for the trees to keep the houses in the background. Add colours to the houses using a mixture of diluted indigo and diluted burnt sienna. Paint the reflections in the water using side brushstrokes. Match the colours of the reflections with those of the houses.

STEP 3
Load a small size Orchid and Bamboo brush with clean water and wet a few patches of the sky. Then paint the sky with sweeping side brushstrokes using a small Mountain and Horse brush and burnt sienna. Use a mixture of diluted burnt sienna and medium burnt sienna to create variations. Use this same method to add colour to the water. The wet water patches will dilute the colour further, making the sky and the water even more interesting.

STEP 4
Prepare three colours: gamboge with a little bit of process white added to it, plain gamboge and cadmium red. When the painting is dry, load a small size Orchid and Bamboo brush with gamboge and paint the leaves using small brushstrokes with the press and lift technique. Point the handle of the brush in the direction the wind is blowing so that the lifts will be on the tail side of the wind. Add more leaves with the paler gamboge and cadmium red.

PAINTING A HOUSE

STEP 1
Sketch the outline of a house with diluted ink using a Red Bean or small size Landscape brush.

STEP 2
Load a size 3 Leopard and Wolf brush with medium ink. Paint the roof and add shadows to the house, like those in the windows.

STEP 3
Darken the ink a little bit and use it to add a few details, such as the windows, the bricks and the base.

STEP 4
Add colour to the house.

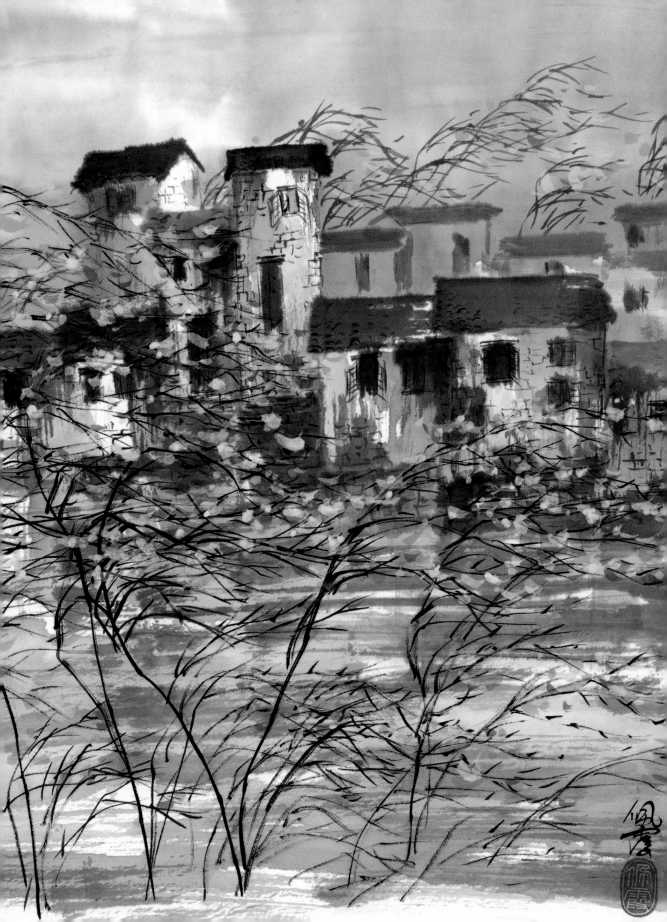





RAIN

Ink

Sap Green

Indigo

Process White

BRUSHES

Size 3 Leopard and
Wolf or big size
Landscape brush

Red Bean or small
Landscape brush

Goat-hair Hake or
Ti brush

Orchid and Bamboo
brush

I have already illustrated how to paint heavy rain and
storms, but actually I find light and gentle rain very
soothing and equally appealing, so I am going to show
you how to paint this kind as well. This painting depicts
the middle of spring, when many trees already have leaves
but others still have bare branches with leaves just starting
to appear. The tree in the foreground is coming into leaf.
I have used light green for the overall atmosphere in this
painting because that is a very appropriate colour for spring.

STEP 1

Start painting the trees in the foreground with dark ink.
Use a size 3 Leopard and Wolf or big size Landscape brush
for the thicker branches and a Red Bean or small Landscape
brush for the thinner ones. Make sap green and another
green with a little process white added to it. Load your
brush with these colours to add some leaves to the branches.

STEP 2

When the trees are dry, prepare two tones of diluted
sap green with one more diluted than the other. Make
two tones of diluted indigo in the same manner. Use
these colours to apply washes to the whole paper using
a Goat-hair Hake or Ti brush.

STEP 3

While the washes are still damp, use a small size Orchid and
Bamboo brush to add the trees in the background with
dots using indigo and sap green. Do not make the colours
too strong or you will spoil the hazy and misty atmosphere
of rain. Let the painting dry.

STEP 4

Add some bare trunks among the trees in the background
with a Red Bean or small size Landscape brush and diluted
ink. Paint the rain following the instructions given below.

PAINTING RAIN

Paint a background wash with sap green using a Goat-hair
Hake or Ti brush and let it dry. Dip a Red Bean or small
size Landscape brush into the undiluted process white and
use thin, short lines to paint the rain. Point all lines in the
same direction. Dilute a small quantity of process white and
add some more thin short lines.

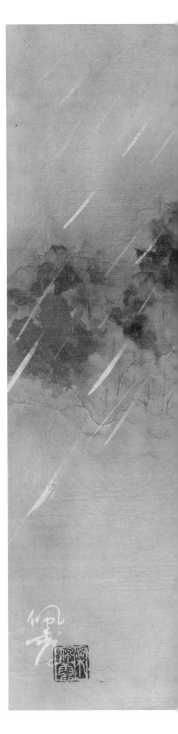

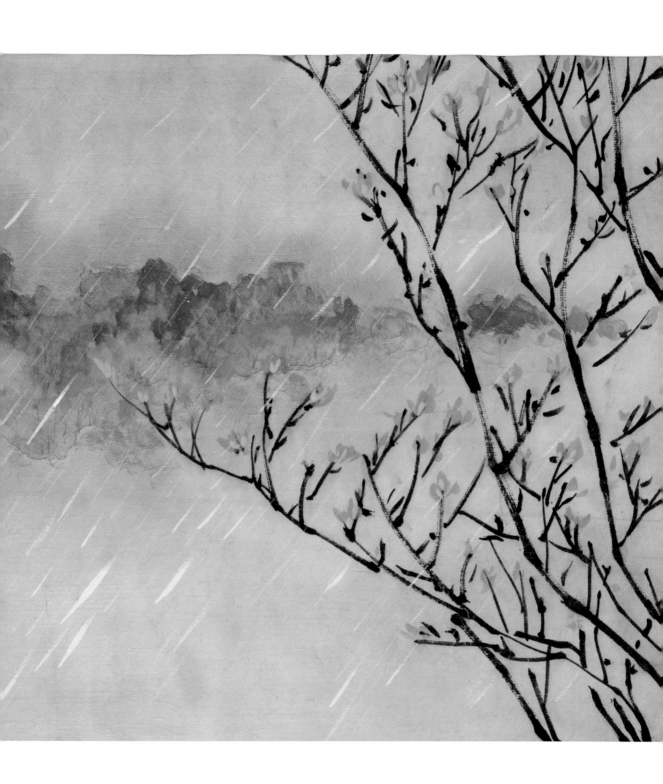

FOG

Ink

Indigo

Alizarin Crimson

Cadmium Orange

Gamboge

Sap Green

Process White

BRUSHES

See instructions

A thick mist will hide anything in its path, but in a thin fog you can still make out some features. I have recorded such an occasion in this painting of the Hong Kong harbour.

STEP 1
Start with a sketch. Outline the harbour and buildings with a Red Bean or small size Landscape brush and diluted ink.

STEP 2
Load a size 3 Leopard and Wolf or big size Landscape brush with medium ink. Use it to paint the harbour beneath the mountains and a bit of the lower part of the mountains. While the medium ink is still wet, use a small Mountain and Horse brush to paint the mountains with dark ink up to the edge of the medium ink, so that the two tones of ink run into each other. Note that I included some mist among the mountains at the back. Paint this mist using the technique of gradual toning or soft edges (page 61). Add a few vessels in the harbour with their reflections in the water using medium ink and a Red Bean brush or small size Landscape brush. All the parts painted with the medium ink will be places where the thin fog will be.

STEP 3
Load a small size Orchid and Bamboo brush with diluted ink and apply to places in the lower part of the painting, where the fog is. While the diluted ink is still wet, use dark ink to add the buildings up to the edge of the fog. Use a size 3 Leopard and Wolf or big size Landscape brush for the larger parts and a Red Bean or small size Landscape brush for the smaller parts. Wait for the painting to dry before the next step.

STEP 4
When the painting is dry, paint the sky with indigo and the sea with diluted indigo using a Goat-hair Hake or Ti brush. Let the colours dry. When the painting is dry, use a Red Bean or small size Landscape brush to paint the lights, first with process white, then with the different colours over it. This method is outlined on the opposite page. Let the painting dry completely.

STEP 5
Mix one part process white with one part clean water. You can add more process white to the mixture if you prefer a thicker fog. Use a small size Orchid and Bamboo brush to apply a wash on the area where the fog is, along the harbour, on the surface of the water and at the lower part of the buildings. You need to be careful, because when you apply process white to absorbent paper, the white mixture very often sticks to the paper underneath your painting. You will then have difficulty in peeling the painting paper off the underlying paper and may tear your precious masterpiece. You can avoid this kind of disaster if you put clean paper towels under the painting. They usually have an embossed pattern, and the white paint cannot stick to it.

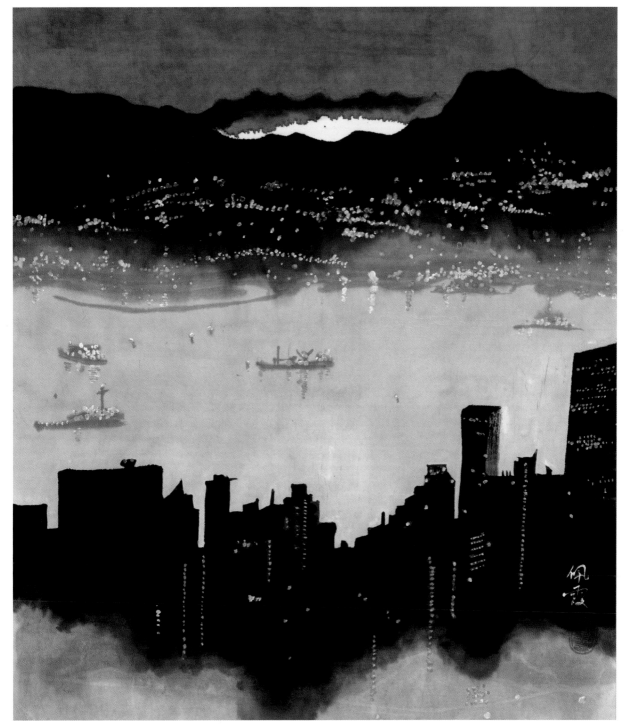

PAINTING LIGHTS

Load a Goat-hair Hake or Ti brush with medium ink and paint a wash for the background. Dip a Red Bean or small size Landscape brush into a thick process white and dot it around on the area where the lights are going to be. Let it dry, and then apply different colours on top of the process white. This is a method used by artists if they want the colours to be brighter. The process white acts as a barrier to the absorbent paper, so colours on top of it will be brighter. If you paint the colours directly on the absorbent paper, they will be absorbed into the paper and will not stand out.

SNOW

COLOURS

Ink

Indigo

Cobalt Blue

Alizarin Crimson

Gamboge

Process White

BRUSHES

Red Bean or small size
Landscape brush

Size 3 Leopard and
Wolf or big size
Landscape brush

Orchid and Bamboo
brush

Goat-hair Hake brush

The simplest way to paint snow is to use process white to add snow on a painting after all the features are finished. Another way is to leave spaces to represent snow. Most Chinese artists use the second way to paint snow and add just sufficient process white to provide highlights. However, this technique requires careful planning, experience and a spirit of adventure.

STEP 1
Mark the outline of the composition using a Red Bean or small size Landscape brush and diluted ink. Load a size 3 Leopard and Wolf or big size Landscape brush with dark ink and paint the tree at the front. Remember to leave blank spaces for the snow – follow the method described below. Paint a second tree at the back, this time using medium ink. Add two more trees to the right with medium ink, following the same method.

STEP 2
Use a Red Bean or small size Landscape brush and dark ink to sketch the outlines of the cottages. Clean the brush and use it to add a little diluted colour to the cottages. I used diluted alizarin crimson, diluted gamboge and diluted indigo. Dip a size 3 Leopard and Wolf or big size Landscape brush into dark ink and add further trees in the distant background. I used long dots to build up the trees.

STEP 3
Mix one part cobalt blue with two parts indigo. Use a small size Orchid and Bamboo brush to apply clean water to the parts of the sky where you want the clouds to be. Paint the rest of the sky with the blue mix. Leave blank spaces for the snow on all the trees.

STEP 4
Use a Goat-hair Hake or Ti brush to sweep a few side brushstrokes with diluted ink and then with diluted indigo in the foreground. Leave space to show the snow. Mix a thick process white. Use this white to dot flakes of snow with a small size Orchid and Bamboo brush.

LEAVING SPACE TO CREATE SNOW

STEP 1
Mark out the framework of a tree with diluted ink and a Red Bean or small size Landscape brush.

STEP 2
Load a bigger brush with dark ink. Paint the leaves. Apply the ink on only half of each group of leaves, usually the lower half, and leave the upper half blank to be the spaces for snow. You can use a mixture of medium ink and dark ink to create tones.

STEP 3
Paint the background around the original sketch of the tree, taking care not to touch the snow created by the blank spaces.

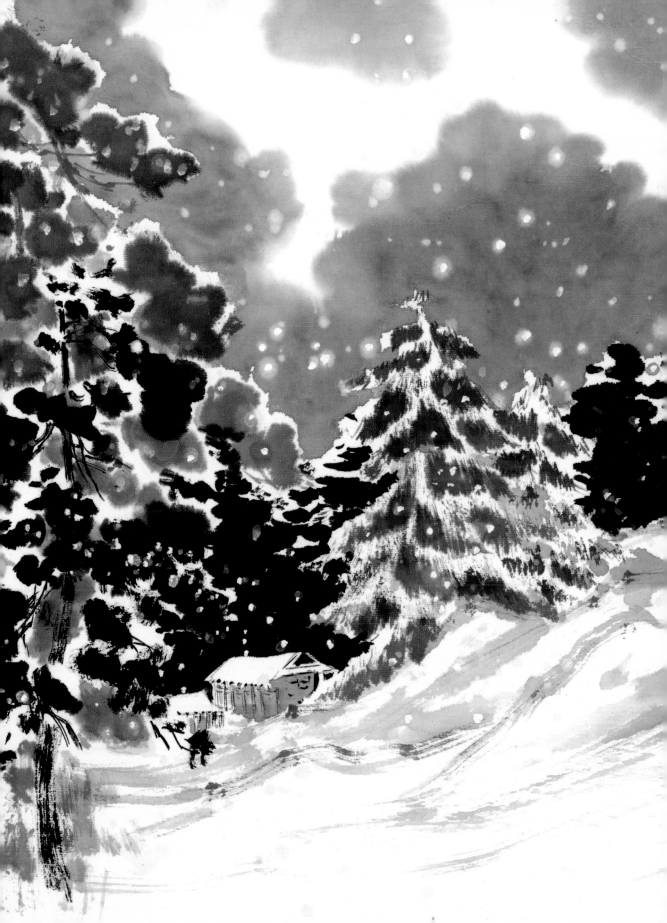

COLOURS

Ink

Permanent Rose

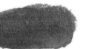

Alizirin Crimson

Burnt Sienna

Cobalt Blue

Indigo

Lemon Yellow

Gamboge

Sap Green

SPRING

Spring is a time of blossoms and sprouting green leaves. The weather can be sunny or grey, and there can be drizzling rain and strong wind. There are spring blossoms in my example. The colours of the blossoms are blurred by the damp weather, the wind is blowing the petals around and you can see bare twigs dotted with sprouting leaves. (I prefer a cold, light green for painting spring, so I mix lemon yellow with sap green instead of using gamboge.)

STEP 1
Sketch the framework of the branches and the pagoda using a Red Bean or small size Landscape brush and diluted ink. Paint the blossoms following the method outlined below. Instead of ink (as used in the illustration below about painting blossoms), I used a mixture of two parts burnt sienna with one part ink to paint the branches.

STEP 2
Draw the outline of the pagoda with the same brush, using dark ink. Add the colours. You can use different colours if you prefer.

STEP 3
Draw the outlines of a few trees in the background using diluted ink and the same brush. Mix one part lemon yellow with two parts sap green. Dilute this mixture and add leaves to the trees using a size 3 Leopard and Wolf or big size Landscape brush. Dilute this green further. Fully load a small size Orchid and Bamboo brush with this mixture and heavily dot the background behind and around the blossoms. This colour gives the background a damp and light feeling of spring. Now add the blossoms as explained below. Add homecoming birds using a No.1 small Wolf-hair brush and dark ink.

PAINTING BLOSSOMS

STEP 1
Mix a diluted permanent rose. Mix also one part permanent rose with two parts alizarin crimson and dilute this mixture. Fully load a small size Orchid and Bamboo brush with diluted permanent rose and paint patches of colour on the paper to represent the blossoms. Then fully load the brush again, this time with the diluted mixture of permanent rose and alizarin crimson, and add more patches. Let the colours dry a little bit.

STEP 2
While the blossoms are still damp, fully load the same brush with alizarin crimson and dot colour on the patches previously painted with the mixture of permanent rose and alizarin crimson. These dots will run in the wet patches, creating more tones. Let the colours dry.

STEP 3
When the colours are dry, dip a Red Bean or small size Landscape brush into dark ink and add the branches. Let the ink dry.

STEP 4
Add patches of very diluted ink to create further shading.

SUMMER

COLOURS

Ink

BRUSHES

See instructions

Everything is lush and thick in summer. Trees are heavily laden with green. Weather can be unpredictable, with scourging heat one moment and torrential rain the next, and even storms. Instead of a sunny scene, which I hope by now you can do perfectly well without my help, I shall paint you a very wet and windy summer storm. I chose to paint it entirely with ink, but if you want to use colours for this example you can apply washes of dark green and sap green instead of the different tones of ink.

STEP 1

Sketch the trunks of the trees with diluted ink using a Red Bean or small size Landscape brush. Paint them with sweeping brushstrokes to create the effect of strong wind.

STEP 2

Dip a Goat-hair Hake or Ti brush into dark ink and use sweeping side brushstrokes across the paper to create the wind movements. Make some side brushstrokes long and some shorter. Let the ink dry.

STEP 3

When the dark ink is dry, use the same brush to apply partial washes with medium ink and also diluted ink to create a wet feeling. Before applying the washes, wet the parts intended to be left untouched with clean water. Heavily load a small size Orchid and Bamboo brush with diluted ink and dot it on the wet surface. These dots make the atmosphere look wetter.

The wind before washes are added.

STEP 4

Load a size 3 Leopard and Wolf or big size Landscape brush with medium ink and paint the riverbank using lines. Hold the brush at an angle to the paper with the handle pointing in the direction the painting movements travel and press the brush down when you paint so that the lines are thick. Vary the lengths of the lines. Wait for everything to dry before the next step.

STEP 5

Retrace the tree trunks with dark ink using the same brush, and add leaves to the trees with side brushstrokes. Add some more leaves hidden in the clouds in the distance on the upper left and right sides.

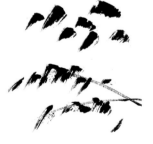

Paint the leaves using short side brushstrokes with the press and lift technique.

STEP 6

Paint a few houses along the waterfront with dark ink using a No.1 small Wolf-hair brush.

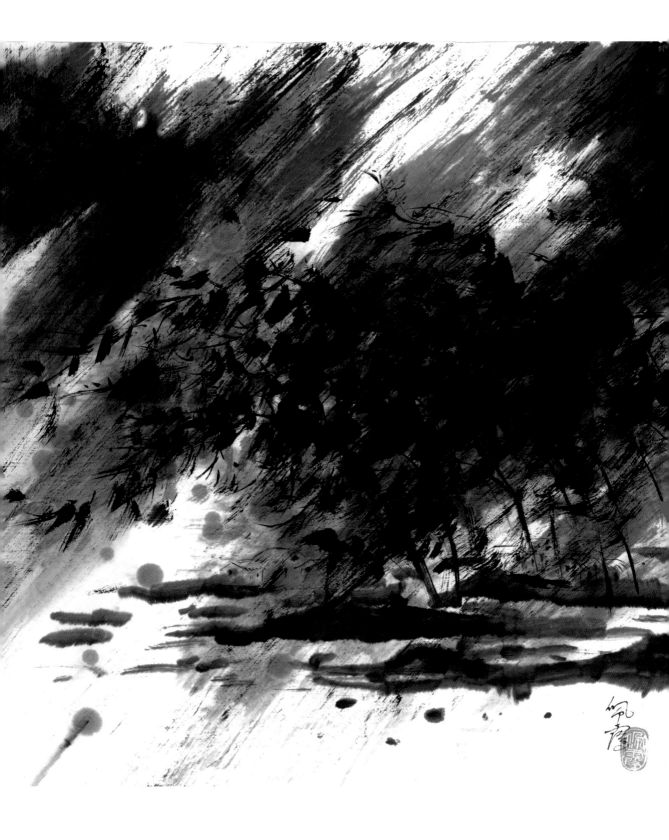

AUTUMN

COLOURS

Ink

Sap Green

Indigo

Burnt Sienna

Gamboge

Cadmium Orange

BRUSHES

Red Bean or small size Landscape brush

Size 3 Leopard and Wolf or big size Landscape brush

This is a painting of autumn in Jiuzhaigou Valley. The place is famous for its breathtaking autumn landscapes. I used strong colours for the main features to make them stand out. The cottages are painted in ink, and the water is left white against the bright colours of the trees.

STEP 1

Start with a sketch using a Red Bean or small size Landscape brush and very diluted ink to plan out the positions of the cottages, the water and the trees. There are going to be a lot of trees to be dealt with. Use the same brush to paint the cottages with dark ink and use a size 3 Leopard and Wolf or big size Landscape brush to colour them with burnt sienna.

STEP 2

Now add the trees. There are basically three levels of trees: those at the front; then the ones in the middle where the cottages stand, and finally those in the distance. In order to make the colours more intense I used a double-colouring technique that is explained below.

STEP 3

Now it is time to trace the movements of the water and paint them properly. Use a dry Red Bean or small size Landscape brush to paint the river and waterfalls with medium ink and diluted indigo. Start from the background and follow the flow of the different tracks. Don't overdo with brushstrokes because you need blank spaces to show off the water.

STEP 4

Finish the painting by adding the island, cottages and bridge in the foreground with strong colours, and the mountains in the far background with diluted colours.

DOUBLE-COLOURING TECHNIQUE

STEP 1

Use a partial wash to fill the space intended for the feature, in this case a tree. You can use one colour, or two or more colours and let them merge at the edges. In this example I used indigo, gamboge and cadmium orange. I diluted the colours a little bit with water. Wait for the washes to dry before moving on to the next step.

STEP 2

Add dots on the washes to create texture. Use the same colour as the wash to paint dots. For example, paint dots using indigo on the part with an indigo wash. For the three levels of trees in the painting, I painted those in the foreground with a small size Orchid and Bamboo brush using dots and long dots. For those in the middle, where the cottages stand, I used a size 3 Leopard and Wolf or big size Landscape brush and only dots for the texture. I left those in the distance untouched apart from the washes so that they all have a diffuse image. These different approaches create depth in the composition.

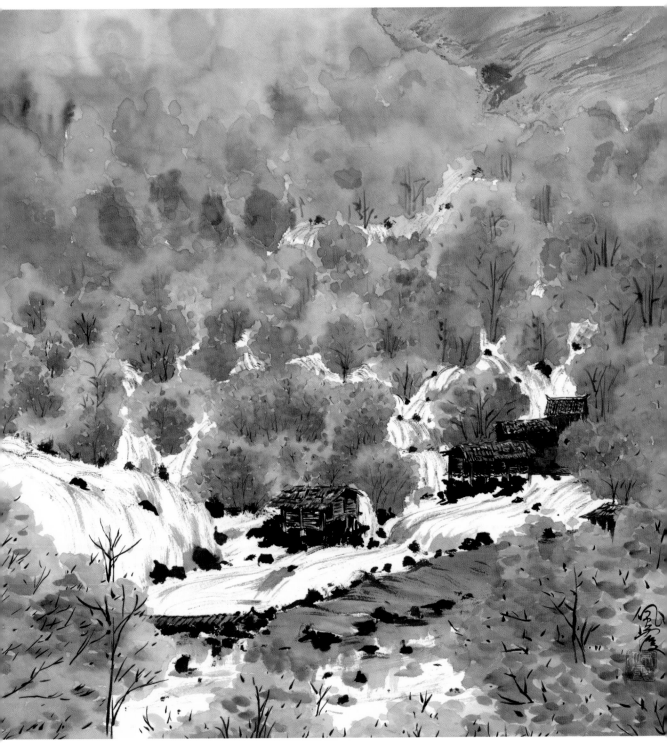

STEP 3

Add the trunks and branches in the front and in the middle with a smaller brush and ink. I used a Red Bean or small size Landscape brush for this purpose. I used dark ink for the tree trunks and branches in the foreground but medium ink for those in the middle. I left the trees in the distance untouched so that the images remained fuzzy.

WINTER

Ink

Indigo

Cobalt Blue

Yellow Ochre

BRUSHES

Small Mountain and
Horse brush

Red Bean or small size
Landscape brush

Size 3 Leopard and
Wolf or big size
Landscape brush

Goat-hair Hake or
Ti brush

Bare trees, deserted lanes, frost, snow and grey sky are the natural features of winter. The mood is cold and quiet. To create this kind of atmosphere you need to keep colours to a minimum; too many will distract from the stillness of winter. Blank space is also effective because it inspires the feeling of a deserted landscape. Snow often appears in winter scenes, but I think bare trees and cold colours can create an equally impressive winter painting.

STEP 1
Start by painting the foreground trees using a small Mountain and Horse brush and dark ink with sweeping elbow movements. If you need some guidelines for the trees, use a Red Bean or small size Landscape brush and diluted ink to sketch the positions of the trees before painting them with dark ink. I would encourage you to try painting them without the diluted ink guidelines, as these nice strong trunks are painted with decisive sweeping elbow movements, and you may lose the effect if you paint them by tentatively following an outline. Besides, by this stage I am sure you can do without guidelines. I added branches only in the upper part of the painting because I wanted to reserve the space on the ground for shadows. Also, it enhances the bareness of the trees.

STEP 2
Use a small Mountain and Horse brush to paint the tall trees on the left side with medium ink. Use diluted ink for the rest of the trees on the right side. Paint all the trees with swift elbow movements. If you find this brush too big for the smaller trees, use a size 3 Leopard and Wolf or big size Landscape brush instead. Add the shadows of the trees with medium ink using this brush, again with swift elbow movements.

STEP 3
Prepare two washes. For one, mix two parts indigo with one part cobalt blue. Dilute a small quantity of this mix for the second wash. Decide which area you want to keep blank – this will be where the moon shines through. Keep this area dry, but wet just one edge of it with clean water and a Goat-hair Hake brush. (Do not apply water to the whole area, otherwise the colour laid on top will seep across and you will lose that blank space.) Apply the diluted blue mix along this wet edge on the side away from the blank space. The colour will start to run into the clean water. Add the darker mix alongside the paint you have just applied, on the edge furthest from the blank space. Repeat until you get to the edge of the paper. Now do the same on the other side of the blank space. You can add further colours to intensify the tones while the washes are still wet. If the washes are dry when you decide to do this, either start again or wet the washes before adding further colour.

STEP 4
When you are happy with the colour wait for the painting to dry completely before adding a few leaves to the trees and on the ground. For the leaves with shadows on the ground, use a size 3 Leopard and Wolf or big size Landscape brush to paint the leaves with yellow ochre using the press and lift technique. Then add the shadows with diluted ink.

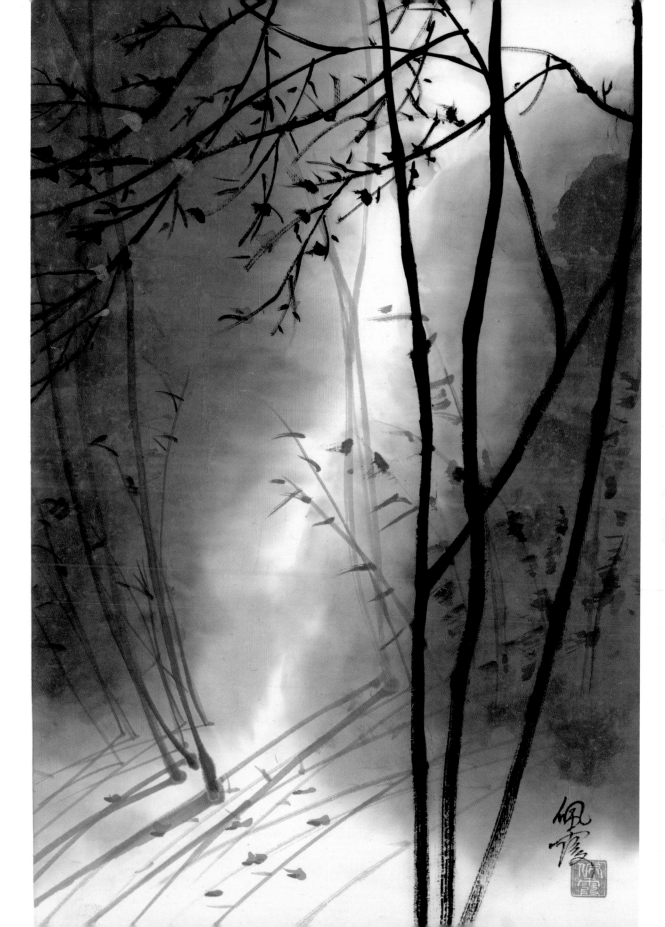

5 GALLERY

My landscape paintings are certainly not limited to Chinese scenes. I have travelled to many parts of the earth and found the world full of beautiful places that I want to capture in paint. The paintings in this chapter are more expressive and personal. I hope they can give you an idea of what you have to look forward to once you get past the initial learning stage.

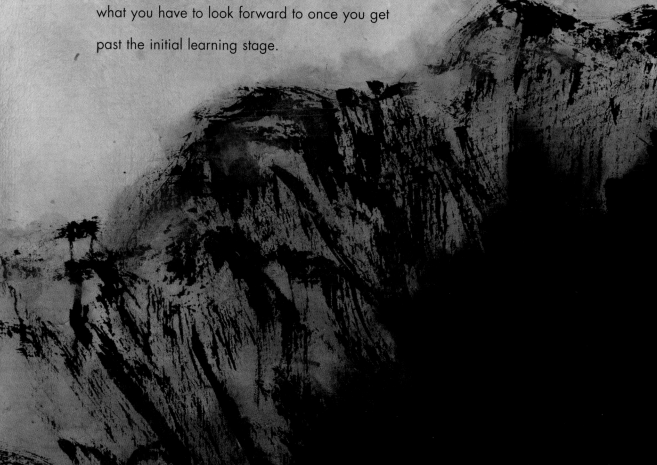

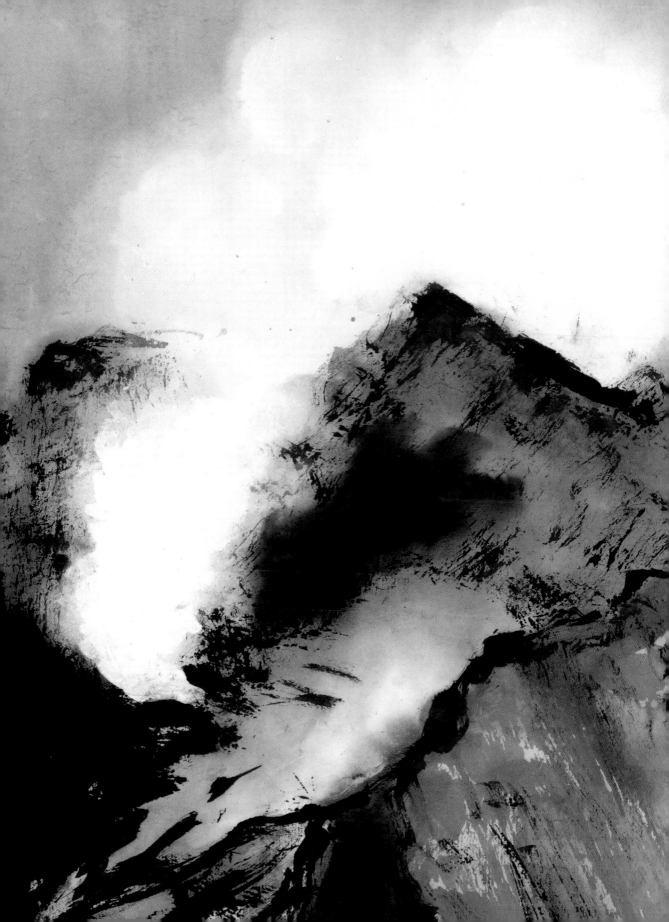

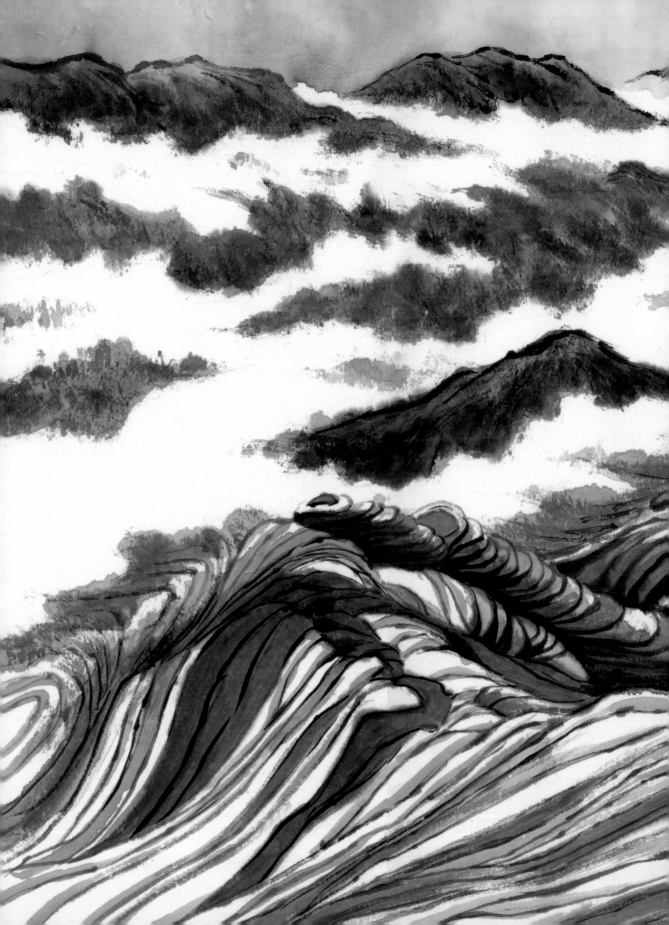

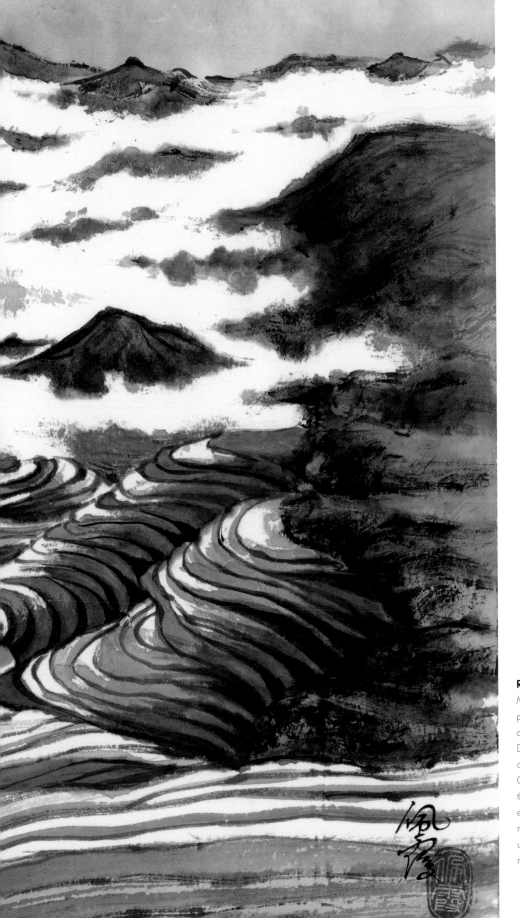

RICE FIELD

Many of the existing rice paddies were actually built as far back as the Ming Dynasty (1368–1644). This one is in Longji, not far from Guilin. When you stand at the top of the hill towards evening, you can watch the mist rushing in. It is an unbelievably magical moment.

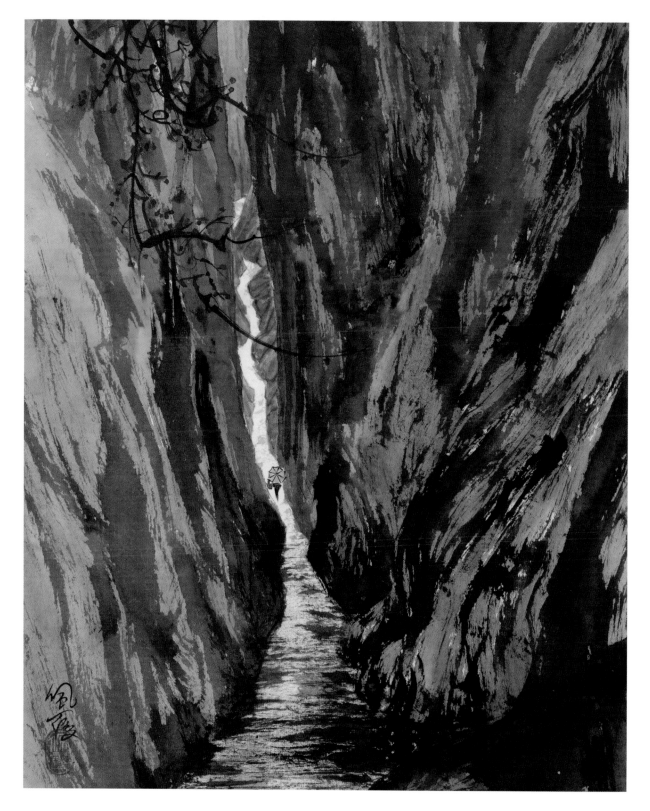

BAIHUIGU THREAD-LIKE SKY

The full Chinese name for this pass is actually very long and translates as 'you can see a thread-like sky in the valley of a hundred flowers'. The mountains on both sides of the pass look as if they were one big peak that has been sliced down the middle, leaving two cliffs standing very close to one another. This artwork was painted on alum-sized Xuan paper.

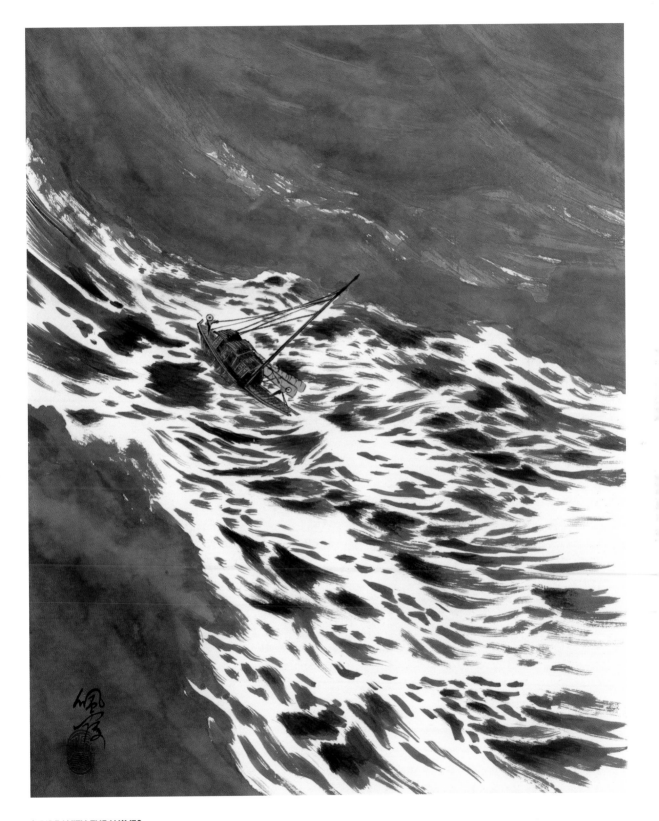

A RIDE WITH THE WAVES

The composition of an artwork need not be complicated. As in this painting, you can create a simple composition that expresses itself powerfully.

Can you feel the swinging elbow movement that I used to produce the sweeping waves of the sea? I used brushstrokes with different tones of blue.

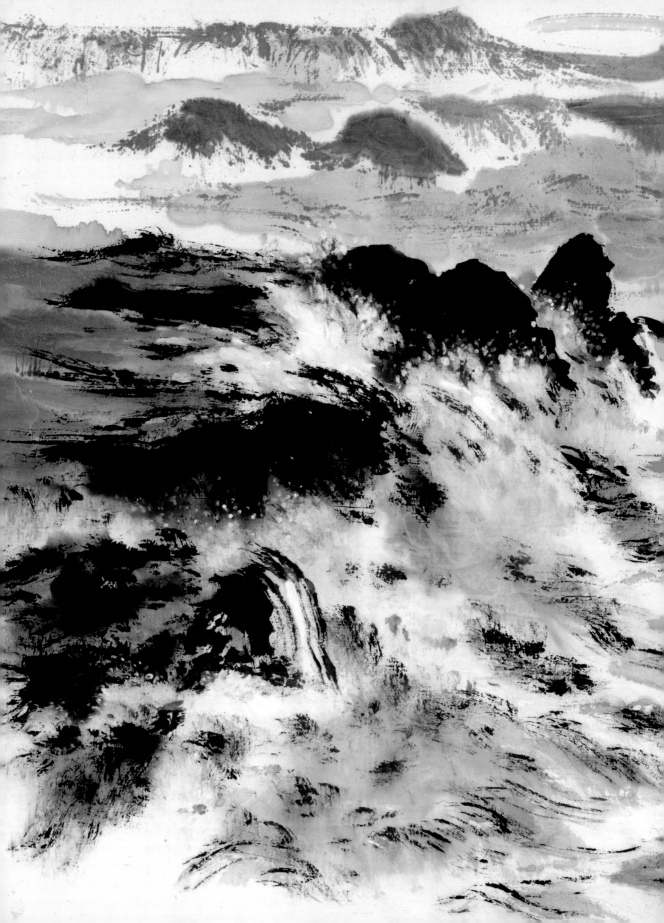

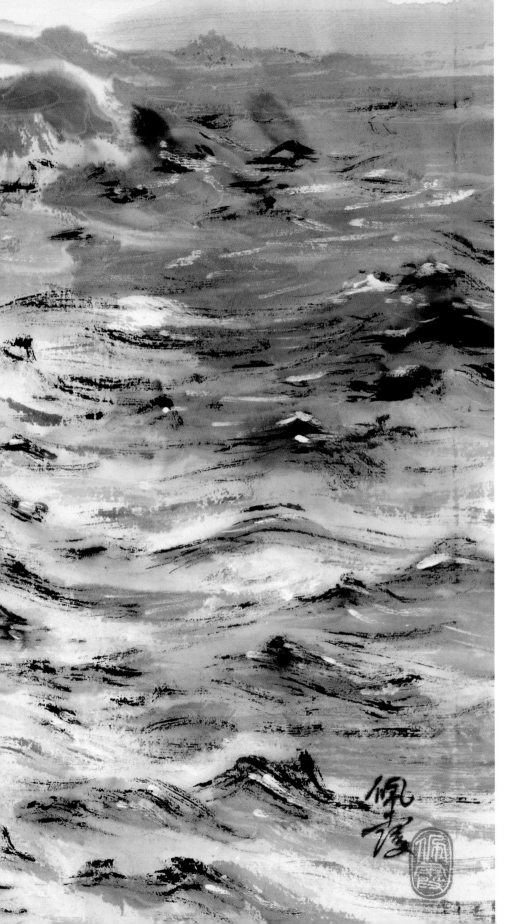

BRITTANY, FRANCE

This painting features a display of dry brushstrokes and partial washes. When both of these techniques are properly balanced, they can produce amazing effects.

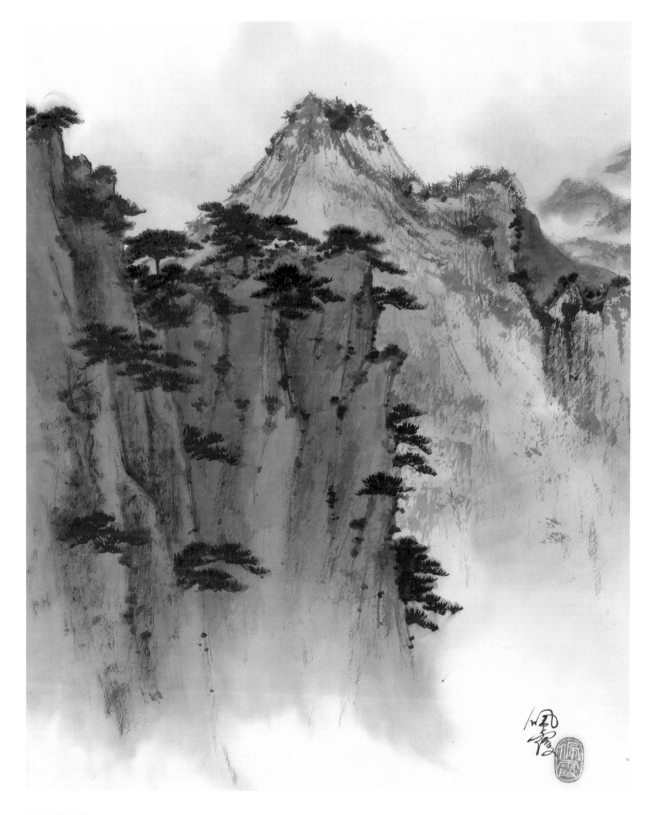

HUANGSHAN

Huangshan is one of the most fascinating mountain landmarks in China. Magnificently formed rocks and cliffs of awe-inspiring formation tower before your eyes, dotted with ancient pine trees – probably the most curiously shaped examples on earth. As if nature wasn't content with that, the whole landscape is imbued with heavy mist. You have to be there to believe it.

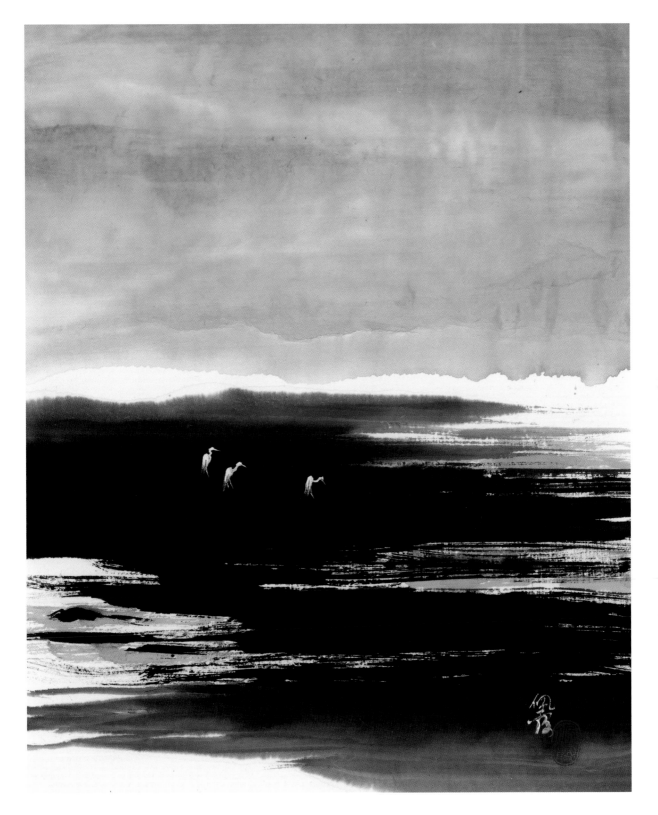

A SANDY BEACH

Again a very simple composition, but one that works very well.

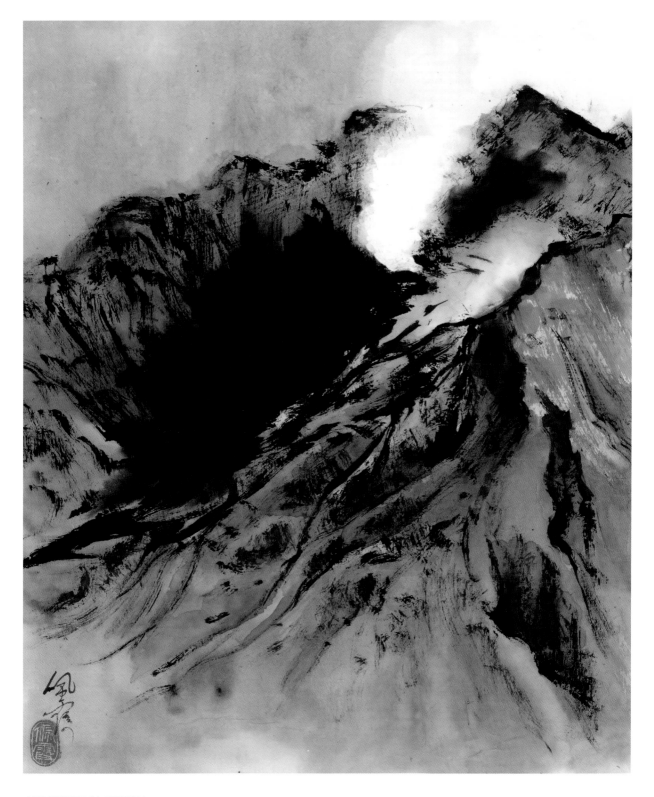

VOLCANOES IN SUMATRA

A pupil of mine once arrived at a lesson with a photograph showing the volcanoes of Sumatra. She wanted to know how we could approach painting a landscape like that. I constructed a painting from the photograph and gave the class a step-by-step demonstration of how to do it, from the choice of brushstrokes and colours to actually painting it. This is the result. Everybody was delighted and had a go themselves, and perhaps you might like to try it as well.

WATERWAY NEAR THE HANSHAN TEMPLE

The Hanshan (meaning 'cold mountain') Temple is in Suzhou. Much of the area is flooded and traversed by waterways, but the temple is on the hill. Made famous in verse, one particularly well-known poem is often written out in calligraphy. Any tourist who has bought a calligraphy artwork in China most probably ended up with it. The poem describes a cold winter night travelling in the waterways and hearing the chimes of the temple bell. This is the atmosphere I am trying to capture in this painting.

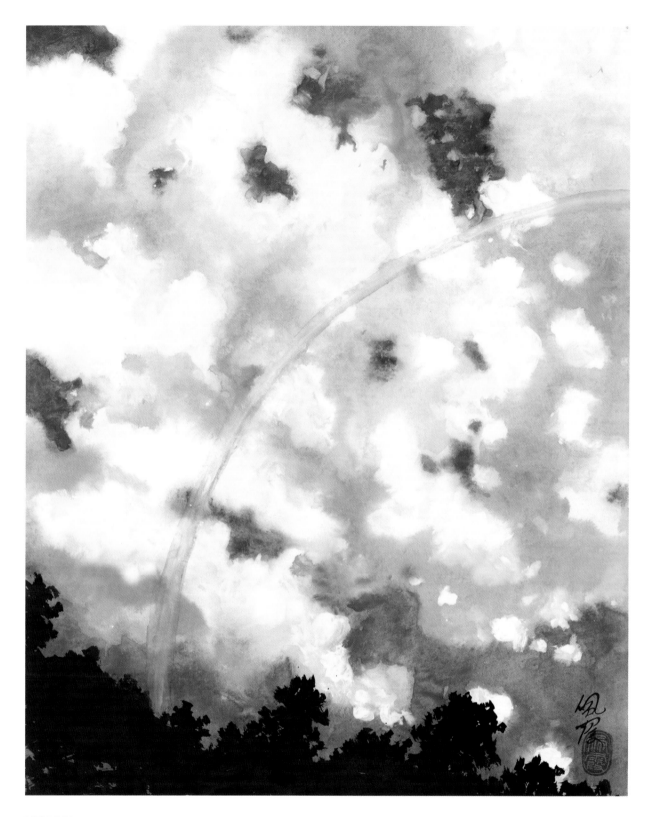

RAINBOW

I saw this rainbow in New Zealand, where there are so many unspoiled landscapes that one would love to paint them all. I was so delighted with this rainbow and the vast expanse of sky, with its massive number of different-shaped clouds, that I wanted to share it with you. The painting was done on alum-sized Xuan paper. Can you spot the techniques for painting sky that I showed you?

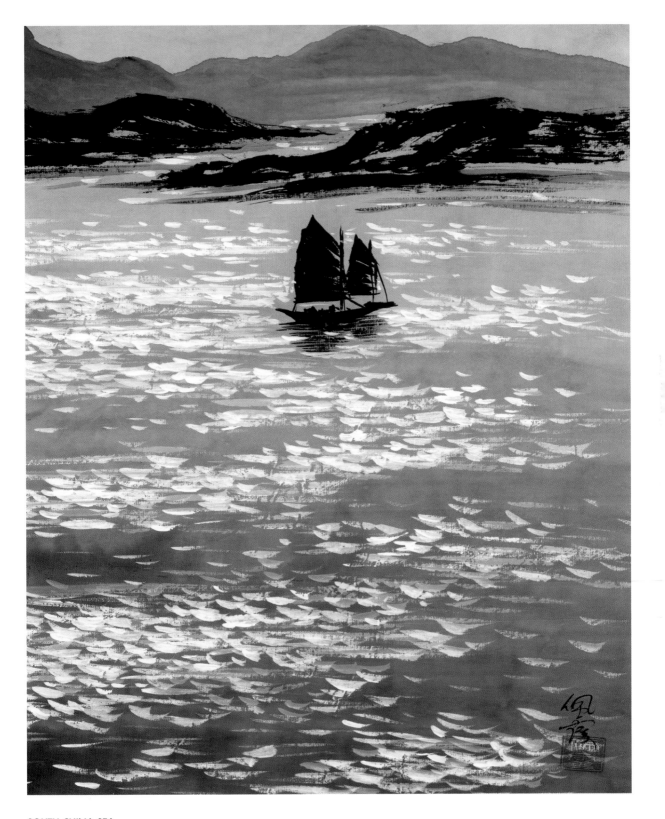

SOUTH CHINA SEA

This area is very near Hong Kong where there are fishing villages and low hills. The strong sunlight makes the water shimmer with beautiful light effects.

APPENDIX:
UNIQUE CHINESE FEATURES

Although I would urge you to paint all kinds of landscapes using Chinese painting techniques, there are those who prefer their landscape paintings to look Chinese. So I am including here some examples of Chinese features. Do feel free to use them in your paintings.

GRASS ROOF SHELTER
There are many such shelters along the country roads, offering shelter from the elements for weary travellers.

COTTAGE WITH GRASS ROOF
Many old farmhouses have grass roofs like this cottage.

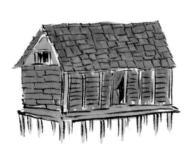

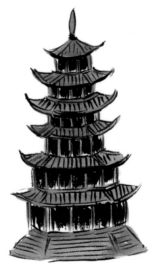

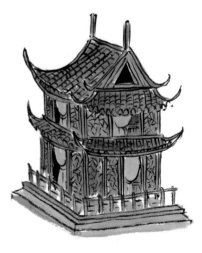

WOODEN COTTAGE
A wooden cottage is a more improved and secure lodging than the grass roof type.

PAGODA
A pagoda can have three, five, six, seven, eight, nine or ten floors. Each number has its own lucky meaning. Chinese always avoid using the number four because it sounds the same as the word for death.

TRADITIONAL HOUSE
Bigger and more elaborate houses are lodgings of the rich. Some of them have many levels. A rich man's property usually has several buildings, like the one shown here, that are linked together on the four sides of a square, leaving the middle open for the courtyard and garden.

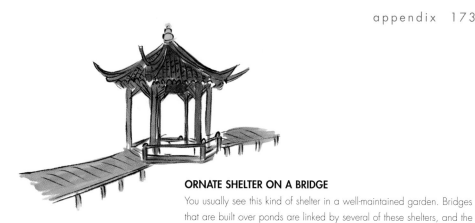

ORNATE SHELTER ON A BRIDGE

You usually see this kind of shelter in a well-maintained garden. Bridges that are built over ponds are linked by several of these shelters, and the family uses them for entertaining guests.

MOUNTAIN PASS

A mountain pass is usually built with wood and intended as a temporary measure, but it can last until it breaks down.

TEMPORARY BRIDGE

This kind of bridge is only built over shallow water and is usually made of wood and hay.

SMALL TOWN BRIDGE

This is a more secure bridge built with bricks.

WELL-BUILT BRIDGE

A well-built bridge can last forever, and you can see many such examples all over China. Many are more elaborate than the one in this illustration, and they can be built from brick, stone or wood. Those in the imperial gardens were built with marble and granite.

SAILBOAT

This was a common method of transport in the past, over long stretches of water. You can still see some of them today.

HOUSEBOAT

There are living quarters in these boats, and some even have several rooms.

SUPPLIERS

US

EChinaArt Store
Tel: 1-718-938-6588
www.echinaart.com

China Art Material and Art Books
China Cultural Centre
970 North Broadway
Suite 210
Los Angeles
CA 90012
USA
Tel: 1-213-626-7295
Fax: 1-213-617-7656
www.ocac.gov.tw

OAS (Oriental Art Supply)
21522 Surveyor Circle
Huntington Beach
CA 92646
USA
Tel: 1-714-969-4470
Tel: 1-800-969-4471
www.orientalartsupply.com

Oriental Culture Enterpises Co. Inc.
13–17 Elizabeth Street
2nd Floor
NY 10013
USA
Tel: 1-212-226-8461
Fax: 1-212-431-6695
www.oceweb.com/en/

Rochester Art Supply
150 West Main Street
Rochester
NY 14614
USA
Tel: 1-585-546-6509

UK

Blots Pen and Ink Supplies
14 Lyndhurst Avenue
Prestwich
Manchester M25 OGF
UK
Tel: 0161 720 6916
www.blotspens.co.uk

Georgina Cowdrey
23 Oaklands Road
Petersfield GU32 2EY
UK
Tel/Fax: 01730 300816
Email: geocow@waitrose.com

Guanghwa Co. ltd
7 Newport Place
London WC2H 7JR
UK
Tel: 0207 437 373
Fax: 0207 831 0137

SAA (Society for All Artists)
PO Box 50
Newark
Notts NG23 5GY
UK
Tel: 01949 844050
Fax: 01949 844051
www.saa.co.uk/shop

London Graphic Centre
16-18 Shelton Street
London WC2H 9JJ
Tel: 0207 759 4500

INDEX